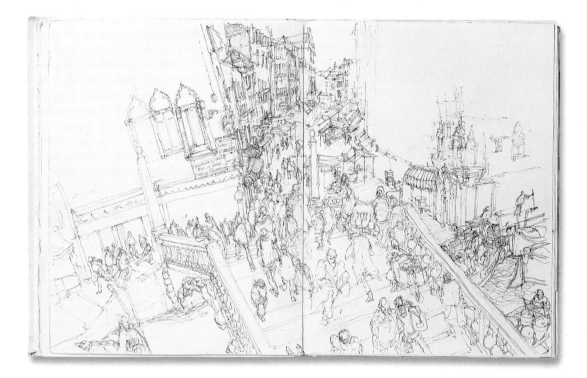

SKETCH
BOOK
FOR THE ARTIST

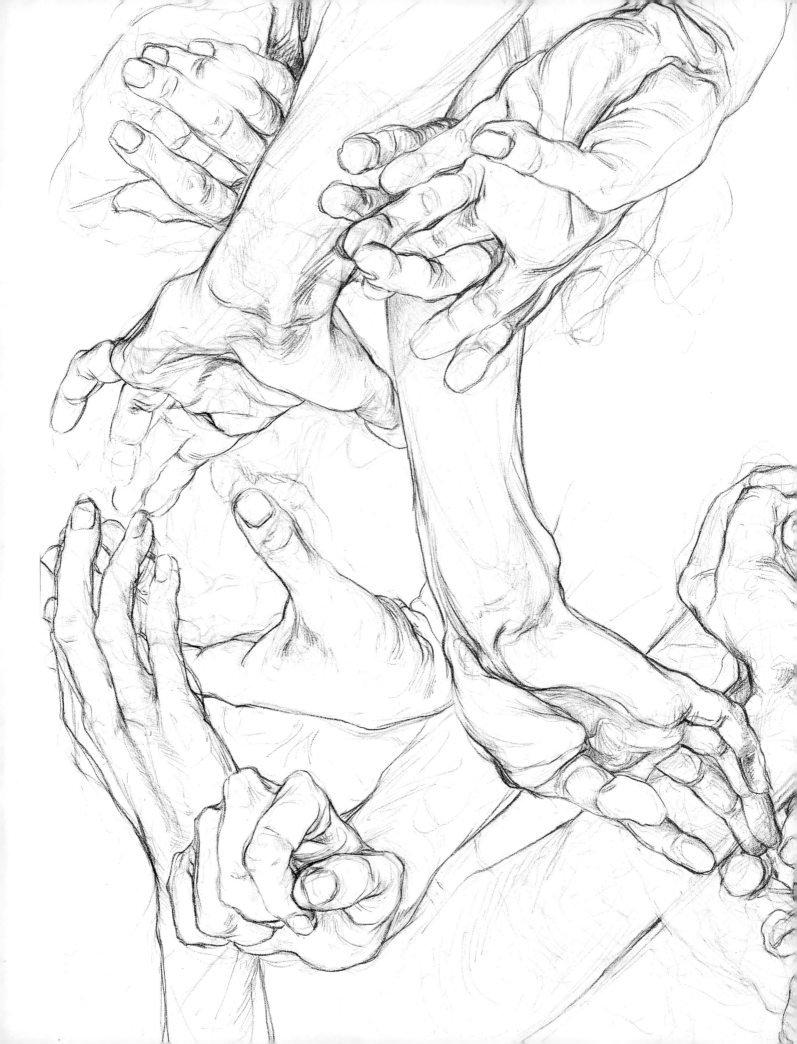

SKETCH
BOOK
FOR THE ARTIST

SARAH SIMBLET

METRO BOOKS
NEW YORK

This 2008 edition published by
Metro Books by arrangement with
Dorling Kindersley Limited, London

Senior Editor Paula Regan
Senior Art Editor Mandy Earey
Art Editor Anna Plucinska
Managing Editor Julie Oughton
Managing Art Editor Heather McCarry
Art Director Peter Luff
Publishing Director Jackie Douglas
Production Joanna Bull
DTP Designer Adam Walker
Picture Research Sarah Smithies
US Editor Christine Heilman

Metro Books
122 Fifth Avenue
New York, NY 10011

ISBN-13: 978-1-4351-0419-8
ISBN-10: 1-4351-0419-6

Reproduced by Colourscan, Singapore
Printed and bound in China by
L.Rex Printing Company

3 5 7 9 10 8 6 4 2

CONTENTS

Foreword

BY DRAWING THE WORLD AROUND US, we learn to see it. By using our imaginations, we learn to feel truly alive. Combine these things and the possibilities are endless. Drawing occupies a unique place in every artist and creator's life, be they a child discovering their vision and dexterity; a sculptor, fashion designer, architect, or engineer; a composer notating a musical score; a cartographer charting the land; or a quantum physicist trying to see for themselves the fluctuations of our universe. For me personally, drawing is the immediate expression of seeing, thinking, and feeling. It is a tool for investigating ideas and recording knowledge, and a reflector of experience. Drawing is a mirror through which I understand my place in the world, and through which I can see how I think. I will always draw, not only to make art, but because it is how I engage with and anchor myself in life. It makes me feel excited to be alive.

Some of my drawings cover entire walls. They enfold their viewer and are made on joined sheets of paper that I reach by climbing ladders. Others can be held in the hand or, by invitation, are made outside as discreet installations, perhaps hidden on a door hinge or a street bench rail, where I expect them to be discovered by some people, remain unseen by most, and be slowly washed or worn away. Some are more traditionally framed and hung in galleries for solo or group exhibitions. I also make drawing books, especially as travel journals. They occupy a shelf in my studio, and I refer back to them for years after they are made. It is my love of these, and their importance to so many artists, that inspired the title and structure of *Sketch Book for the Artist*. Chosen in any color, texture, shape, and size, a drawing book is the perfect portable private vehicle for your imminent exploration of drawing.

For twelve years I have enjoyed the privilege of teaching drawing, as a visiting professor at universities, art schools, and local community classes. I work with people of diverse ages, aspirations, and experience, from schoolchildren to senior citizens, undergraduates to fellow professors, night security staff, doctors, geologists, and makers of special effects. The most rewarding challenge is always the newcomer, still standing by the door, who tells me firmly upon approach that they cannot draw. I know that with their cooperation I can soon prove them wrong, and in a few sessions they will be flying. We can all learn how to draw.

The very first step is to believe it.

MEMORY THEATERS
This pen-and-ink drawing was made from imagination during research for my PhD. I was training in anatomy and studying how, through history, we have looked at, understood (and often misunderstood) our own bodies. I was also reading among *The Confessions of St. Augustine* his notes on memory, in which he describes himself flying and diving in his imagination through pictorial caverns of knowledge. These inspirations led me to invent museums, where spaces are shaped by nothing more than the objects and activities contained within them.

Where We Begin

There is a fundamental drive in our human nature to make a mark. Children cannot be restrained from running across the pristine white lawn of newly fallen snow, inscribing every fresh part of it with their eager scrapes and trails. Most adults still feel that certain exquisite pleasure on arriving at a beach to find the tide out and the sand perfect, like a great canvas for them to mark. At home and at work we doodle, scrawling shapes and cartoons when on the telephone, in lectures, and in meetings. Sometimes we draw because we are bored, but more often because drawing actually helps us to focus and take in what is said. We are surrounded by drawings in our daily lives, not just chosen pictures on our walls but everywhere—maps, signs, graffiti, logos, packaging, and patterns on our clothes. We are bombarded with linear and tonal pictorial information, and we spend our lives reading it. The sense of relief we may feel from the information overload of modern commercial life when visiting a country in which we can no longer read every written word, is not afforded us by drawing. Drawing is international, irreverent to language barriers. We can always read each other's drawings.

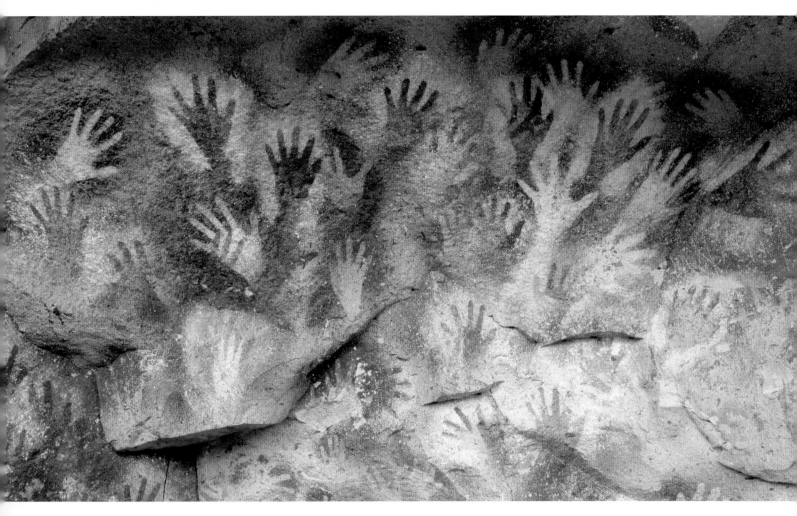

"CAVE OF THE HANDS"

In this drawing, a great crowd is raising their hands in greeting, waving to us from many thousands of years ago. These ancient silhouettes were drawn with earth pigments rubbed onto rock. They have a natural affinity to many modern graffiti signatures.

Cueva de las Manos, Río Pinturas
13,000–9500 BCE

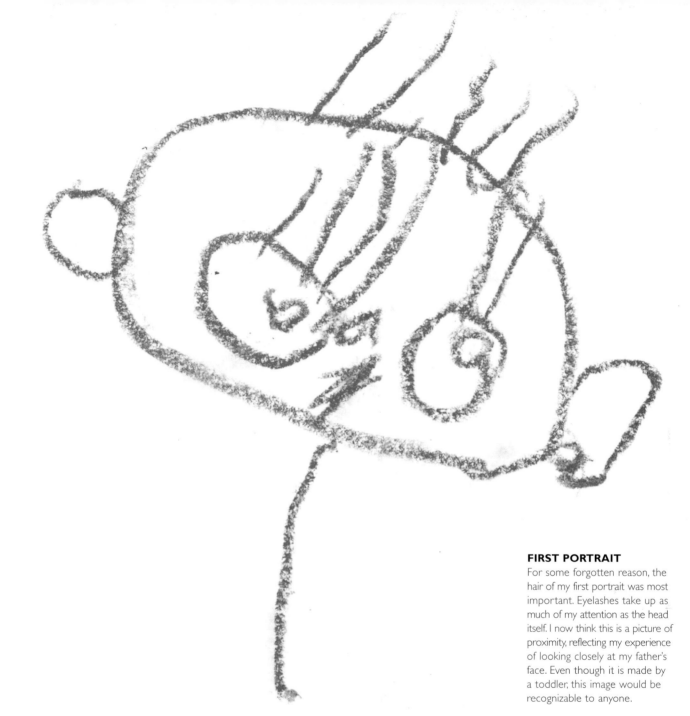

FIRST PORTRAIT
For some forgotten reason, the hair of my first portrait was most important. Eyelashes take up as much of my attention as the head itself. I now think this is a picture of proximity, reflecting my experience of looking closely at my father's face. Even though it is made by a toddler, this image would be recognizable to anyone.

MAKING OUR MARK

It seems reasonable to assume that we have engaged in pictorial mark-making for as long as we have made conscious use of our hands. In cave paintings like the one opposite, we see our oldest surviving images, created by societies of hunter-gatherers, who in their day-to-day hardship made time to picture themselves and the animals on which they depended. Cave art was not made for decoration but as a fundamental part of life, an expression of existence, power, and belonging to place.

On a particular afternoon in September 1974, at age two-and-a-half, I was sitting with my mother. She gave me a notepad and a red crayon and asked me to draw her "a picture of Daddy." Until this day, I, like all toddlers, had happily scribbled, enjoying the physical sensation of crayon on paper, and the appearance of my strikes of colors, but I had never yet attempted to figuratively picture my world. The image above is what I gave back to my mother, and she kept it as my first step beyond the delighted realms of scrawl.

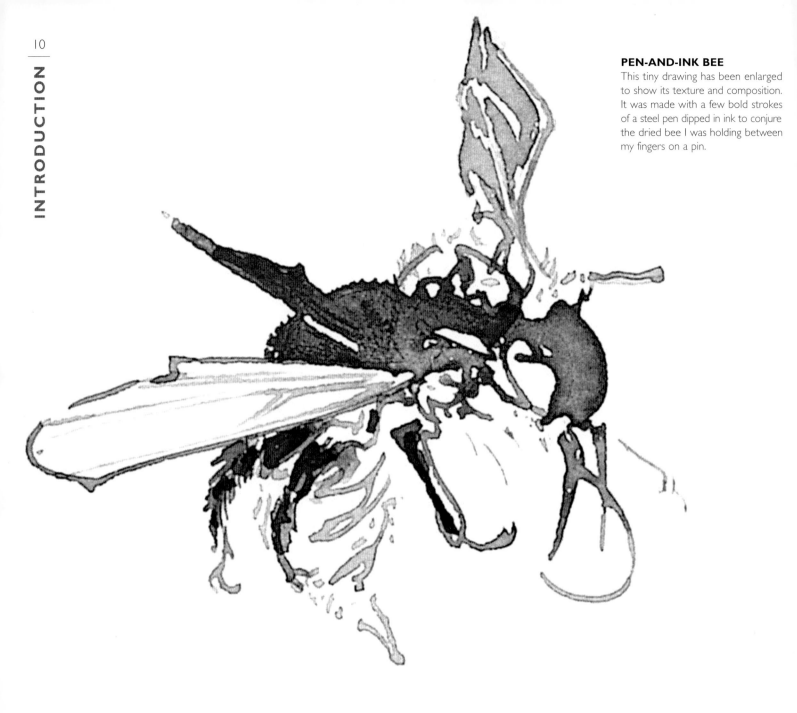

PEN-AND-INK BEE
This tiny drawing has been enlarged
to show its texture and composition.
It was made with a few bold strokes
of a steel pen dipped in ink to conjure
the dried bee I was holding between
my fingers on a pin.

PROGRESSION

There is a point in all our lives when we first control our mark and make it a line, then drag our line into a loop, and from that first unit build and describe the shape of something or someone we know. Young children love to draw. Hours are lost immersed in the glorious world of imagination, and this activity plays a vital role in their development. But as adolescents, most of us stop. Inhibitions creep in and ideas of good and bad terminate confidence. At this point many will insist they cannot draw, yet still turn to drawing when their verbal language fails or is inadequate. We do not hesitate to draw a map, for example, to help a stranger see their way.

When taking first steps in relearning how to draw, it is important to value your natural abilities and ways of seeing, however small and unformed you believe they are. As you progress, be proud of what makes your work individual to you. Don't be persuaded to draw in a way someone else

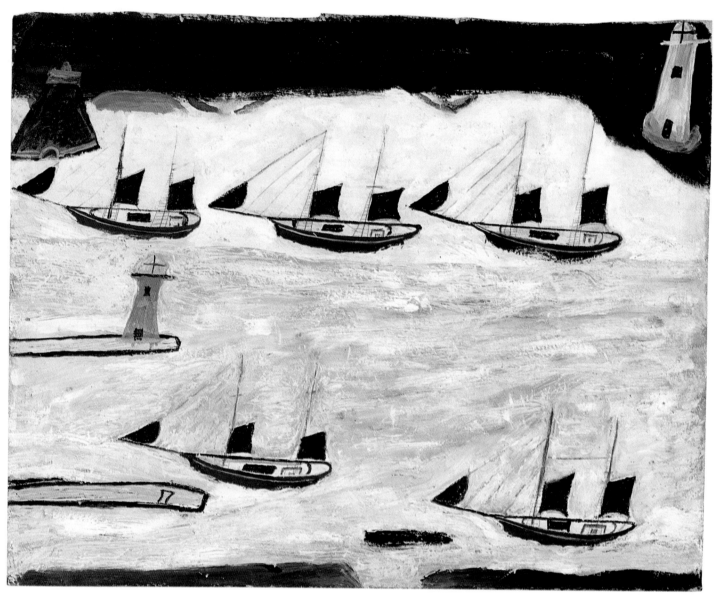

A UNIQUE SIGHT

This innocent yet sophisticated drawing of boats, harbor, and sea is one of many that Alfred Wallis made from memory while sitting at home. He was a retired Cornish fisherman and junk dealer who began drawing at the age of 70 "for company" after his wife died. He used leftover ship and yacht paint with crayons on cut-out pieces of cardboard boxes.

Five Ships in Port with Lighthouse
c. 1925–42
5⅜ x 8⅞ in (135 x 225 mm)
ALFRED WALLIS

prefers and tells you is better. Think how much would have been lost if anyone had interfered with Alfred Wallis' personal sense of proportion and perspective in the exquisite drawing above. As you read this book and perhaps attend art classes, remember that all advice is only advice. After experimenting and trying each new idea, you must decide whether to keep or discard it. Enjoy the control of your own journey.

Occasionally, I meet students struggling unhappily with a particular method of drawing. Someone once told them they must draw in this way, and they have never questioned why. I ask them their reasons for drawing, what they most want to achieve, and which aspects of the vast wealth and diversity of graphic language would be most appropriate to their goals. The journey of every artist demands hard work and discipline, but it does help to set out facing in the right direction.

VISION

All artists see the world differently. The art historian Professor Sir Ernst Gombrich, author of *The Story of Art*, wrote as the opening line of this great work, "There really is no such thing as Art. There are only artists." The clarity and empowerment of these words, is, I hope, embedded in this book. When we look back at Wallis' seascape (*see p.11*), it may not be accurate to our critical adult eye, but the child in us knows that this is an all-embracing, clear-minded understanding of the sea, boats, and breathtaking wind of a choppy harbor. If as artists we nail a subject down too hard, we can drive out its spirit, and lose the very thing that attracted us to it. Our

imaginations are the tools with which we can increase the essence of life, be visionary, and inspire others.

The observed world may be our subject, but it should be the experienced world we draw. There should never be a slavish obligation to represent things exactly as we collectively agree we see them. We all see differently. We also see differently ourselves, depending on the occasion and our purpose. There are countless reasons for drawing. We

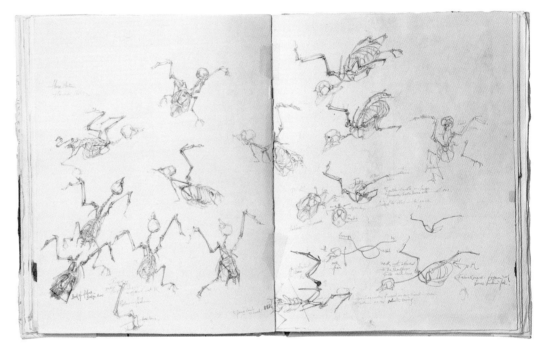

BIRD STUDIES

The flutter of faint scratches that dance across the pages on the right is an attempt to see the movement and bony weightlessness of a bird. Below, the breast- and collarbones and shoulder blades of a different bird almost become new creatures in themselves.

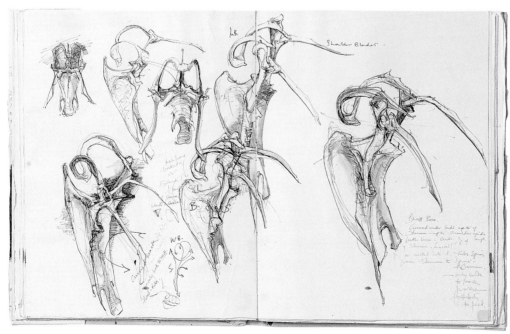

IDEAS AND INVENTIONS

These active machines, right, all raise water. From the Archimedes' screw to Leonardo's own cupped wheel, the page bristles with the focus of ideas. His notes visually balance his drawings. They are also always written backward, not for disguise but as a personal choice, perhaps for comfort or ease as a left-hander, or a habitual enjoyment of the challenge.

Archimedes' Screws and Water Wheels
1503
LEONARDO DA VINCI

should not try to know how every finished picture will look, but it is important to be clear why we are making it.

Decide before you start whether you are drawing to warm up, or to discover the best use of a new material, to express the beauty in a moment's play of light, conduct an experiment, make a calculation, shout against a terrible injustice, or illustrate a dream. Opposite, I drew to understand the apparatus of flight, while below, Leonardo drew to invent a machine. Our drawings are annotated investigations into the mechanisms of nature and of an idea. We have both covered our paper with focused, stripped-down parts, drawing in pursuit of our own thoughts and understanding. My drawings of a house-martin (*opposite top*) illustrate the importance of repeated study. More was learned drawing the bird 18 times than would have been understood drawing it only once or twice. Each fresh image reflects growing confidence and the experience of the preceding study. This also applies if struggling at length with a larger picture; when it looks tired and still feels wrong, it may be best to start afresh. Don't be disheartened; time spent is not lost. It will be invested through your experience in the new drawing.

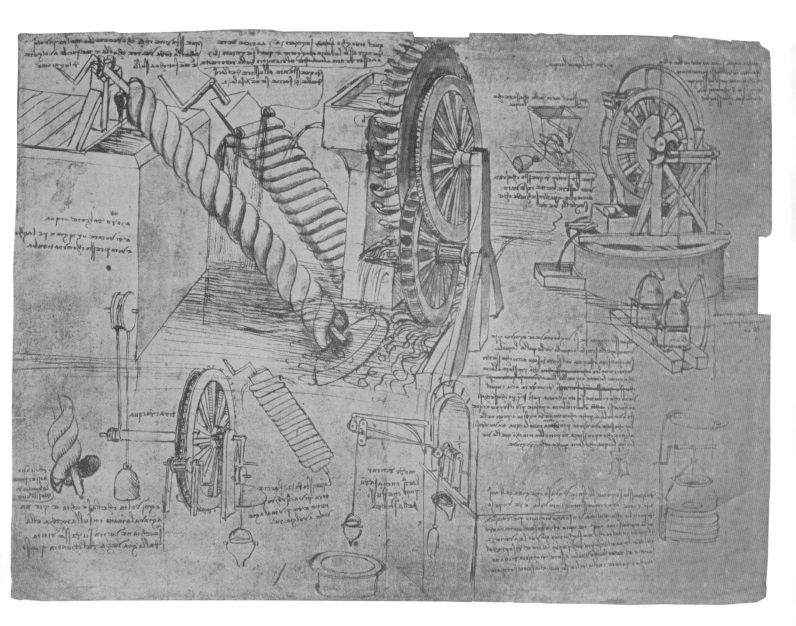

ALCHEMY

At school, and sometimes beyond, we are advised or even required to plan our pictures, declare the idea, explain the composition, and practice each part before putting the final image together. This suits many artists well and is perfectly valid. However, excessive planning can get in the way of the imagination, the unknown, and what you discover in the process of making. It denies the importance of accident, which can offer keys to other things.

These two brush drawings, created centuries and cultures apart, are both made of ink laid onto wet paper with speed and agile certainty. The physicality, balance, and spirit of each subject was held strongly but loosely between the fingertips, and allowed to flow through the brush. Each image relied upon past experience to know the probable behavior of the brush, ink, water, and paper. They each allowed the energy and focus of the moment to be expressed through controlled accident and a degree of the unknown. Both drawings were made trusting the marks, and at speeds beyond conscious thought.

As you draw any subject—something you see, feel, or imagine—it is not enough to only render its shape, size, and position in space. You must also think of its intrinsic nature: its purpose, meaning, and how it feels to the touch. Know the texture, temperature, depth, and opacity of your subject. Imagine these qualities so strongly that you feel them in your mind and at your fingertips. Whatever the material— wood, silk, bone, metal, fire, or ice—you must actually feel it beneath your fingers as you draw. As your hand meets the paper to make a mark, it should be responding to the sensation and meaning of the subject it draws. If you can do this, your marks will become the subject on the paper. This is the alchemy of drawing.

BRUSHED LANDSCAPE
This is a detail of a brush-and-ink drawing by a Japanese Buddhist monk. Our position as viewer is unsteady. We float toward the quiet vista as it also moves toward us. We are caught in a shifting focus that makes everything fluid, and we can just make out the distant stains of mountains, mists, and an island brushed with trees.

Landscape in Haboku Style
15TH CENTURY
58½ × 14⅞ in (148.6 × 32.7 cm)
TOYO SESSHU

FLOWING SKELETON
The gliding poise of this walking anatomy comes as much from the feeling of movement as it does from the feeling of drawing. I made it almost unconsciously with a pen and a brush, trusting my intuition to find a visual equivalence for the sensation of weight within my body.

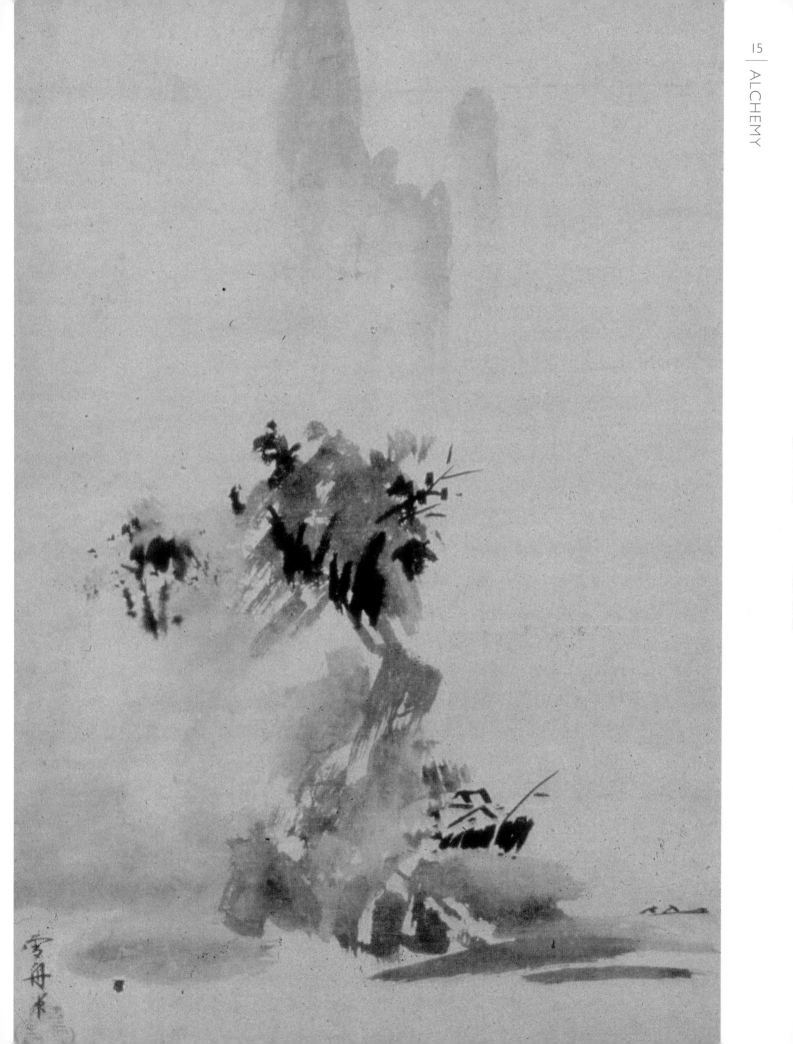

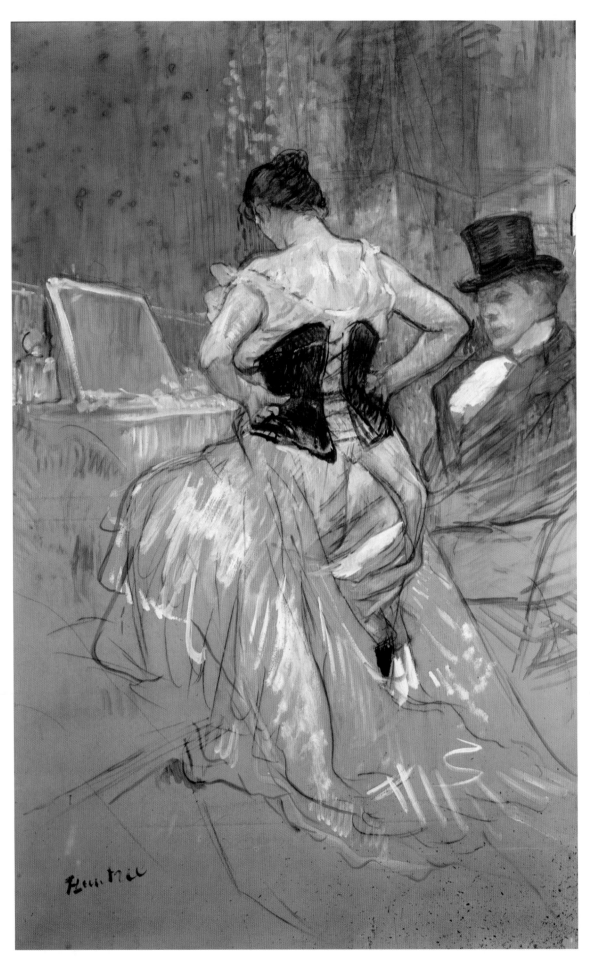

PLACE AND MOMENT
The heat and teeming atmosphere of this Parisian dressing room, left, lives on, more than 100 years after its making. Lautrec's flamboyant splashes of petticoats and pantaloons are drawn with long sweeps of chalk and brushed oil paint. He dazzles us with flashes of light and dabbed marks of shadow, which evoke realities of place and the power of moment.

Woman at her Toilet
c. 1896
41 × 26 in (104 × 66 cm)
TOULOUSE LAUTREC

RIB-CAGE DRAMA
This drama, right, is set inside a rib cage, one of many luminous works in watercolor, acrylic, pastel, gold leaf, and spray paint, made by a young British artist who creates alphabets of the absurd from familiar childhood characters. Walter also makes books: some, like folded insects, stand table-sized with furniture legs attached to both sides of their jacket.

Focusing on the Negative
2004
22 × 30 in (56 × 76 cm)
JOHN WALTER

FREEING THE HAND

If you are just beginning to learn how to draw, try not to grip your pen worrying about the technical terms you might have heard. Ignore these at first and allow yourself the freedom to play. Start by choosing a material you like the look of and cover a piece of paper with different marks. Enjoy discovering what your hand and the material can do. Choose other materials and do the same. Much will be learned on these test sheets and in your first drawings, just through the act of making. With no help and advice at all, you will naturally make progress on your own in response to concentration and the decision to look and draw. As you follow lessons in this book, take your time and don't worry if you need to make several attempts to grasp a concept. Drawing is exploratory, and mistakes are a valuable process of learning. Try to keep all of your first drawings, even those you dislike. Put them away and look at them later, at a point when you feel you are not making progress; you will be surprised and encouraged to see how far you have come.

One of the advantages of a drawing book is that you can shut it. Pages do not have to lie open for other people to inspect and comment on. It is yours. Such books are personal: the territory of new exploration and experiment; potential ideas still forming; diary-like observations; and miscellaneous items of inspiration.

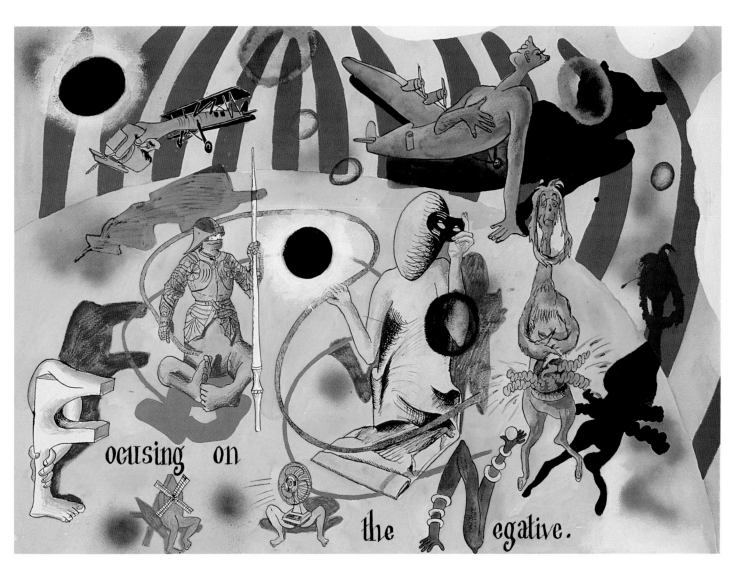

THE THINKING EYE

Techniques and materials are the grammar and vocabulary of drawing and can be studied and shared. An artist's personal voice is something that also evolves through lessons learned. However, it is this voice that is the subtle part of their art and something that ultimately, when they are more experienced, comes from within. Imagination needs nourishment. It rarely flourishes in isolation. As you draw, seek ideas in the life around you. Look to your own experience and also learn from the work of others.

Drawing is a living language that over millennia has grown and changed, adapting its form and occupation, and enfolding new media. The chapters of this book present 90 different artists' ways of seeing, and many more reasons for drawing the world. To these I have added my own drawings to explain elementary materials and techniques and offer introductory approaches. Note that the drawing classes are allocated to subjects, but not confined to them.

In the total wealth of these pages, we still only glimpse a corner of the magnitude of this subject and the infinity of what can be achieved. This practical journey will take you through the door into the vivid heart of drawing. Once there, the path is yours. The real drawing book has yet to come; it will be your creation as you discover your own personal vision.

AN ARTIST'S HANDS
These are the hands of the artist Phyll Kiggell (see p.150). Their elegant strength seems to summon a lifetime of drawing, and became a great subject for me. I was particularly attracted to their gentle articulation and understated determination, caught between action and repose.

ELECTRIC BULL
With a penlight, Picasso has just finished his drawing, which is held frozen in space by a camera lens. Its sensuous and flowing line seems to drift like smoke, three-dimensionally. Picasso is poised smiling, staring straight through his image of a bull, which of course he cannot see.

Picasso Painting with Light at the Madoura Pottery
1949

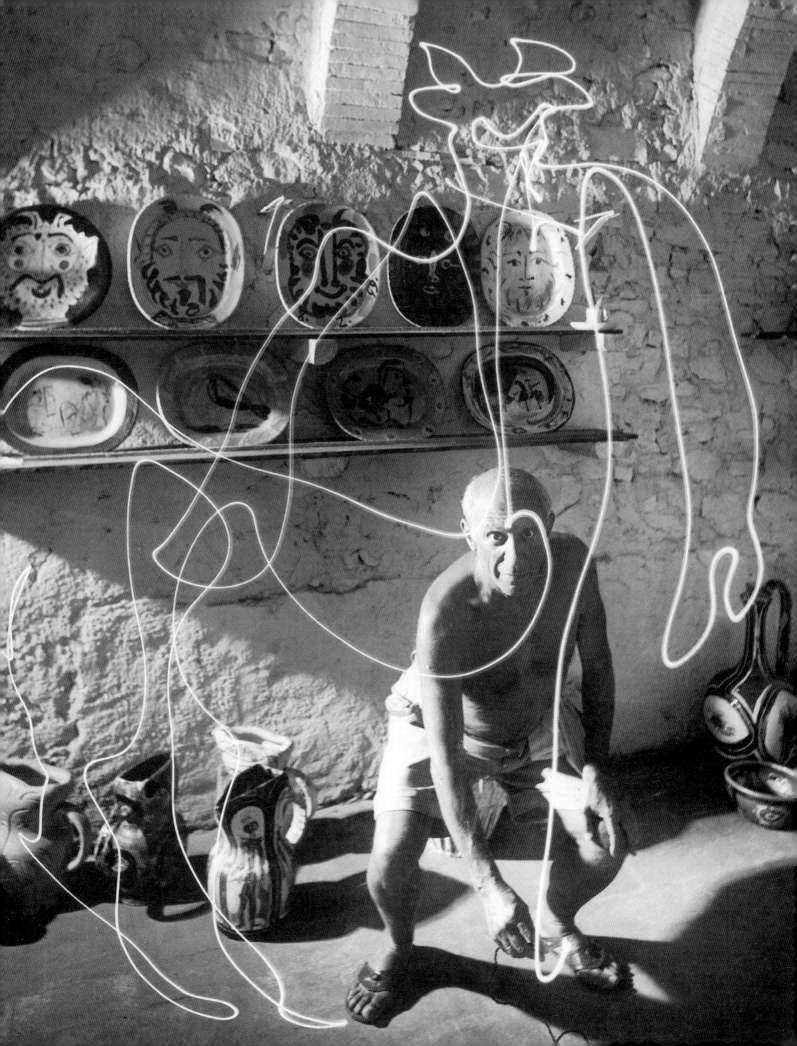

Drawing Books and Papers

TO BEGIN YOUR EXPLORATION of drawing, you need a drawing book. There are dozens to choose from. Gleaming store purchases vary greatly in format, binding, color, texture, thickness, quality, and cost. Homemade books can be assembled easily from found materials or selections of loose sheet papers, which are also sold in an enormous range. Art students often make use of printed books picked up from secondhand stores into which they draw, cut, and collage their ideas. It is also useful to own a portfolio. A high-quality one will last a lifetime; cheap corrugated plastic ones fall apart in days. Alternatively, study the structure of a good portfolio and make your own. You simply need two strong boards hinged together well, ties on either side to keep your papers in place, and handles to lift the weight of your artworks.

Drawing boards are invaluable. They can be very expensive in art stores; it is better to have them made at a lumber yard or home improvement store. Calculate a range of useful dimensions and have several cut at once. Smooth plywood, thick enough not to flex, is perfect. Sand the edges to avoid splinters. If you intend to carry your boards for a distance, be sure they fit comfortably under your arm.

DRAWING BOOKS

Select drawing books to suit your aims. For evening classes, choose larger formats to give you scope for experiment. For traveling, choose smaller hard-bound books that fit in your pocket or bag; their jackets will act like drawing boards and protect your work. Many artists invent ways of binding their own books. Dissecting a discarded hard-bound book will soon show you how it is made; this is how I learned.

1. CANVAS-COVERED HARD-BOUND: Ideal for carrying around; a length of black elastic tied around the middle will hold the contents together when you fold in collected items. Note the widely differing choice of papers with which these are made.

2. BLACK POCKET BOOKS: Hand-sized with ready-made elastic binder and a marker ribbon. Most contain thin paper and are perfect for use with disposable pens.

3. COLORED PAPERS: Large art supply stores often sell thick books full of colored papers. These are perfect for working in color. If planning to use pencils, pastels, and crayons, be aware that paper texture effects and changes their marks.

4. RING-BOUND PADS: These are the least expensive and useful for opening flat. However, ring bindings often break. Purchase a high-quality ring-bound pad if you wish to keep your drawings together long-term.

5. FOUND BOOKS: Old printed novels, catalogs, and reference books found in second-hand stores make unique subjects for experiments and collage.

6. HOMEMADE: I made this book from drawing paper that I folded, stitched, and glued to a strip of bias binding. The hard-board jacket is stretched with canvas beneath the paper sleeve.

Tantalus or *The Future of Man*
2002
8½ x 6¼ in (215 x 158 mm)
ROSE MILLER

1

2

3

4

5

PAPERS

Papers differ in thickness (weight), size, texture, color, absorbency, Ph, and cost. They are hand-, mold-, or machine made in sheets, blocks, or rolls. Cotton papers are high-quality and acid-free, resisting deterioration. Cheap wood-pulp papers are acidic, turning brown and brittle. Use cheap paper for rough ideas and quality paper for work to last. See the glossary (*pp.256–59*) for explanations of rough, cold, not, and hot pressed papers.

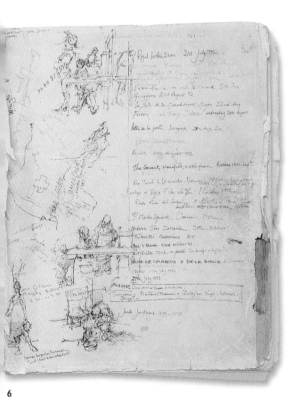

7. TISSUE PAPER: Place sheets between drawing book pages to keep images from printing on each other, and use for delicate collage.

8. GLASSINE: Sold as protective wrapping. It is also excellent for drawing with marker pens on layered sheets.

9. METALLIC PAPER: Thin paper in different metallic colors, printed on one side only.

10. MAGIC PAPER: A reusable sheet for testing ideas without creating waste. Use with a brush in clean water. Water makes a dark mark like ink and becomes invisible again when dry.

11. CARBON PAPER: Available in dark and light blue, yellow, red, and white, used to imprint lines of these colors onto a surface.

12. SAUNDERS WATERFORD NOT 300GMS: Mid-quality textured watercolor paper.

13. JAPANESE PAPER: Strong, fine, and translucent, it is made from rice, bamboo, mulberry, and other plant fibers. Use for brushwork drawings.

14. TWO RIVERS GREEN 410GMS: Very heavy tinted textured cold-pressed watercolor paper. See Two Rivers Yellow.

15. FABRIANO ACADEMIA: Standard medium-range multipurpose paper. Use with any media, from pencil to paint.

16. AQUARELLE ARCHES 300GMS: The very top quality hot-pressed (smooth) watercolor paper. 100% cotton and sold in sheets, blocks, and rolls. For use with any media.

17. FABRIANO ROUGH 600GMS: Very heavy, tough, white textured paper that can take abrasive use of any medium.

18. TWO RIVERS YELLOW 410GMS: See Two Rivers Green

19. VELIN ARCHES 250GMS: Printmaking paper available in black, white, and cream sheets or rolls.

20. CANSON: Inexpensive lightweight pastel paper in many colors, also good for drawing with colored pencils.

21. FABRIANO INGRES: Thin, smooth, pastel paper in flecked pastel colors with a distinctive ribbed marking.

22. ITALIAN PARCHMENT: Imitation-animal-skin parchment that is translucent and slightly waxy. It is available in white or cream.

Posture and Grip

TO DRAW WELL, your whole relaxed body should be involved. In this book we will look at parallels between drawing and music. There are also parallels to dance. You do not have to dance to draw, but you need to understand that the expression of a line or mark originates in the body and flows through the shoulder, arm, and hand to the fingertips. If your body posture is well balanced and you can move freely, your drawing will reflect this. It will also reflect discomfort if you are in any way cramped.

How you hold your drawing materials is also important. Examples are shown here, but it should not be forgotten that many people make remarkable and striking works drawing with their feet or holding their brush or pencil in their mouths. If using an upright easel, place it on the correct side: if right-handed, place it on your right, and look to the left of it at your subject; if left-handed, place it on your left, and look to the right. There should be an open, flowing space between your hand, body, and subject. Placing your easel on the wrong side folds your body against your drawing arm. If seated on a bench easel (a donkey), or with your drawing board angled between your lap and a chair, don't sit too close to the paper. If your hand twists to maneuver between the paper and your body, your lines will distort. Accelerated perspective also occurs if you look down the surface steeply (*see pp.116–17*). Ideally, you should be able to look comfortably straight ahead at your picture plane.

SPACE TO WORK

Drawing classes can be cramped places, but wherever possible, make sure you have enough room to back away and view your work. Regularly step back 6–9 ft (2–3 m) to check your progress. From a distance you will spot errors you cannot see close up. Turning your drawing sideways or upside-own will also help reveal what is wrong.

Cramped grip: This photograph illustrates how some people hold a pen to write. You cannot draw like this—your hand is locked and your fingers can barely move. This cramped grip tires your hand and makes small, strangled-looking drawings.

Relaxed fingers: Hold the pencil away from its tip and relax your fingers. Use the side of your little fingernail as a support on the page. With your hand in this position, you can draw lines freely and achieve a significant arc of movement.

Large scale: This loose "candle" grip is very useful when drawing with your arm extended, roughly marking out a large-scale work. It is most comfortable when reaching to draw above your head.

Unfamiliarity: The habitual movements of our handwriting style will sometimes infringe upon our drawing. To stop this, find an unfamiliar, alternative way of holding the pencil, or change to the wrong hand. This can give a new lease on life to your mark-making.

ALL MEDIA

There are no rules as to how you should hold your drawing media. As long as your fingers, arm, and body are not restricted, hold your material as you find most comfortable, depending upon what it is and how large you are working.

GRAVITY

Remember that gravity affects the flow of ink and paint. If you turn a brush or dip pen up into the air to draw above your hand, liquid will run down your hand, not up to the paper. Brushes can be used on upright paper but dip pens need a level surface.

Anticipating effects: A fully loaded brush pressed against an upright surface will cause a dribble of ink to run down your drawing. This can be used to great effect, or it can spoil your work if not anticipated.

Soft media: Short materials such as pastels and charcoal can be accommodated in the palm. But be careful not to tense your fingers. Remember, you can also draw just by dipping your fingers in pigment—this is how many women draw in rural India.

Brush calligraphy: This comfortable, upright way of holding the brush near its base is similar to the Japanese way used in Zen calligraphy (see pp.232–33). Large amounts of ink can be applied without fear of uncontrolled running if the paper is flat.

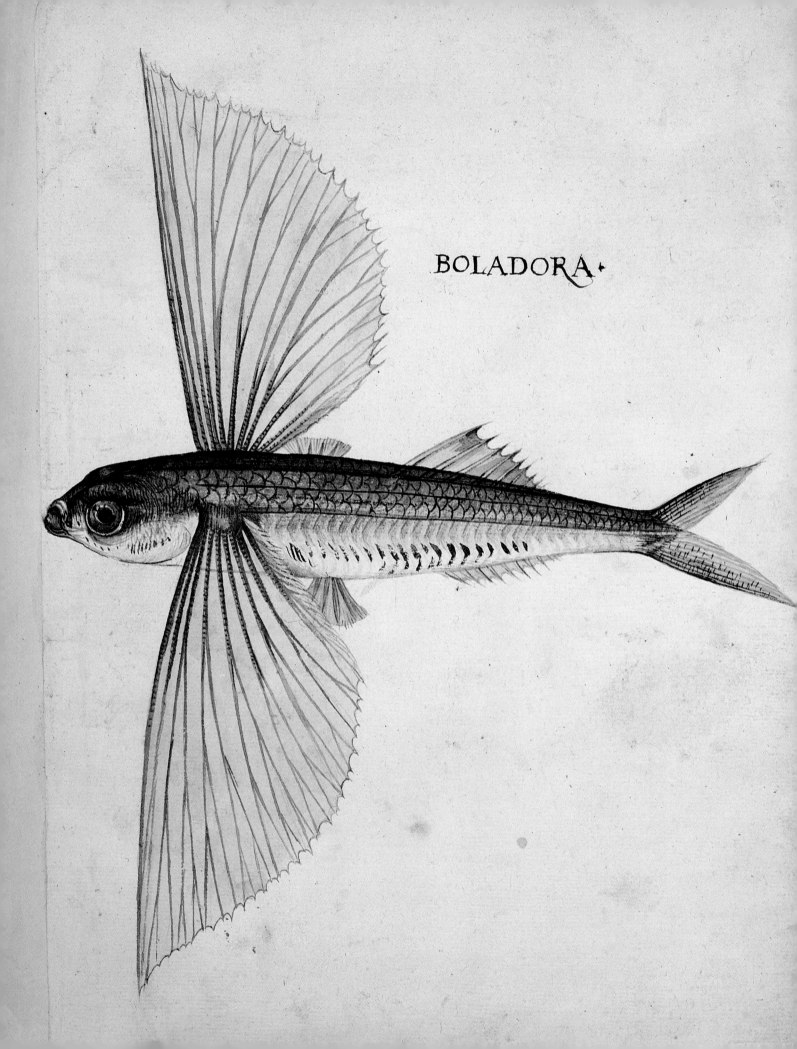

BOLADORA.

Animals

HUMANS HAVE DRAWN ANIMALS from the beginning of our time. After the subject of ourselves, they are perhaps our favorite pictorial preoccupation. We have drawn them on the walls of caves to evoke their kinship and power. We have drawn them in manuscripts to explain our genesis and to count their species into Noah's ark. In medieval England, the Latin bestiary was one of the most popular picture books—an illustrated dictionary of one hundred parts, each dedicated to the moralized tale of an animal or monster. The bestiary profoundly influenced the art of its period, and we still see escapees from its pages carved and grinning as the gargoyles of churches, or scampering through the initials and borders of pictures from that time.

When lost to explain our own emotions, we turn and take the features of beasts. In 19th-century Europe this became a "science." Paranoid newcomers crammed into swelling industrial cities used handbooks of physiognomy to identify and judge their neighbors. Facial features were analyzed in terms of their animal likeness, from which personality and predicted behavior were "deduced." Animals perpetually feed our imaginations. As children we delight in the humanized trials of Tom and Jerry and their cartoon relations. Over the centuries, bats, birds, fish, dogs, and snakes have between them engendered harpies, mermaids, werewolves, and dragons.

When less preoccupied with understanding ourselves, we have employed artists on expeditions, to be there at the moment of discovery, and to bring home drawn documentaries of their finds. Here (*left*) we see John White's exquisite record of a flying fish, which very likely leaped onto the deck of Sir Walter Raleigh's ship *Tiger* as it sailed north from the Caribbean to Virginia in 1585. Europeans on board had never seen such a thing, and this very drawing was to endure many copies and plagiarisms after its triumphant return to the English court of Queen Elizabeth I.

For the novice artist, animals provide a perfect subject with which to begin. Framed in the zoo or in domestic cohabitation, their different speeds and patterns of action, which are so unlike ours, offer challenges and delights to draw. In this chapter we discover the use of pens and ink through the delineation of insects, and learn how to capture form and movement from the mannerisms of honking geese, sleeping dogs, floating turtles, and silent, museum-mounted skeletons of birds.

JOHN WHITE
British artist, cartographer, and pioneer born c. 1540. On the Roanoke voyages of Sir Walter Raleigh, White's commission was to "...drawe to lief one of each kinde of thing that is strange to us in England." He worked with the scientist Thomas Harriot, who described in words what White drew. Together they made maps and documented animals, insects, plants, and people. This drawing is made in black lead (metal point) with watercolor. Highlights of silver would have gleamed, but are now oxidized and so appear black.

Flying Fish
c. 1590
11 x 9¼ in (277 x 234 mm)
JOHN WHITE

Documentaries

DÜRER'S RHINOCEROS AND STUBBS'S skeletal horse are superb affirmations of the power of drawing as a recorder and communicator of knowledge. The first live rhinoceros to reach Europe came from India in May 1515, a gift to the Portuguese King. He in turn sent the mysterious creature to the Pope via Marseilles at the request of the King of France. Sailing to Rome, the ship was lost, but 'the drowned animal washed ashore. Carefully stuffed, it continued its journey to Rome. Meanwhile, a drawing of it arrived in Nuremberg, the home of Dürer. He studied the image and drew his own interpretation. Converted into a print, Dürer's image changed eager hands until it was known across Europe. It was to become the animal's only accepted likeness for 250 years, inspiring countless works of art and so touching people's imaginations that later, when more accurate portrayals were made without armor and scales, they were rejected. Stubbs's *Anatomy of the Horse* achieved similar documentary status. Unsurpassed, it is still consulted by veterinarians today, years after its publication.

ALBRECHT DÜRER
German Renaissance painter, draftsman, printmaker, naturalist, writer, and mathematician. Dürer traveled widely to study at different European schools of art, filled journals with ideas and observations, and wrote four books on proportion.

Life-like This is Dürer's original quill-and-ink drawing made after an anonymous Portuguese drawing. It is such a lifelike triumph of imagination and intelligence that for centuries zoologists never questioned its authority. Contemporary texts related accounts of the beast as the mortal enemy of the elephant and rare relative of the "more common" unicorn.

Original Ink Drawing of a Rhinoceros
1515
10¾ × 16½ in (274 × 420 mm)
ALBRECHT DÜRER

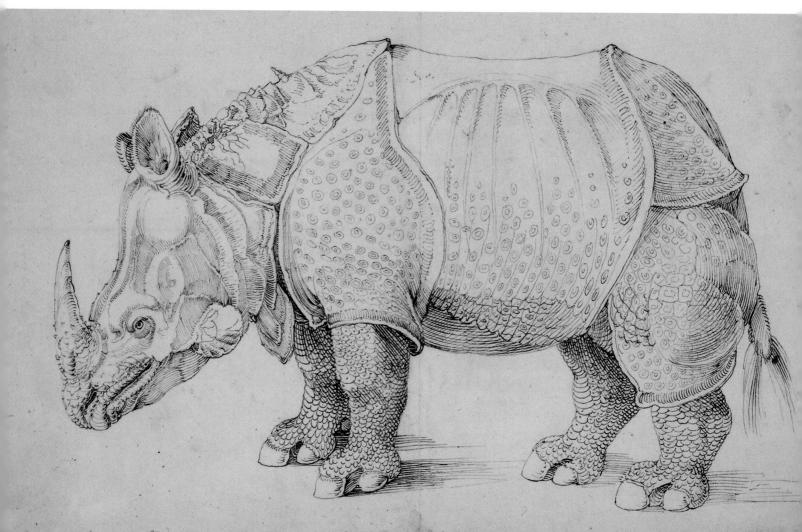

GEORGE STUBBS

British equine and society portrait painter,
naturalist, and anatomist. Stubbs was one of
the first European artists to make an accurate
representation of the rhinoceros. His painted
portrait of the beast is in the Royal College of
Surgeons of England, London. Stubbs's most
celebrated publication, *Anatomy of the Horse*,
comprises 18 plates showing dissections in
layers from bone through musculature to skin,
in three views—rear, front, and side.

Dissections *Stubbs took his knife and his pencil and physically
climbed inside the horse, dissecting and drawing until he
understood the mechanisms of its power and grace. Dissections
were made over a total of 18 months. The entire project was
developed over ten years. This is one of Stubbs' original finished
pencil drawings, composed from notes and observations. He
translated his own drawings into engravings for publication.*

Lighting *Stubbs's breathtaking work won immediate
international acclaim, which has never diminished. There
is no other work like it. He composed each plate from his
knowledge of parts, and therefore invented the lighting that
makes each horse appear so real and three-dimensional.
Compare how Stubbs and Dürer both invented lighting to
portray the reality of their animals.*

*Table III of the Skeleton
of the Horse (rear view)*
1756–58
14 × 7 in (354 × 180 mm)
GEORGE STUBBS

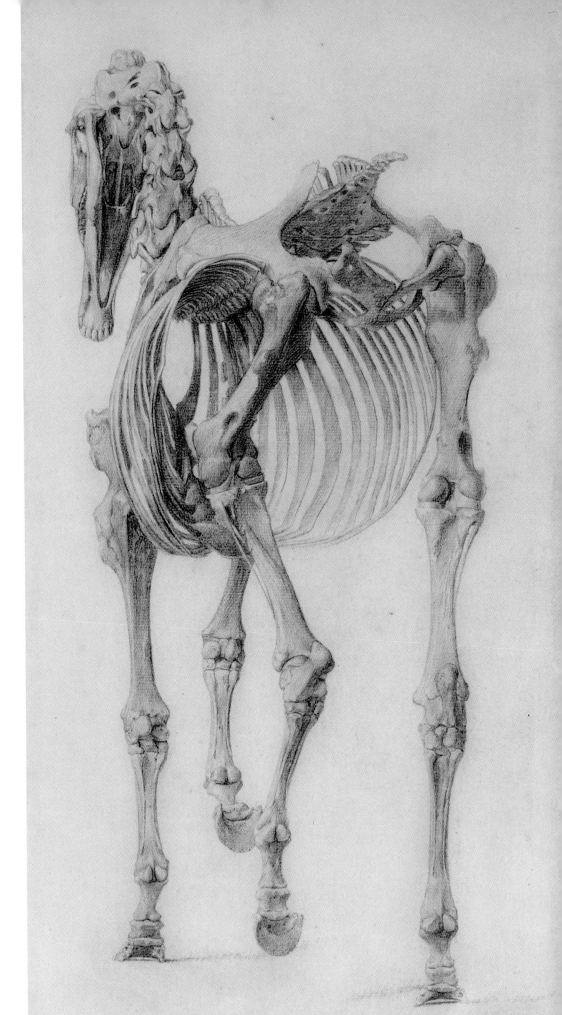

Presence and Mood

THESE DRAWINGS HAVE BEEN CHOSEN to show two very different ways of picturing a wild animal. Hugo mixed his media and drew from memory and imagination to create narrative atmosphere. By contrast, Gericault took a sharp pencil to make repeated direct observations from life.

Hugo's page is flooded with the fearful presence of a remembered octopus. As if disturbed from its gritty bed by our presence and curiosity, the ominous beast unwinds from the dark of the sea and of our nightmares. Apparently drawn in its own ink, it silently rises to the light, conjured by the hand of a great author of French literary fiction.

Gericault's sheet appears almost scratched by the ferocious play of his cat. He has watched her pounce, snarl, and turn, drawing her again and again to pin down the texture of her loose skin, her bony frame, her sharp teeth, and her distinctive temperament.

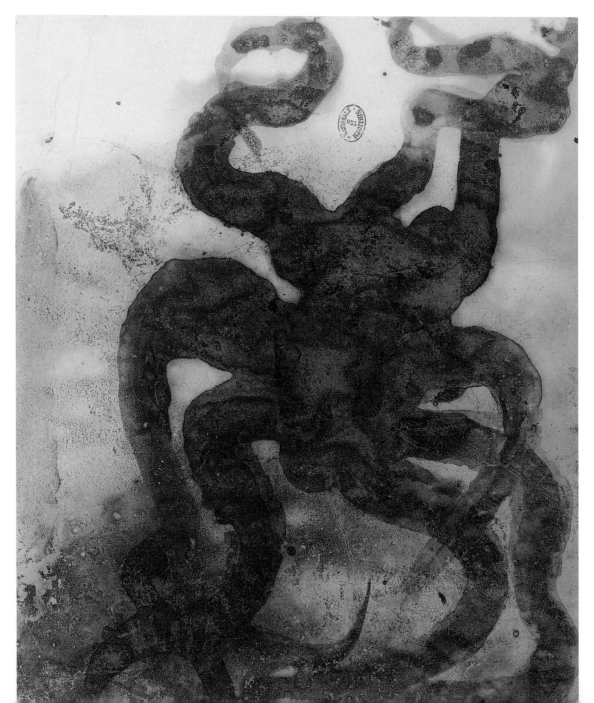

VICTOR HUGO
Poet, novelist, playwright, and leader of the French Romantic movement. Hugo's novels *Les Miserables* and *The Hunchback of Notre Dame* have become classics of film and stage. His copious drawings are characterized by mixed media, drama, and a love of accident.

Layers and shadows Throughout this drawing, linseed oil soaked into the paper has made shadows and repelled the ink to create translucent tentacles. The octopus is formed in layers applied and distressed with a brush. Surrounding sprays of graphite powder are stuck into washes of oil and ink to suggest glutinous depths.

Mixed media Here, Hugo used graphite powder, ink, and linseed oil on paper. He wrote to poet and art critic Charles-Pierre Baudelaire about his experiments, saying "...I've ended up mixing in pencil, charcoal, sepia, coal dust, soot, and all sorts of bizarre concoctions which manage to convey more or less what I have in view, and above all in mind...".

Pieuvre
1866–69
9½ × 8⅛ in (242 × 207 mm)
VICTOR HUGO

THEODORE GERICAULT

Controversial, fiery, short-lived French Romantic painter and lithographer. Largely self-taught; horses were a favorite subject together with politics and history. He is best known for his gigantic painting, *The Raft of the Medusa*, displayed in the Louvre, Paris.

Repeated study *This drawing demonstrates the importance of feeling confident enough to isolate parts of a subject, repeat different views, and keep trying again. Remaining focused upon seeing will lead to a greater understanding of the subject. Much is learned from repeated study, and it can be applied to any subject (see pp.118–119).*

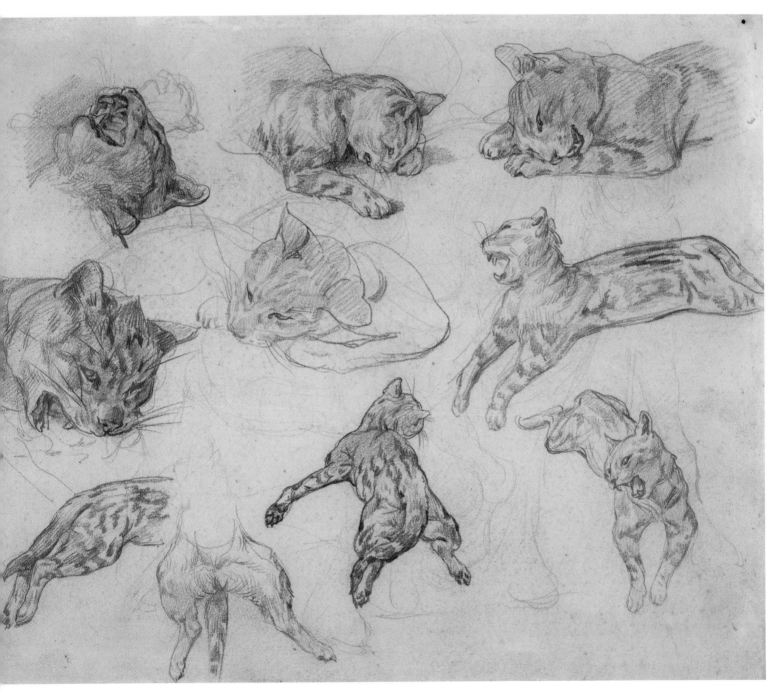

Undertraces *Beneath these graphite studies we see traces of drawings Gericault erased. At the center of the page is the outline of a horse, standing sideways, facing right. Before paper became so cheap, artists reused sheets and crammed them full of studies. Here, undertraces of previous drawings unify and vitalize the composition.*

Tones *On the top row we see clearly how Gericault laid broad areas of tone using fast, parallel, diagonal strokes of his pencil. Tones that do not follow surface contour is very difficult to do well, since it can lead to a flattened form. Beginners are advised to follow the natural contours of form as shown on pp.124–25 and p.144.*

Sketches of a Wild Striped Cat
1817–18
12½ × 15½ in (319 × 398 mm)
THEODORE GERICAULT

Movement

MOVEMENT IS OFTEN THE CHARACTERISTIC by which we identify an animal: the fast cheetah, slow tortoise, flapping bird, or proud, quivering horse. Artists commonly focus on such actions, taking them to guide their hand in bringing form and essence together. In these two drawings, made only a year apart, we see semi-abstract, flattened animals composed almost entirely of movement. Both Picasso and Klee have enclosed their subjects to compress and amplify the speed of

their lines and the power of their beasts. In Picasso's drawing, noise is everywhere. His powdery, dissolving faun kneels stranded, overwhelmed by a screeching bird, the whinnying of a frantic horse, and waves breaking distantly below.

Klee's riders are constructed from all the gestures of greeting mules. The fact that they never stand still influences the movement in his line. His hand must have shuddered and twitched just like the constant actions of this humorous meeting.

PABLO PICASSO
A prolific Spanish painter, sculptor, draftsman, printmaker, ceramicist, graphic and stage designer who lived in France. Picasso cofounded Cubism, the first abstract movement of the 20th century, with George Braque (see p90).

Ink and gouache This drawing is made in black Chinese ink and gouache (opaque watercolor) applied with a brush. The ink is used to make sharply defined solid, hooked, and scrolled lines. Gouache is brushed softly in translucent hazy layers of cool blue, gray, and brown. These media complement and amplify each other with their brilliant contrast.

Faune, Cheval et Oiseau
1936
17⅜ × 21¼ in (440 × 540 mm)
PABLO PICASSO

PAUL KLEE

Swiss painter, sculptor, draftsman, printmaker, violinist, and teacher at the Bauhaus school. With his drawings Klee bound sophisticated theories to personal and often witty childlike imagery. He is author of *The Thinking Eye* (1923), well-worn copies of which are found in many art schools.

Layers of marks In this pale pencil drawing we see layers of agitated marks that together present a kind of visual "itch." They chatter in groups, turning our eye around and around inside the bodies and postures of the paper-thin creatures, all happily drawn on top of each other in the same pictorial space.

Endless lines Look closely at how Klee's lines rarely leave the paper and how they are free from the constraint of finite shape. They remain in contact with the surface of the page and scribble back and forth as they maneuver from one area to another. The entire drawing suggests the endless small movements of horses standing still.

Scene der Komischen Reiter (Scene of Comical Riders)
1935
6½ x 11½ in (419 x 291 mm)
Morton G. Neumann Family Collection, Chicago
PAUL KLEE

Icon and Design

IN THESE TWO MANUSCRIPTS we discover diagrammatic drawings of animals that are each held tightly in a surprising space: a giant fish wears a ship's hull, and blackbirds fly in formation through a mosaic of text. Baker lived in an era when ships were built without drawn plans. Below we see his revolutionary design for an Elizabethan warship, later called a galleon. He studied the anatomy of fish, and from them learned that if he designed his ship with a "cod's head and mackerel's tail" (full bow, slim stern), it would achieve greater speed, balance, and steerage. This drawing illustrates Baker's theory, which in application gave strength and advantage to the English fighting the Spanish Armada.

In contrast to the practical clarity of Baker's thought, Knopf's drawing opposite is the personal enigmatic expression of a mind gripped by illness. His birds stare, seemingly looking for our attention, and to assess our next move.

MATTHEW BAKER
Master shipwright, mathematician, and author of *Fragments of Ancient English Shipwrightry* (1586), the earliest geometrically defined elevations, plans, and sections of ships. Baker initiated the scientific practice of naval architecture and applied hydrodynamics, based on his studies of fish.

The fish *It is likely that Baker drew with a quill dipped in iron-gall ink, adding washes of color with a fine brush. Exquisite details in this drawing include the lips of the fish, the expression of its eye, and the carefully observed gills, fins, and scales.*

The ship *The upper decks of the ship appear curved toward us at both ends. Baker did not intend this. It is simply how we read his perspective. In just one drawing he has displayed more angles of his design than we would expect to see from a single viewpoint.*

Fragments of Ancient English Shipwrightry
1586
10½ × 15⅜ in
(270 × 390 mm)
MATTHEW BAKER

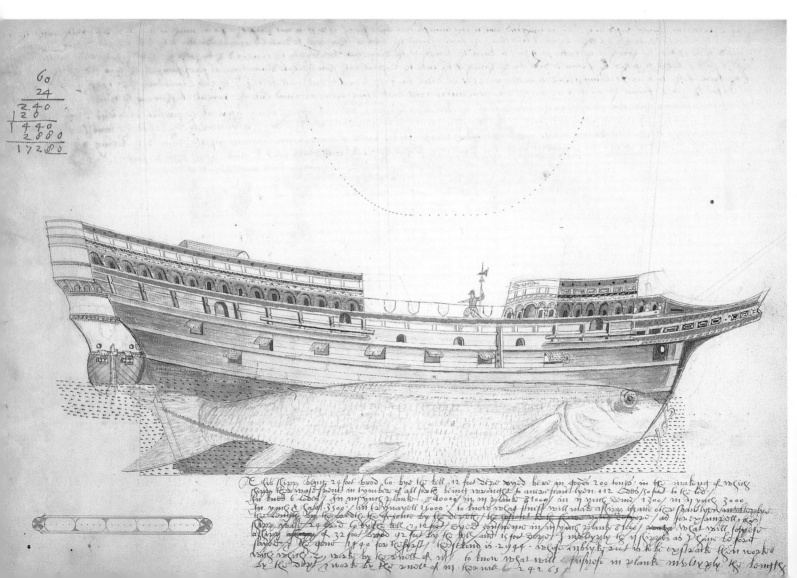

JOHANN KNOPF

An "Outsider" artist who suffered from mental illness. Knopf believed he could understand the language of birds, which often feature as symbolic creatures in his drawings. The German art historian and psychiatrist Hans Prinzhorn collected this image.

Outline and tone The blackbirds illuminating this frantic manuscript are drawn in pencil, firmly outlined, numbered, and filled evenly with tone. The main group is placed in a circle drawn with a compass. The text, written last of all, appears to be stirred like water by the presence of the circle and the birds.

The Mysterious Affairs of the Murderous Attacks
UNDATED
13⅜ x 11⅝ in (340 x 296 mm)
JOHANN KNOPF

Pen and Ink

WITH A HANDFUL OF FEATHERS, sticks, and metal points, you can have great fun drawing the world around you. Intricate or dramatic lines, spots, and spatters can be made with an exotic choice of inks. The Egyptians and Chinese are credited with the invention of carbon ink, simultaneously 4,500 years ago, and it is still in use today. A German recipe of 1531 gives a simple description: "Take a wax candle, light it, and hold it under a clean basin until the soot hangs to it; then pour a little warm gum water into it and temper the two together. That is an ink." "Gum" refers to gum arabic extracted from the acacia tree, and first used by the Egyptians. The Chinese used animal or fish glue. The paste from either recipe is pressed and dried into a bar for storage. The bar is then rubbed into water on a slate block to produce ink.

Today, high-quality Chinese and Japanese inks are subtler and more complex than those produced in Europe. Masters choose brands of long, distinguished manufacture, the recipes for which have been handed down over centuries. In the Far East, ink is traditionally applied with a brush (*see pp.246–47*). Dip pens began their history in the Nile River, where reeds were gathered. Quills were later cut from feathers, while metal nibs began as rare gifts in gold and silver before being perfected by the British steel industry.

PENS

Dip pens are essential and inexpensive drawing tools, which range greatly in their handling and character of line. Responsive to slight changes in pressure, they are associated with rapid, expressive drawing techniques such as the ones we explore in this chapter.

1. REED PENS: A broad nib can be cut from bamboo or another tubular grass. Each pen has a unique character, producing a different line.

2. QUILLS: These are cut from the barrel of a flight or tail feather. The best are goose or swan. Early artists recommended raven and crow for especially fine work.

3. FOUNTAIN PENS: These vary in quality and nib width. The reservoir gives a constant flow of ink for very long unbroken lines and continuous bottle-free use. Only fill with suitable inks.

4. METAL PENS: Inexpensive removable steel nibs are available in a range of widths. They fit into wooden holders. Avoid needle-sharp mapping pens, which scratch rather than draw.

INKS

Four types of ink were common before the 20th century, and are still in use today: carbon (Chinese and Indian), iron-gall, bistre, and sepia. Now we also have acrylic ranges in many colors. Inks can be lightfast or non-lightfast, waterproof or non-waterproof, and most can be homemade.

5. CARBON INK: Traditionally produced from oil or resin soot (Lamp Black), roasted wine sediment (Yeast Black), charred bone (Ivory Black), or charcoal, suspended in a binder and stored as a solid block. Blocks are imported today from China.

6. IRON-GALL INK: Abnormal spherical growths caused by parasitic wasps can be collected from some oak trees in fall. Crushed, boiled, reduced, and sieved, they produce a golden dye for drawing. The complexities of traditional iron-gall ink are explained on p.36.

7. INDIAN INK: Carbon ink sold today in liquid form. Waterproof types contain shellac. It dries with a sheen and clogs uncleaned pens. Non-waterproof Indian inks can be reworked with a wet brush after drying. Old stock turns solid and bottles are not dated.

8. SEPIA AND BISTRE INKS: Sepia, an often misused term, is the ink of a cuttlefish or squid extracted post-mortem. Bistre is the more humane use of soot scraped from the fireplace and ground into wine. Beechwood soot is best.

9. ACRYLIC / CALLIGRAPHY INKS: Available in black and a range of colors. Excellent for drawing, they are bright and non-clogging, and can be mixed and diluted to create subtler colors and tones. They are the easiest inks to use.

Drawing With Ink

TO MAKE A QUILL OR REED PEN, keep all your fingers behind the blade and cut away from you. Practice to gain a feel for how materials behave, then cut a final nib (feathers, for example, are surprisingly tough.) You can make ink easily from the boiled, reduced, sieved, fleshy skins that surround ripe walnuts. Collect skins from the ground beneath trees once they are blackened. Walnut ink is gloopy, red-brown, and delicious to draw with. Oak galls, forming the basis of iron-gall ink, can also be collected from affected trees, crushed, and boiled to make a golden ink. For centuries, galls were ground with iron sulfate to make an unstable solution. Running fresh, it was gray-purple. It dried black, and turned brown with time. It also oxidized and ate or burned paper. Some of Michelangelo's drawings are now a little eaten by their own ink. Although oak galls and walnut skins are harmless, always be cautious when experimenting with recipes.

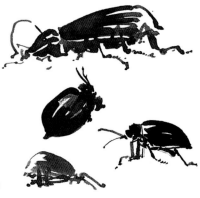

REED PENS

Reed pens dispense ink quickly, giving a short, dry mark. Under heavy pressure, they stick and judder forward. I used these qualities to draw the worms above. Rembrandt, Van Gogh, and Matisse also enjoyed them. Scribes of the Middle Ages, finding reed pens unwieldy, reserved their use for large choir books, and developed the quill instead.

Reed marks The darker left wing of this beetle was drawn with the wet, inky stroke of a loaded nib. The lighter right wing, drawn with a dryer nib, appears to glisten where the mark has broken to show paper beneath.

QUILL PENS

Quills are highly responsive to changes in pressure. They give a finer, more extended line than reed and a more organic line than metal. Michelangelo's dragon on p.244 is an exquisite example. Quills are also called Dutch pens, since the Dutch were the first to realize that they could be hardened and improved with heat treatment in ash or sand.

Quill marks Quills carry more ink than reeds, giving longer lines. The darkest strokes of this grasshopper (around the head and wings) were made first. Paler strokes for the legs and antennae were made as the ink ran out.

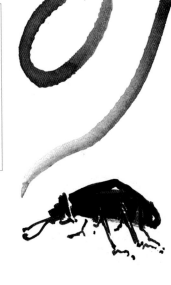

METAL PENS

Metal pens give long, sharp, clean strokes, withstanding great pressure without sticking, breaking, or being ruined as fountain pens would be under the same pressure. Loaded with ink and pressed hard, they splay to make thick or double lines. When the nib is pressed upside down, marks become fine and needle-sharp.

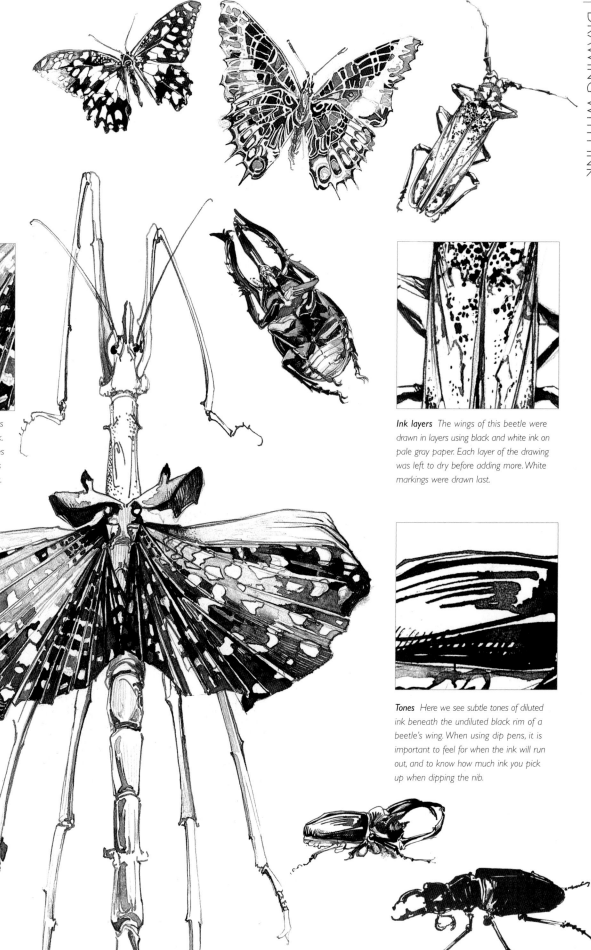

Filled outlines Each segment of wing was outlined, then filled with a droplet of ink. The dome of the drying droplet encourages particles of pigment to fall to the edges of the shape, giving a graded, tonal effect.

Ink layers The wings of this beetle were drawn in layers using black and white ink on pale gray paper. Each layer of the drawing was left to dry before adding more. White markings were drawn last.

Tones Here we see subtle tones of diluted ink beneath the undiluted black rim of a beetle's wing. When using dip pens, it is important to feel for when the ink will run out, and to know how much ink you pick up when dipping the nib.

Capturing Character

GEESE ARE EXCELLENT SUBJECTS to draw when practicing the first use of pen and ink. It happens that goose feathers also provide artists with the best type of quills. That said, there is no obligation to prepare a quill; steel nibs are fine. Geese are nosy birds, so pick a spot where other people can keep them entertained. Study them before drawing. Watch their heavy feathered bodies flap, waddle, and bellyflop off the waterside. Dip your pen in ink, touch the bottle's rim to drain the excess, and boldly plunge into your drawing.

Focus on the geese, not on your drawing. Attempt with a loose hand to capture their posture and outline. Quick drawing trains you to see what is most important about a subject and to mark only its most essential expression. It teaches confidence and focus through intensive repetition. Illustrating this exercise on Oxford Port Meadow, I covered eleven sheets in sixty quick drawings—in less than an hour.

Experiment, test your limits, and be brave. You cannot break the nib, and there is no "wrong." If you don't like a stroke, make another one. Cover your drawing book pages in speedy responses to the geese and try to capture each bird in as few lines as possible.

MATERIALS NEEDED
Pack plenty of tissue around a bottle of calligraphy or acrylic ink, to absorb blots when drawing. Take a cup and water for diluting a range of tones, and a large drawing book or plenty of paper. Use masking tape to secure pages against the wind.

Posture
Look for a bird expressing a simple posture. Focus on it. Try to hold the whole posture in your mind's eye, and quickly draw around it using only three or four strokes. Empathize, draw what the bird is doing, be bold and press firmly. Take no more than ten seconds to draw each one and make lots of drawings. Cover a sheet.

Action

With growing confidence, look among the birds for more complicated actions such as shaking off water, running, flapping, and diving. Use more lines than before to express these. Again, draw the feeling of what you see, and don't worry about mechanical facts or accuracy.

Texture

Gradually allow yourself more lines to describe the texture of each bird as well as its posture and action. Avoid detail unless really tempted by a close-up visit. Fluctuate the pressure of your pen in response to how you know the bird would feel if you touched it.

Sleeping Dogs

RAS WAS A GREAT CHARACTER, a dog who was always engaged in his and everyone else's business. The only time he remained still was when he was sleeping, and even then he twitched and stretched in dreams. These drawings are not an analysis of his anatomy or breed but the expression of his satisfied comfort in a deep sleep after a night out on the town. Sleeping animals present the artist with ideal opportunities to study their texture, form, and personality. For this class you will need one oblivious dog, your drawing book, a dip pen and ink of your choice (*see pp.34–37*), together with a glass of water for diluting tones on the nib, and a tissue for blotting drawn lines that appear too dark.

MAKING A PALE LINE

To make a pale line, first dip your pen in ink, and drain the excess by touching the nib against the rim of the bottle. Then dip the nib quickly into a glass of water and drain the excess again. This will give a medium-gray line. Dip the nib quickly again into water, and again drain it. Now it will make a pale line. Make a test sheet to discover your control of diluting on the nib.

Ras Curled Up Asleep

"Capturing the true character of a cherished companion is best achieved with objective determination rather than sentimental shyness."

DRAWING YOUR DOG

Be bold in this exercise. Character is better captured drawing quickly with confidence than working slowly, concerned about detail. First lines are first thoughts; second thoughts may be different. Changing your mind is a positive aspect of seeing and thinking. Layers of thoughts can bring a drawing alive.

1 | Fix your eyes at the center of the dog. Then, ignoring all detail, see how the animal's posture determines its whole shape. With pale lines, quickly draw what you see. Trust your intuition. Do not go back over lines you are pleased with—doing so dulls their lively freshness.

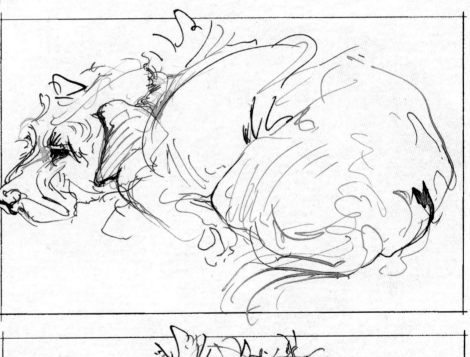

2 | Reload your pen with ink, this time to create a line a little darker in tone. Remain focused on the whole dog and, in bold layers, add more detail. Here I marked the features of Ras's head. Then I immediately rebalanced the drawing with lines around his hind quarters, to emphasize how he is curled up.

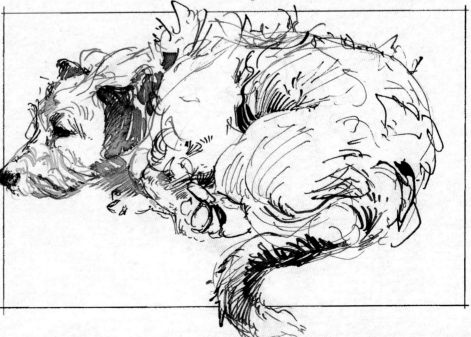

3 | Gradually introduce darker tones. Here, I added ink to Ras's nose, ears, tail, and the shadows in his coat. To add texture, alter the pressure and moisture of your line in response to how you know your dog feels when you ruffle its coat. It is essential when drawing any subject (even something abstract) to know how it feels and to emulate this with your line.

Turtles

THE ELONGATION AND BUOYANCY of a group of turtles is fascinating to observe. Beyond the glass wall of the aquarium, they stretch and paddle, swinging their limbs and shells with a slow circular movement. A perfect subject for the beginner, turtles often pause, unexpectedly, as if caught in a camera freeze-frame, offering plenty of time for the artist to draw the pose.

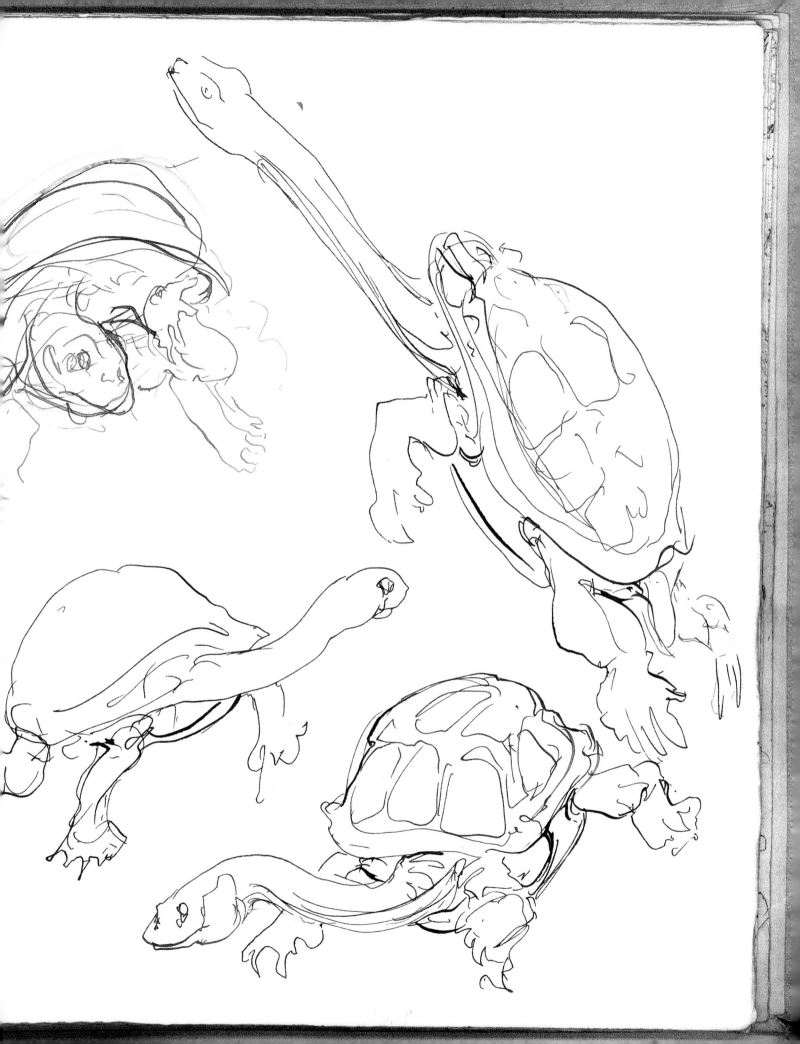

height of whole bird bone forward

Tiny scapulae & wing bones

Translucent cranium.
Beak like a BLADE

Dry Birds

THESE ARE THE ARTICULATED BONES of a kiwi and a house-martin drawn in a museum using a steel pen, India ink, and water. Beginning with very pale tones, I darkened lines as each drawing progressed. With speed, I sought to capture the form, balance, and sharp, dry, weightlessness of the kiwi. I made repeated studies of the housemartin to discover its mechanism of flight.

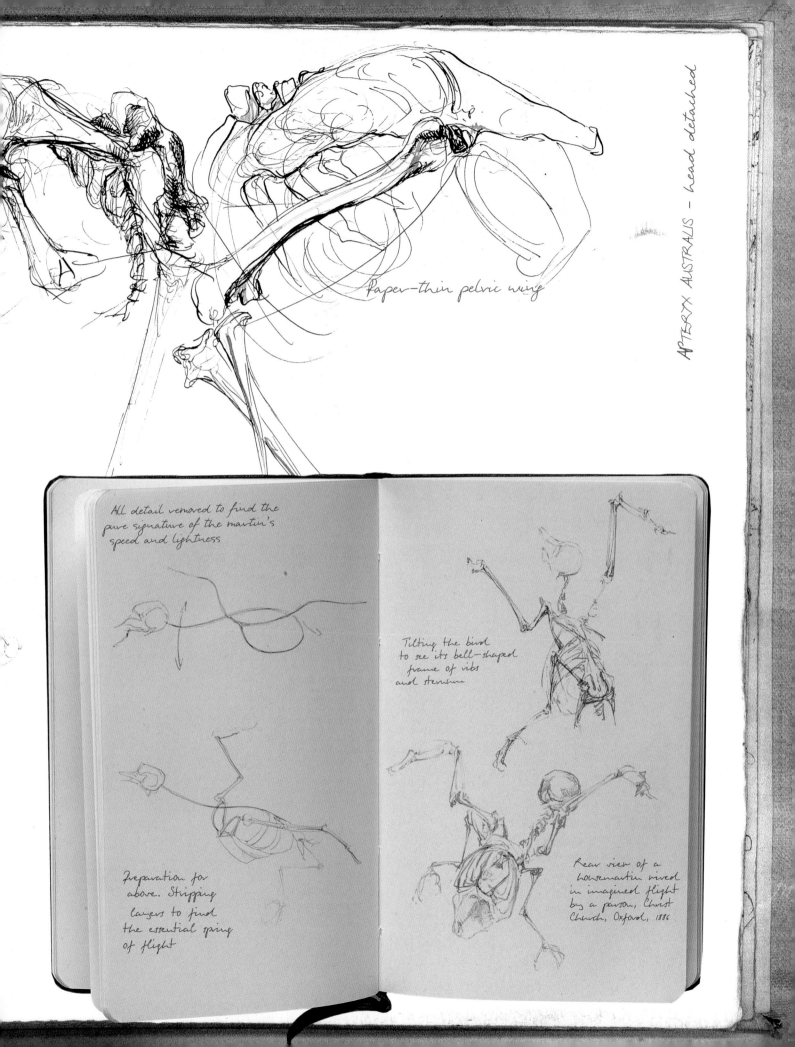

Paper-thin pelvic wing

APTERYX AUSTRALIS — head detached

All detail removed to find the pure signature of the martin's speed and lightness

Preparation for above. Stripping layers to find the essential spring of flight

Tilting the bird to see its bell-shaped frame of ribs and sternum

Rear view of a housemartin viewed in imagined flight by a person, Christ Church, Oxford, 1886

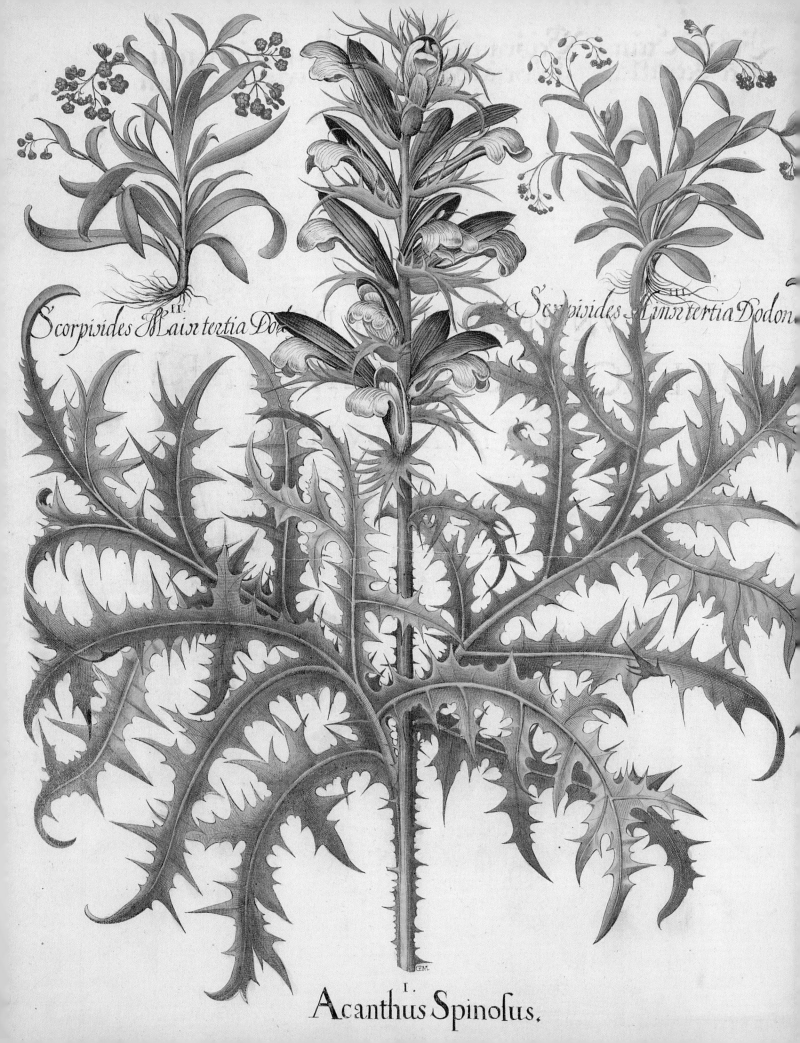

Scorpioides Maior tertia Dodon.

Scorpioides Minor tertia Dodon.

II.

I.
Acanthus Spinosus.

Plants and Gardens

W E SHARE THIS PLANET with the more ancient, robust, infinitely vivid, and diverse kingdom of plants, on which our lives depend. We collect, nurture, and hybridize them for our sustenance and pleasure. We draw them to celebrate their beauty and range, to catalog our knowledge, and to ornament our lives. Plants are the principal inspiration of the decorative arts—from Roman Corinthian columns crowned with carved leaves of the acanthus, to the proliferation of floral designs with which we have dressed ourselves and furnished our homes for centuries.

Botanical illustration is a precisely defined and scientific art. From its history there is one overriding lesson to be learned: the importance of looking and seeing with our own eyes. Early European illustrators were trapped within dogma that was determined by ancient scholarship. Medieval knowledge was not gained by the first-hand observation of life but by reading. The revolution came in the 1530s, when botanists founded new work upon the direct study of plants. Fledgling years of scientific research bore manifold explosions of knowledge in a fever of discovery. Natural scientists accompanied explorers to document unknown finds. Plants poured off ships returning from the New World and were eagerly collected and drawn. Botanic gardens were established and expanded. Classifications were set out. Patrons funded the breeding of decorative, as opposed to only herbal, specimens. Rich owners of private gardens commissioned large-format florilegiums to immortalize their personal taste and power of acquisition, and the drawn pages burned with the urgency and excitement of explaining every plant's form, color, and beauty. Later, the microscope was refined to unfold yet another world. After four- and-a-half centuries of intensive observation, we now have laid before us an infinite wealth of material to explore.

There are close parallels between the acts of gardening and drawing. Both embrace the anticipation of evolving shape, form, and texture; the punctuation of space with structure and mass; manipulations of light and shade; and the constant but exhilarating struggle to make a living image feel right. In this chapter, we see very different cultural visions of plants and gardens and use pencils and plants to learn the pictorial values of space, shape, and focus.

BASILIUS BESLER
Botanist and apothecary who compiled the *Hortus Eystettensis* —the largest and most influential botanical book of the early seventeenth century. It was published plain in 1611 and with hand-painted plates in 1613. More than 1,000 species of plants are depicted life-size in 367 copper engravings. Chapters are arranged by season. Conrad von Gemmingen, Price Bishop of Eichstätt commissioned the volume to document his private garden of the same name. He sent boxes of plants to Nuremburg where a number of uncredited artists drew them for Besler. Here *Acanthus spinosus* is combined with forget-me-nots to show how well their colours complement each other.

Acanthus spinosus
1613
18⅞ x 15¾ in (480 x 400 mm)
BASILIUS BESLER

Botanical Studies

THE SCIENTIFIC VALUE OF A BOTANICAL DRAWING lies in its subtle union of beauty, detail, and meticulous precision. Each plant must be clearly distinguished from its closest relative. Botanical art conceals the challenge of its making. Behind detailed, measured drawings, such as we see here in Bauer's *Protea nitida*, were specimens that often refused to stay still, opening and closing in the warmth and light of the studio, or that were diseased, insect-ravaged, and wilted. With bright optimism, Stella Ross-Craig said of the need to draw from a dried herbarium plant "I could make it live again." Her slipper orchid shows that botanical drawing must often resolve the challenge of its subject's producing parts in different seasons —roots, stems, leaves, flowers, fruit, and seeds conventionally appear on one plate. The rest of us are free to draw as we wish. Here, Mackintosh expresses the folded petals of a broken rose bud so delicately we can sense the perfume.

FRANZ BAUER
An Austrian artist who trained at the Schonbrunn Imperial Gardens in Vienna. Sir Joseph Banks, naturalist, explorer, and advisor to King George III invited Bauer to London in 1790. The King was then establishing the Royal Botanic Gardens at Kew, and Franz Bauer and his brother Ferdinand were employed there to draw specimens. They are counted among the most accomplished 18th-century botanical artists.

Outline *Bauer prepared a pencil outline before laying in fleshy succulent hues and tones of watercolor. Light in this drawing is given by the paleness of the paper showing between washes of darker tones.*

Dissections *Across the lower part of this drawing we can see dissections of seed pods and petals. It is likely Bauer would have studied these under a microscope. He has made the spatial and physical relationships in this drawing all the more real by placing a single, delicate, petal tip over a lower leaf.*

Protea nitida
1796
20¼ x 14¼ in (513 x 362 mm)
FRANZ BAUER

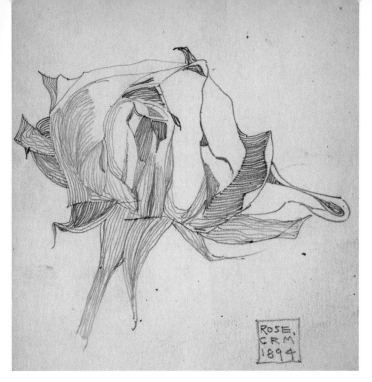

ROSE, CRM 1894

CHARLES RENNIE MACKINTOSH

Scottish architect, designer, painter, and founder of the Glasgow School of Art. Mackintosh's flair had an enormous influence on the avant-garde in Germany and Austria, and he inspired, among others, Gustav Klimt. In his retirement Mackintosh made numerous inventive pencil and watercolor drawings of plants.

Lines and shadows This lush, sensual pencil drawing is found among Mackintosh's later works. Closer to fiction than reality, it is small and discreet, and it shows how design, imagination, and observation can come together in one image. Pencil lines cling to, and follow perfectly, the nuance and contour of every shadow.

Rose
1894
10¾ × 8¾ in (275 × 221 mm)
CHARLES RENNIE MACKINTOSH

STELLA ROSS-CRAIG

A trained botanical artist, Ross-Craig joined the staff at the Royal Botanic Gardens, Kew, London in 1929. Her *Drawings of British Plants*, published 1948–73 in 31 parts, is recognized as the most complete and important work on British flora. As many as 3,000 of her drawings are kept at Kew Gardens. She also contributed to *Curtis's Botanical Magazine*, an archive of thousands of drawings, accessible today via the Internet.

Swift lines The drawing was planned in pencil and then overworked with a lithographic pen. Ross-Craig said of her work: "Plants that wither rapidly present a very difficult problem to which there is only one answer—speed; and speed depends upon the immediate perception of the essential characteristics of the plant…and perfect coordination of hand and eye." This line drawing is one of 1,286 studies for her book Drawings of British Plants.

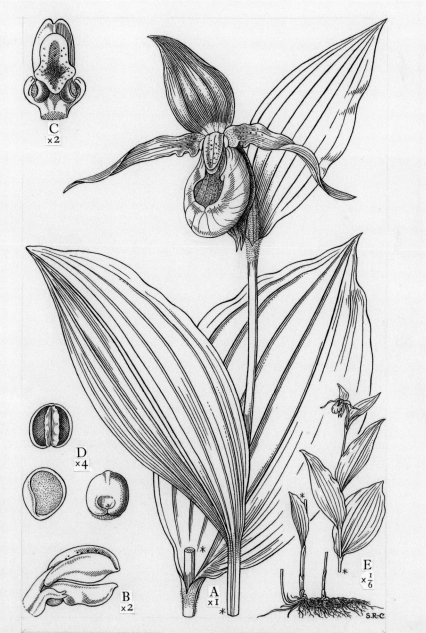

Line Drawing of
Cypripedium calceolus L.
c. 1970
12¾ × 8¼ in (325 × 210 mm)
STELLA ROSS-CRAIG

Jeweled Gardens

AMONG DRAWINGS FROM the Middle East we find exquisite stylization of form and upright formality in pictorial space. The first Mughal Emperor Babur's Garden of Fidelity (*Bagh-e Vafa*), which he personally created near Kabul, Afghanistan, in the early 16th century, is remembered in the pages of his journal. Below, in miniature, Babur directs his gardeners in the design and planting of this quartered *chahar bagh*. Envoys chatter outside the gate, anticipating their view. Every fiber of

paper is brimming with the beauty and celebration of nature, urgent attentive human activity, and miraculous growth.

Opposite is the Rose of Mohammed; the sumptuous petals permeated with prayer and wisdom. Drawing, painting, and calligraphy are brought together to hold the sacred names of prophets and the 99 beautiful names of God. By Muslim tradition, roses took their form in a bead of perspiration on the brow of Mohammed as he passed through his heavenly journey.

BISHNDAS AND NANHA

Little is known of these Mughal painters who were related as uncle and nephew and commissioned to illustrate the pages of Babur's journal. Bishndas was probably responsible for the overall design, and Nanha, a notable portrait painter, drew the faces.

Bright pigment These pages were illuminated by Mughal artists in the late 16th century. They used a fine brush to lay pigment over a line drawing. The white of the page shines through the brilliant color. Upright shallow perspectives, fluctuations in scale, uniform focus, and attention to detail are all shared with medieval European manuscript drawings.

Babur Supervising Out of the Garden of Fidelity
c. 1590
8⅝ x 5⅝ in (219 x 144 mm)
BISHNDAS AND NANHA

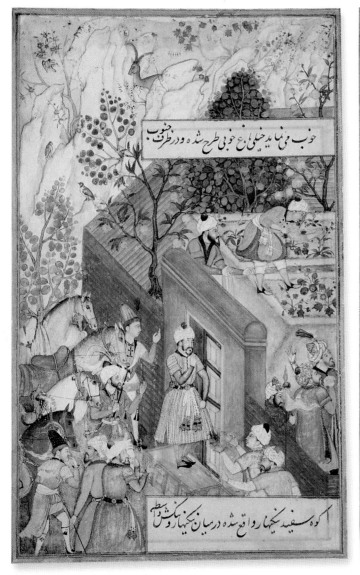

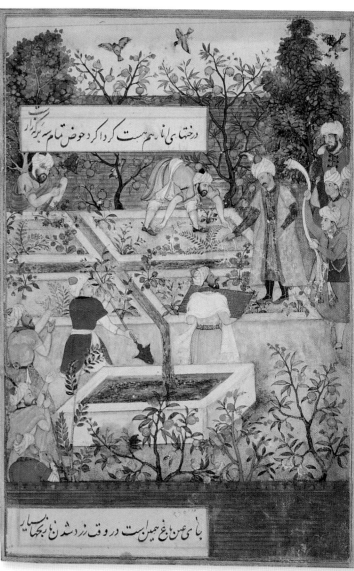

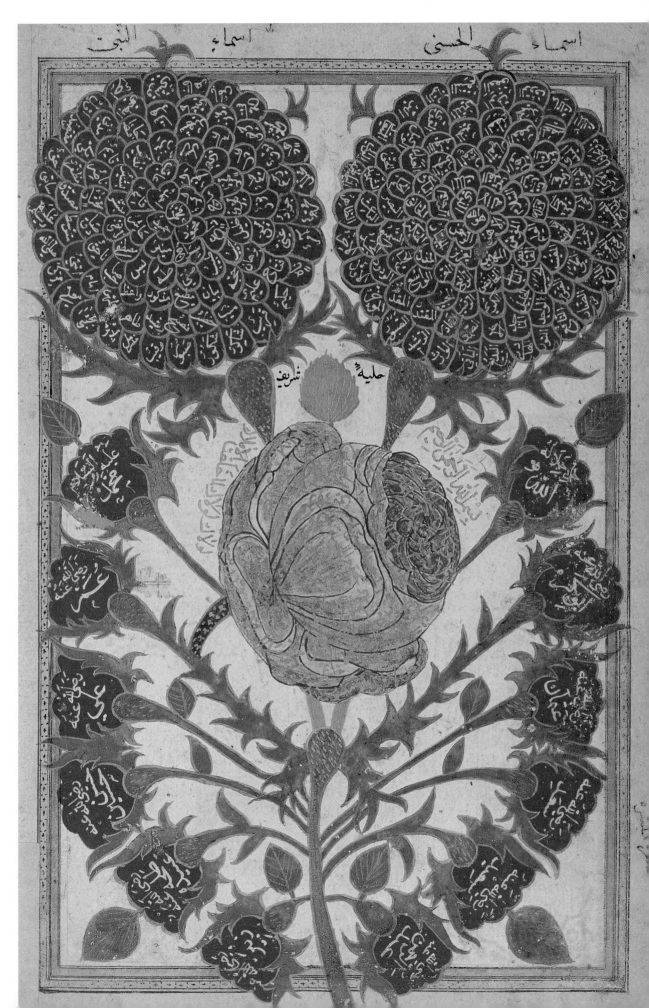

AKHLAQ-I RASUL ALLAH

This is a detail of a page from an 18th-century Turkish manuscript, a book of religious ethics written in Arabic. It is now kept in the Oriental Collections of the Staatsbibliothek zu Berlin, Germany.

Border *The elegant border of this drawing was made with a pen and ruler. It cleverly compresses and defines the composition, so that overlapping petals and stems give an impression of fulfillment and abundance.*

Sacred words *The central rose is more solid than any other on the page. However, look closely and you will see words written in gold fluttering over the form of the flower, fragmenting its detail in a whisper of prayers.*

Stylized motif *A fine brush has been used throughout this drawing to apply inks and watercolors. The physical anatomy of the rosebud has been studied and translated into a repeated stylized motif. Note how each bud is essentially the same shape, and how the shape has been repeated freehand.*

The Rose of Mohammed
1708
9½ x 6½ in (240 x 165 mm)
FROM THE TURKISH
MANUSCRIPT *AKHLAQ-I
RASUL ALLAH*

Fast Trees

IN CONTRAST TO THE QUIET, formal detail of other drawings in this chapter, these powerful fast trees enact the actions of plants. Each tree reaches out and holds its landscape with dynamism and pulse. In both drawings we find testament to the inexorable energy of growth.

Rembrandt expresses a delicate quickness. Gentle lines draw a warm breeze through this remote wooded garden. Rustling in a loose foliage of soft marks, his pen evokes the weight of abundant activity on this late summer's day. Mondrian's arch of scratching branches is drawn with such force it will always be alive. We can still feel his hand storming across the paper. Set within a frame of smudged landscape, the tree possesses a musical agitation. This characteristic will increase in the artist's later abstract work. Here, we see a punctuated ordering of space. Sharp branches cut out negative shapes of winter sky.

REMBRANDT VAN RIJN
Dutch painter, etcher, and draftsman. Rembrandt's prolific output comprises oil paintings of historical and religious subjects together with group and self- portraits. His emotive etchings and pen and ink drawings (see also p.174) are great resources for artists learning to understand the potential of these media.

Horizon Pen and ink lines describing foliage also tell us the directions of sunlight and wind. An arc crossing the bottom of the drawing from one side to the other supports the scene and separates us from the landscape beyond. Compare Rembrandt's arc to that of Mondrian's, and note the similar treatment of low horizons in both works emphasizing the height and dominance of trees.

Cottage Among Trees
1648–50
6¾ × 12⅛ in (171 × 308 mm)
REMBRANDT VAN RIJN

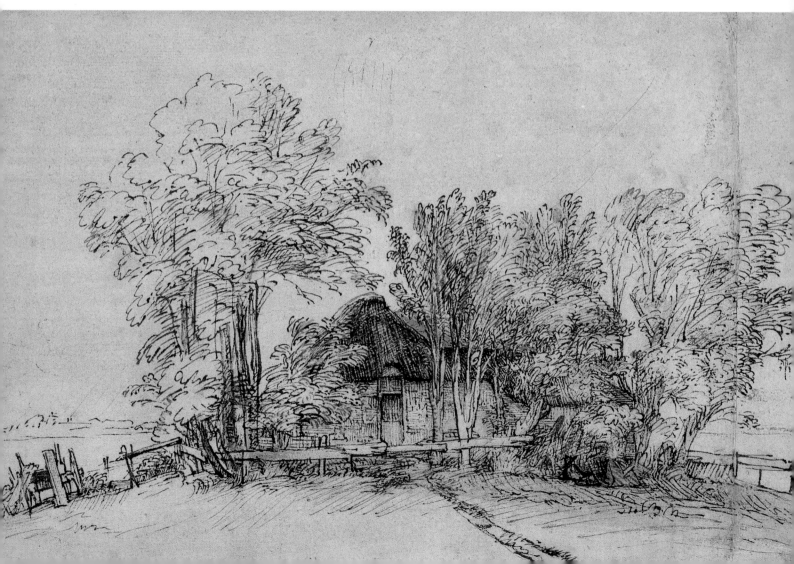

PIET MONDRIAN

Dutch Pure abstract painter preoccupied with line and plane relationships. With increasing austerity, Mondrian banished the subject from his drawings. In his later work he also banished space, composing visual harmonies using only straight lines and flat planes of black, white, gray, or primary color.

Atmosphere Here we see how shapes of negative space are as important as the physical subject they enclose (see pp.58–59). Mondrian has again lightly dragged his chalk on its side to evoke a wet depth of atmosphere. These passive gray marks contrast with the assertive tension of the tree.

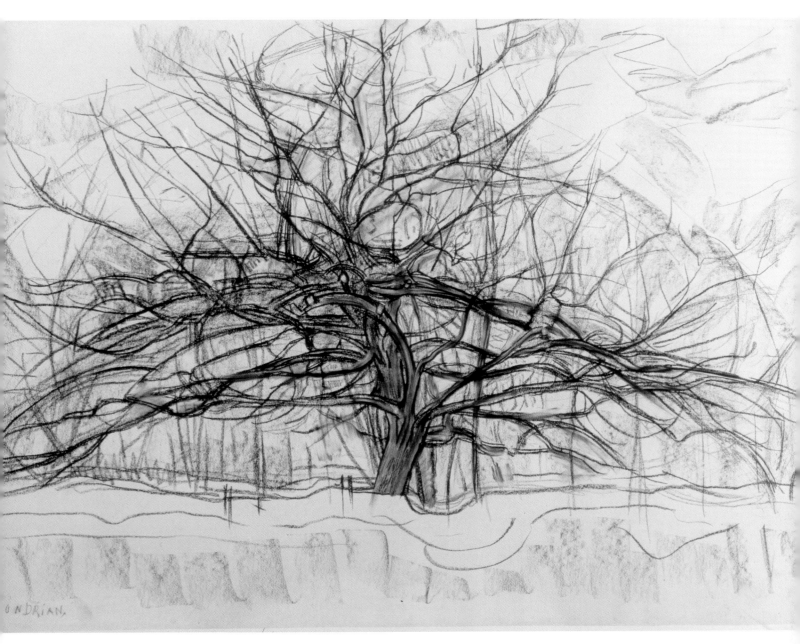

Winter ground Short vertical marks along the bottom of this drawing reveal the length of the black chalk Mondrian used. Rubbed on its side, it roughly blocks in the ground. This crude economy of line is all we need to feel the cold, wet, unwelcoming quality of this winter earth.

Branches and trunk Lines shaping the branches of the tree are built up in layers. To make the trunk more dense, the artist has rubbed and smudged preliminary marks with his fingers before firmly overdrawing with new lines. Solid black lines are achieved by pressing the chalk hard. When used lightly, it shows the texture of the paper.

Tree: Study for the Grey Tree
1911
23 x 33⅝ in (584 x 855 mm)
PIET MONDRIAN

Graphite and Erasers

GRAPHITE, FROM THE GREEK word *graphein* (to write), is a soft and brittle carbon. It was first mined in Cumbria, England, in 1564, and was initially used in small, pure pieces bound in lengths of string. Pencils as we know them—with their slender wood casing and "lead" of graphite—were invented in France in 1794 by Nicolas-Jaques Conté. He discovered that milled graphite mixed with clay and water, press-molded, and baked to a high temperature produces a harder and paler medium than graphite alone.

Modern pencils are graded from 9H (hard and pale) to 9B (black and soft). Graphite-clay sticks are also available, together with a powder form. All possess a natural sheen and are erasable to a varying degree. Graphite drawings smudge easily, so fixative, a form of varnish, can be used to hold a drawn surface in place. It is applied as a fine mist from an aerosol can, or from a bottle using a diffuser. For the beginner, ordinary hairspray is an effective and cheaper alternative.

USING GRAPHITE

This drawing illustrates a range of marks and tones that can be achieved with graphite pencils of different grades.

3B pencil A range of marks and textures can be achieved with a 3B pencil when you vary its pressure, speed, and direction, as this detail shows.

HB and 5B Layers of tone have been built up with HB and 5B pencils. Softer pencils require less pressure to make a mark, revealing the texture of the paper surface. It is important to keep the point of the pencil sharp with either a craft knife or a sharpener.

MATERIALS

Here is a selection of 14 items to illustrate a basic range of pencils, graphite sticks, sharpeners, erasers, and fixative.

1. AND 2. HB AND 3B PENCILS:
It is unnecessary to possess every grade of pencil. HB, the central and most common grade, is perfect for making delicate lines. 3B gives a blacker tone. A great variety of effects can be achieved with just these two.

3. WATER-SOLUBLE PENCIL:
Effective for atmospheric drawing, but be aware of how watery tones can dull the impact of the line.

4. AND 5. MECHANICAL PENCIL:
Thick or fine leads are made in a range of grades. They are particularly useful because they do not require a sharpener.

6. ROUND SOLID GRAPHITE PENCIL:
Excellent for large-scale drawing, producing thick, bold lines. A range of grades can be honed with a craft knife or sharpener.

7. THICK GRAPHITE STICK:
For large-scale drawing. Graded soft, medium, and hard. It crushes to produce graphite powder.

8. SQUARE GRAPHITE STICK:
Useful for making broad, sweeping marks in large-scale drawing. If worn and rounded, the stick can be snapped into pieces to regain the sharp, square end.

9. CRAFT KNIFE AND BLADES:
Handles are sold in two sizes to fit large or small blades, and blades are sold in a range of shapes. Perfect for sharpening pencils to a long point, to cut lines in paper, or to remove areas.

10. PENCIL SHARPENER:
Makes a uniform point. Keep one in your pocket for drawing outside the studio, together with an envelope for shavings.

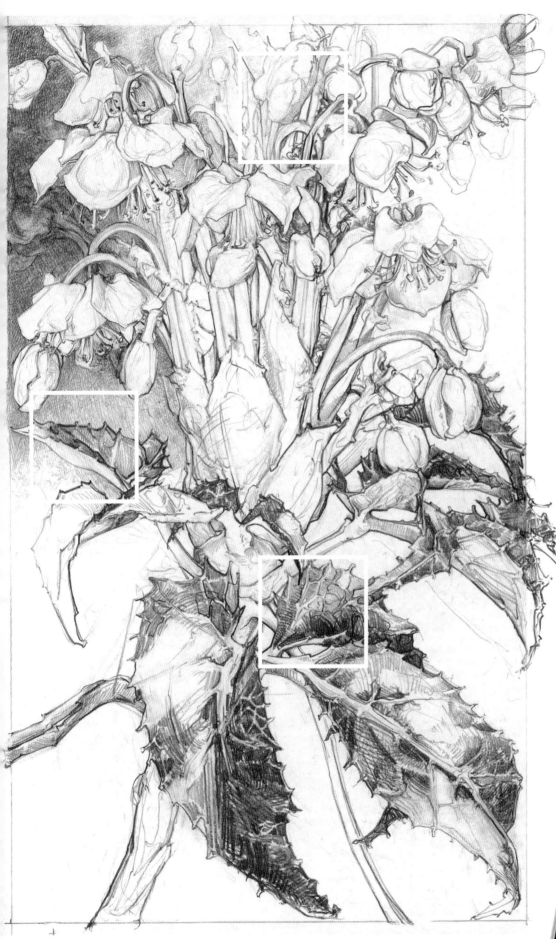

Helleborus corsicus (Corsican hellebore)

ERASING AND FIXING

Erasers can be used to blend and soften lines, or to remove them altogether. Fixative prevents smudging and secures lines.

Using fixative *You can use fixative while drawing to hold the definition of lines you wish to gently fade but not remove entirely, for which you would use an eraser.*

11. PLASTIC ERASER:
Avoid cheap colored erasers that may stain drawings with grease and dye. White brands are available in soft and hard versions.

12. PUTTY RUBBER:
Warm it in your hand before use. It is excellent for removing powdery materials, and for making crisp sweeps of light across a delicate pencil drawing.

13. DIFFUSER:
Traditional tool for applying liquid fixative, or to spray mists of ink.

Cropping and Composition

MANY STUDENTS WILL START a drawing in the middle of the paper. Focused on the shape and detail of their subject, they remain happily unaware that there is, or should be, any relationship between what they are drawing and the surface they are drawing it on. The paper is only paper, and the troublesome subject floats somewhere in the expanse of it.

However, a single fig drawn in the middle of a large, empty square of paper gives quite a different impression from the same fig drawn on such an intimately small square

that its skin nearly touches the boundary. The meaning of the same drawing changes simply by its relationship to the space it occupies. The size of any subject, its placement on the page, the size of the page, and its overall proportion are all discrete and essential aspects of successful picture-making.

Before you begin to draw, think carefully about where to place your subject. Are you are happy with your paper? If not, change it; add more, take some away, or turn it around. Do not just accept what you are given, adapt it to what you need.

CHOOSING A VIEW

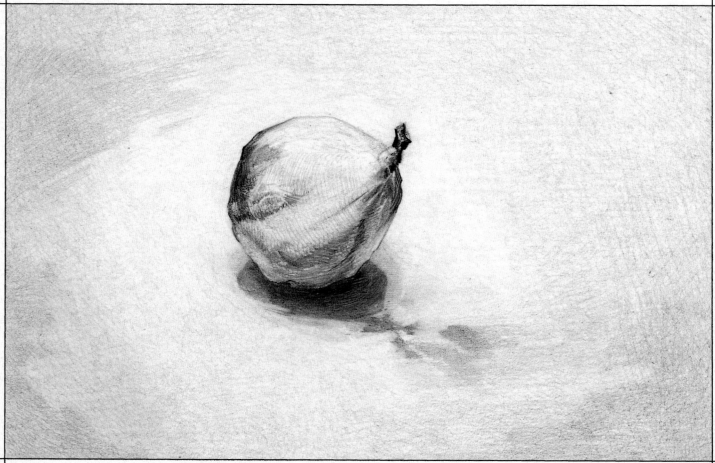

A Single Fig

"The size, shape, and orientation of the paper are so integral to the composition that they determine the impact and meaning of the drawing."

THE VIEWFINDER

These pencil drawings of figs demonstrate different crops and compositions. A card with a small rectangle cut out of it makes a useful viewfinder. Close one eye to look through the hole, then move the card to explore different views. Use it as a starting point, a device to help you decide what to draw.

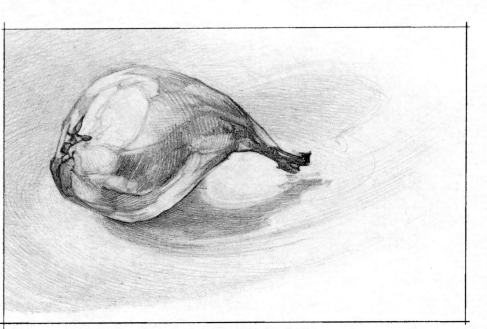

Off-center and diagonal

Here I held my viewfinder so the fig appeared upper-left in the space, its stem and shadow framing a white center. The angle of the fruit together with dark shadow (top left) and bright light (bottom right) suggest a diagonal division across the whole drawing, running corner to corner, bottom-left to top-right.

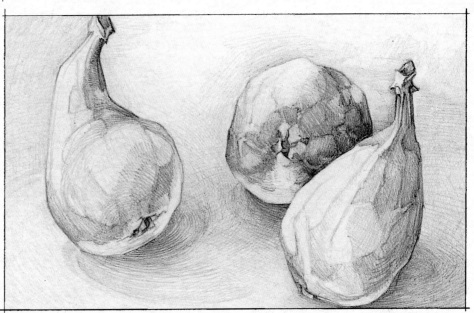

Touching the edge

When the subject of a drawing touches one edge of the paper, it attaches to it visually. Here the left fig is attached to, and therefore apparently suspended from, the uppermost edge of the drawing. When subjects touch two or more edges, as also shown here, they establish a tension and unity with the paper.

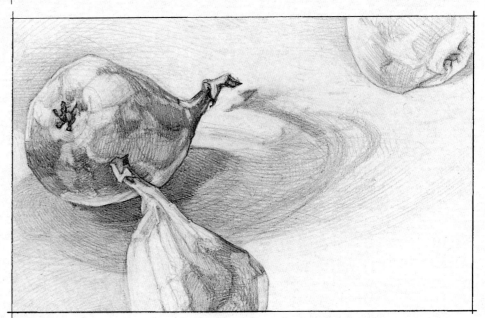

Space as the subject

In all pictures, spaces between things are as important as the things themselves. This drawing has been cropped to emphasize space between the fruit. Our focus is on the white cloth supporting the figs, its illumination, and lines describing shadows cast by the fruit.

Negative Space

UNCONSCIOUSLY WE ASSESS spatial relationships all the time to guide ourselves through the world. But how often do we look at the air between things; shapes of air cut out and defined by the physicality of our environment? When we look into the branches of a tree, do we see myriad distinct and unique shapes of daylight or do we just see branches? Why as artists should we look at the air?

Every space in a picture has a shape, position, tone, and a role to play. Viewers appreciating a finished image may not see shapes of space, but if the artist does, their subject and composition will become more real, unified, dynamic, and engaging. Negative space is the simple key to getting positive shape right; a foundation stone in picture-making. Unfamiliar shapes of negative space reveal the real shape of a positive subject. Looking at negative space overrides the problem of drawing what you know, rather than what you see in front of you. It is an astonishingly simple device that many artists use and I strongly recommend.

The drawing opposite is of the uppermost leaves of a potted fig tree. In following this class, you will need a similar large-leaved plant, a sharp HB pencil, an eraser, and a fresh page in your drawing book. Remember that plants do move! Therefore it is best to complete your drawing in one sitting if possible.

WHERE TO START

Arrange your plant and paper so you can look back and forth by barely moving your head; this ensures a consistent view. The box opposite isolates an area, which is shown in the three steps below. Follow these from left to right and see how I began with one complete shape between two parts of a leaf, erasing and adjusting lines until itlooked right, then added a second shape, third, fourth, and so on. In your own version, remember to draw only space, not leaves. It helps to start at the center and map outward.

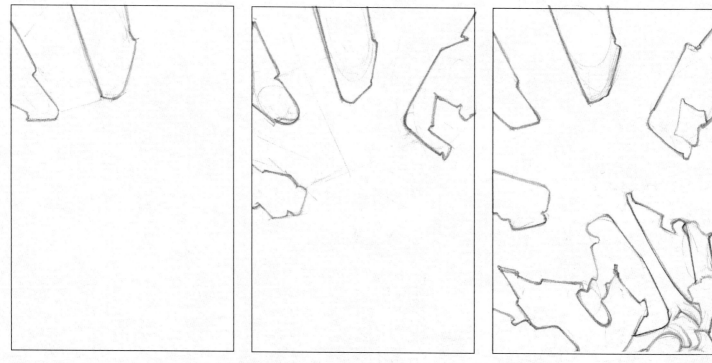

Draw a complete shape *Map outward from the center* *Erase and adjust lines until correct*

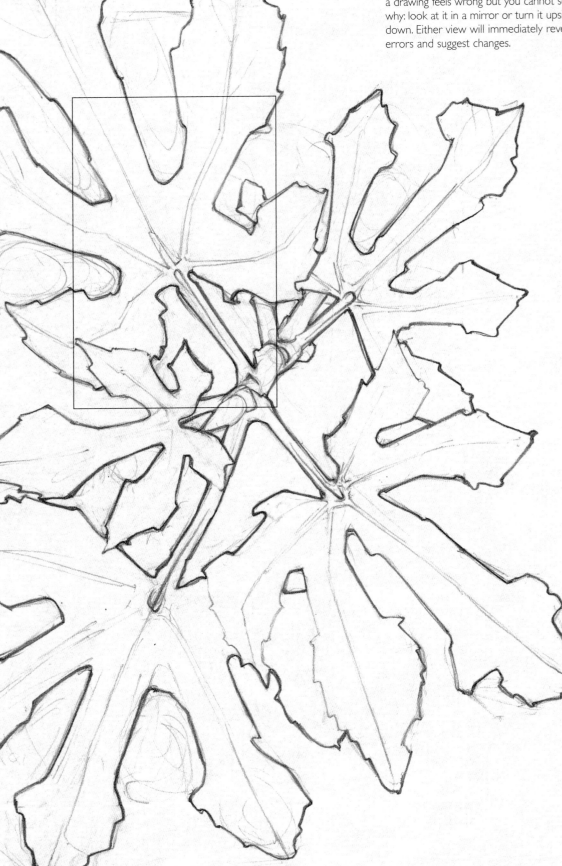

Spaces between leaves

Here I drew only spaces, adding one to another until the leaves were revealed. Besides looking at negative space, there are two other useful things to do when a drawing feels wrong but you cannot see why: look at it in a mirror or turn it upside down. Either view will immediately reveal errors and suggest changes.

Fig Tree

WALKING IN THE ALPUJARRAS in Andalucia,
Spain, I drew a bare fig tree clinging to the
wall of an almond grove; a perfect subject
for seeing negative space. I marked its
essential frame of large branches first,
frequently erasing lines and changing
my mind until the balance felt right.

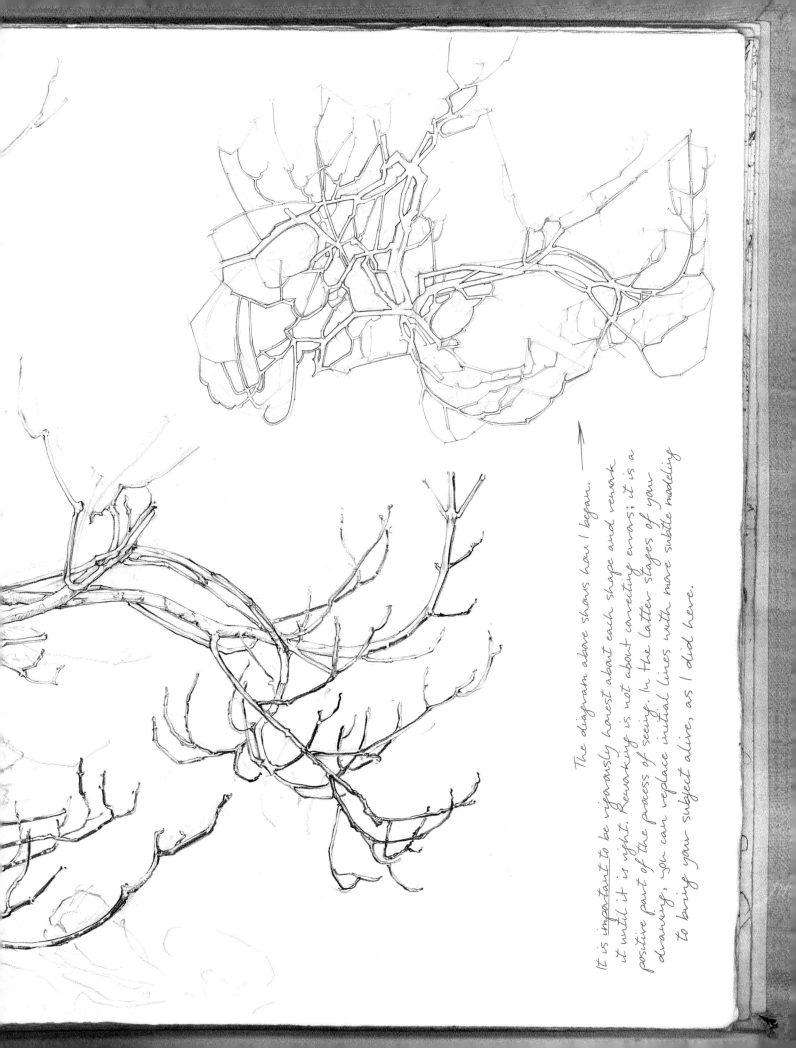

The diagram above shows how I began. →

It is important to be vigorously honest about each shape and rework
it until it is right. Reworking is not about correcting errors; it is a
positive part of the process of seeing. In the latter stages of your
drawing, you can replace initial lines with more subtle modeling
to bring your subject alive, as I did here.

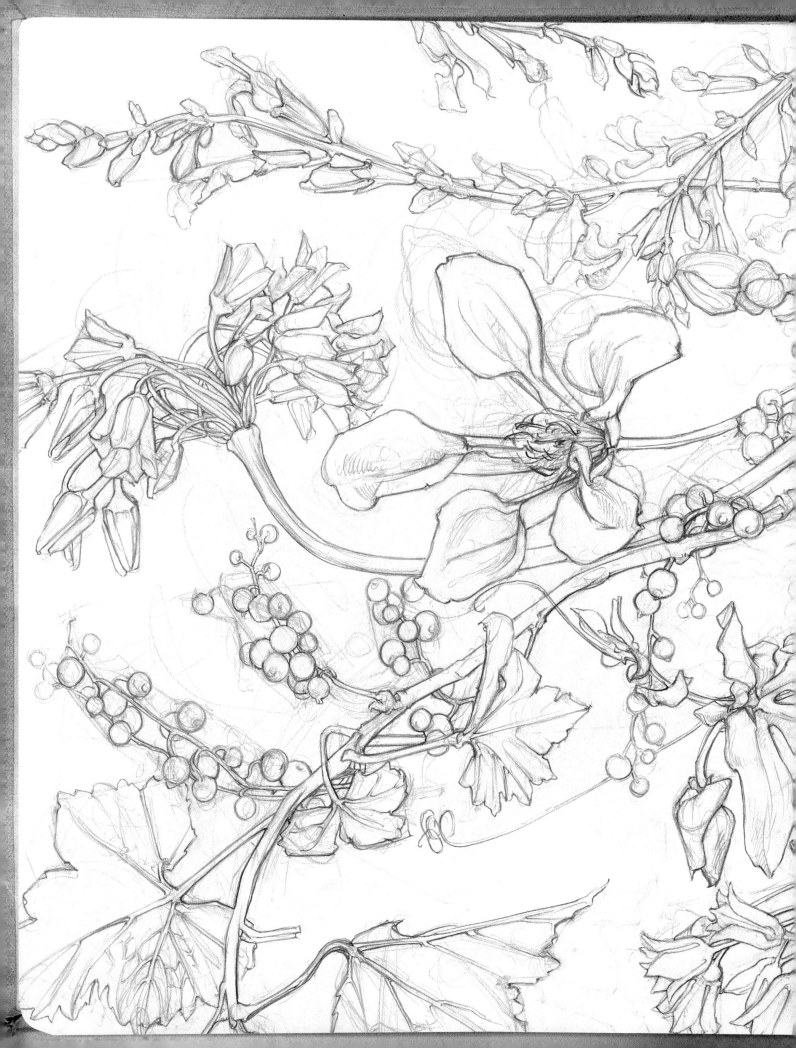

Summer Flowers

SALVIA, *RIBES*, *CLEMATIS*, *Allium*, *Passiflora*, *Alchemilla*, and *Acanthus* drawn with an H pencil by observing the negative spaces between the stems, petals, and leaves. I arranged the flowers on a sheet of paper in a cool room and rapidly sketched a composition. Then I put them in water, taking the stems out one at a time to draw.

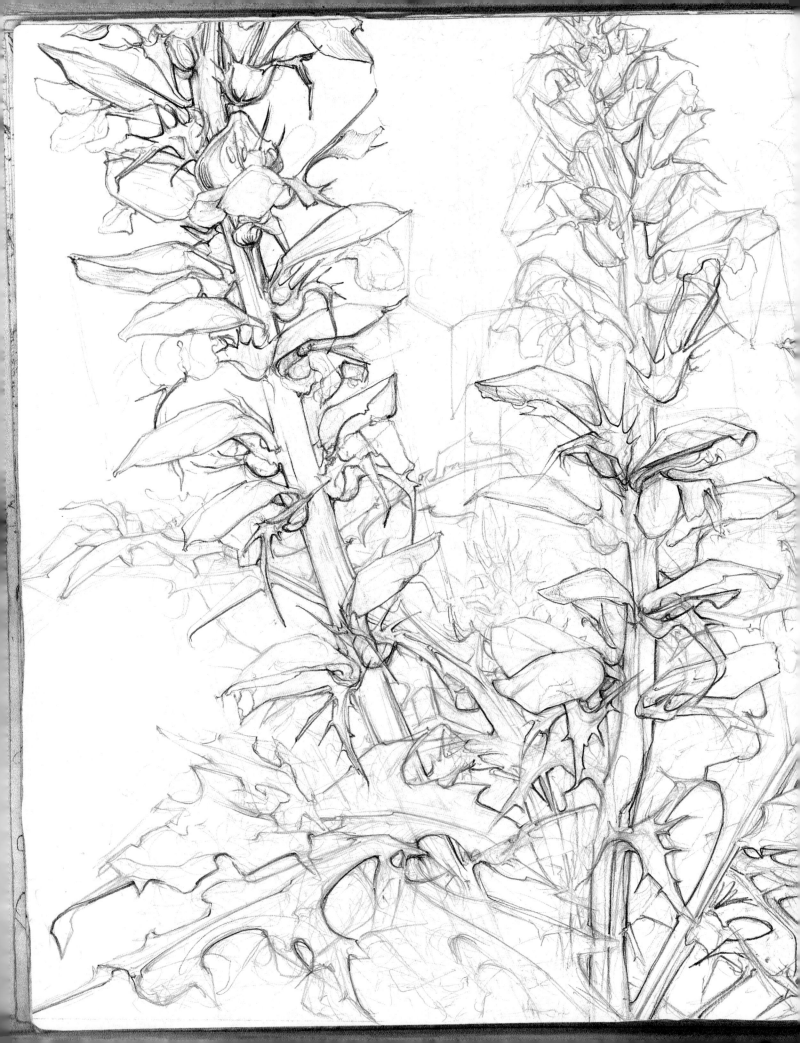

Acanthus Spinosus

As WE LOOK AROUND, our eyes travel and adjust from one point of focus to another, gathering less distinct information on the way. We never see everything at once. If an artist changes the pace of their line and focus of their attention, interfolding points of detail with areas of loose suggestion, they emulate our experience of seeing. Excessive detail leaves no space for the eye to rest or imagination to wander. Compare changes of pace and focus here to the flatter finish of Summer Flowers (*see pp.62–63*).

Architecture

IN THE CONTEMPORARY PRACTICES of architecture, film-set design, and computer game imaging, we find the most recent steps in the evolution of graphic language. Computer programs allow the virtual drawing of ideas. Through the animation of the screen, architects and designers can imaginatively "climb inside" three-dimensional space and, once there, add and subtract ideas, drawing plans around themselves within a program as opposed to on a flat sheet of paper.

Architects have been fine-tuning their specialized branch of drawing for centuries. Besides sketches of first thoughts and polished drawings of the finished look for clients, they also have a diagrammatic language for communicating plans to builders. At the core of their practice, to help them create new form, they have the Golden Section. It was the mathematicians, philosophers, and architects of ancient Greece who first pursued the formula for "divine proportion," reflecting the eye's love of unity in difference. This harmony, which can be clearly seen in ancient Greek architecture, was preserved into the Renaissance where it became a foundation stone for thinking and creativity. From 15th-century Italy, the formula for perfection spread through Europe, and in the 19th century it was given the name the Golden Section. It was also during the Renaissance that the architect Brunelleschi invented linear perspective, the device that has since governed most of our picture-making (*see pp.74–75*).

Since the first flowering of Modernism in the early 20th century, architects, designers, composers, filmmakers, fine artists, and writers have been breaking away from traditional forms of representation to seek new expressions of shape, mass, balance, space, time, and sound. Since Picasso and Braque's revolution of Cubism in around 1907, European conventions of pictorial perspective have lost their monopoly on seeing. Yet the pursuit of divine proportion and harmony remains. Perhaps in the sheer planes of some of our greatest modern buildings it is finding its clearest expression.

Among the drawings of this chapter we look from 17th-century ecclesiastical calm to 20th-century film fantasy; from political commentary to musical abstraction; and from the child's view to the infinity of the vanishing point. Linear perspective is a marvelous device, invaluable to understand and apply when you choose. It is the focus of each practical class in this chapter, coupled with the importance of exercizing your imagination.

VICTOR BALTARD
French architect employed by the city of Paris, Baltard designed the Church of St. Augustin, which was the first church in the capital to be built entirely of metal and then clad in stone. This is a pencil drawing, with gray and brown watercolor wash, of the west facade of St Augustin, made by the architect himself. The church is still in use today.

West Facade of the Church of St. Augustin, Paris
1871–74
VICTOR BALTARD

Master Builders

EVERY NEW BUILDING, embodying a massive investment of ideas, materials, and labor, marks the end of a long journey from the first few marks the architect made on a sheet of paper. Drawings underpin every great human-made structure like hidden linear ghosts at their core. Architects draw for many reasons: to visualize ideas; evoke presence; describe a finished look to a client; calculate function, structure, and balance; and ultimately to show builders what to do.

Hawksmoor's drawing is both a plan and an evocation. Lines define structure while washes suggest light and atmosphere. Gaudí's fluid architecture grew up through many kinds of drawing. The photograph opposite shows his studio hung with metal pendulums, a three-dimensional drawing made with wires and weights, testing gravity to calculate the inverted shapes of domes. Below it, densely layered lines in mists of color weave the presence of the expected building into shape.

NICHOLAS HAWKSMOOR
One of Britain's "three great" Baroque architects (along with Sir Christopher Wren and Sir John Vanbrugh). Hawksmoor established his reputation with university and church architecture including All Souls College, Oxford, and six London churches. A student of Wren's, and later an assistant to Vanbrugh, he also worked on St Paul's Cathedral, Hampton Court Palace, Blenheim Palace, and Castle Howard.

Three aspects This subtle and sophisticated drawing made in pen and wash displays three distinct aspects of Hawksmoor's baptistry. Together they explain how interior structure and space define exterior form and shape.

Finished surface On the left, the finished surface of the building is given depth and emphasis by immaculate vertical and horizontal brush strokes of shadow. We see the modeled detail of Corinthian columns, pilasters, and an inscribed entablature.

Cut-away interior On the right, a section cut through the center of the building reveals material thicknesses, relative levels, and the shapes of interior domes and apses.

Pillars and floor At the base of the drawing, a compass-drawn plan tilted downward through 90 degrees illustrates the arrangement of pillars around a central circular floor.

St Paul's Baptistry
c. 1711–12
NICHOLAS HAWKSMOOR

Wire Sculpture of Güell Crypt
c. 1900
ANTONIO GAUDI

ANTONIO GAUDI

Visionary Catalan architect. Gaudi's cathedral in Barcelona, churches, and apartment homes are distinguished by their unique organic shapes, their manipulation of light, and high embellishment. Flowering curves of stone or concrete are often encrusted with bright ceramic mosaics. Gaudi was inspired by medieval and oriental art, the Art Nouveau movement, and his love of music.

Wire and watercolor Above is a three-dimensional drawing made with linked wires and weights. Gaudi preferred to calculate form in the air rather than on paper. To the right is a watercolor drawing thought to have been made over a photograph of the model above. This sculptural drawing envisions the finished crypt, glowing and ethereal as if caught in the light of red morning sun.

Güell Crypt at the Time of its Construction
c. 1910
24 × 18¾ in (610 × 475 mm)
ANTONIO GAUDI

The Order of Sound

BOTH OF THESE VISIONARY DRAWINGS occupy a slender, upright pictorial space. The architect and musician Daniel Libeskind has drawn a stampeding cacophany of airborne architectural detail, while the composer Erik Satie has made an enclosure of quiet order and grace. Both men used rulers and pens to carefully and slowly construct their compositions.

Contemporary musicians commonly collaborate with artists by interpreting images as sound. There has always been a natural affinity between the visual rhythms of pictures and the audible rhythms of music. We can see, and in a sense hear, such a rapport in both of these drawings. Libeskind begins quietly in the upper space of his drawing, before cascading into a riot of line and sound below. Satie draws quietly throughout, and the spaces between his windows and turrets are the visual equivalent of pauses in his music compositions for piano (*see also Bussotti, p.223*).

DANIEL LIBESKIND

A Polish American architect of international acclaim. Libeskind's numerous commissions include concert halls and museums. He also produces urban and landscape designs, theater sets, installations, and exhibitions of his drawings. Libeskind studied music before transferring to architecture. He also contributed to plans for the rebuilding of the World Trade Center site in New York.

Floor plan This drawing has been made with a rapidograph, a refillable pen that feeds a constant supply of ink through a fine tubular nib. Across the top and center right of the image we perceive an almost recognizable architectural plan. Floor space appears divided by discernible walls, corridors, and rooms, and arched dotted lines depict the radius of doors.

Visual rhythms In the lower half of this drawing, architectural language has broken loose: escaped and transformed into an image of rebellious pleasure. We can imagine how a musician might interpret this drawing by looking at the abstract visual rhythms of masses composed of long straight poles, short curved poles, flat boards, and dotted lines.

Arctic Flowers
1980
DANIEL LIBESKIND

ERIK SATIE

French pianist and composer for the piano, theater, and ballet. Satie collaborated with his friends Jean Cocteau and Picasso. His witty, minimalist scores scandalized audiences with orchestrations for the foghorn and typewriter. He performed in cabarets, dressed eccentrically, lived alone, and founded his own church, of which he was the sole member.

Parcel paper Satie has drawn this fantasy hotel using a ruler, a conventional dip or fountain pen, and ink on a fragment of folded brown paper—a scrap of everyday material that happened to be at hand.

Eastern influence The upright pictorial space and subject of this image is reminiscent of Middle Eastern and medieval European drawing. Compare the even and elegantly stylized order of the many windows and the shape of the perimeter wall to the arrangement of details and the shape of the wall in Babur's Garden of Fidelity on p.50.

Composition Look how well this drawing fits and resonates with the upright, narrow shape of its paper. On pp.56–57 we discussed how important the shape, orientation, and four edges of the paper are to the composition and impact of an image. Edges are effectively additional lines in a work. They define space and pictorial balance.

Hotel de la Suzonnières
c.1893
7⅞ × 5½ in (200 × 140 mm)
ERIK SATIE

Future Fictions

THESE THREE HIGHLY DETAILED DRAWINGS invite us to enter the long-shadowed architecture of imaginary worlds. Boullée's monolithic apparition was drawn as a monument to Sir Isaac Newton. Within it, antlike mortals might have speculated upon the universe. This is the work of an architectural theoretician; the ominous globe exists only as a series of drawings. Among preparations for Fritz Lang's film *Metropolis*, made in 1926, we find other utopian visions soaring above normal life. Art director Erich Kettlehut's vertiginous design for the city of a slavelike populace had a future influence on movies such as *Blade Runner*.

Paul Noble's epic drawing summons an imperfect and disturbing township where ruin and activity are equal and strange. We glide over exquisitely drawn wastelands of damage and abandonment, experiencing a fascinating conflict between curiosity and desolation.

ETIENNE-LOUIS BOULLÉE
French architectural theorist, painter, and draftsman. Boullée lived in Paris, and taught at the Academie d'Architecture. His celebrated imaginary buildings are characterized by pyramids, spheres, arched vaults, cylinders, and dramatic lighting.

Light illusions This pen-and-wash drawing shows a subtle application of the principles of illumination demonstrated with an egg on p.96. The lower-left section of the building appears relatively pale against a darker sky, and the reverse is true on the right. This shift makes the cenotaph appear three-dimensional.

Newton's Cenotaph
1784
15¾ x 25 in (402 x 635 mm)
ETIENNE-LOUIS BOULLÉE

ERICH KETTLEHUT

Influential film art director, draftsman, and model-maker. In the preparation of *Metropolis*, Kettlehut and his co–art director Otto Hunte, together with cinematographer Karl Freund, used forced perspective camera techniques to amplify the magnitude of buildings in relation to human characters.

Brush and ink This is a dramatic drawing from a film that shaped the history of world cinema. Kettlehut drew using a fine and relatively dry brush dipped in black, gray, and white ink on brown-gray paper. Working on toned paper such as this gives an artist greater scope for dramatic lighting effects than if they work on white paper.

Fritz Lang's Metropolis
c.1926
ERICH KETTLEHUT

PAUL NOBLE

British contemporary artist who creates monumental, intensely detailed graphite drawings explaining and questioning the geography, architecture, mythology, and morality of an invented place called Nobson Newtown. His political visions and satires of humanity are exhibited worldwide.

Graphite shapes Nobson Central is one of a series of very large graphite drawings of the spoil and detritus of Nobson Newtown. Its sheer scale engulfs the viewer and demands time and patience to be read. Building shapes are based on letters and in some works can be read as text.

Nobson Central
1998–99
9 ft 10 in x 13 ft 2 in
(3 x 4 m)
PAUL NOBLE

Pathways of Sight

LINEAR PERSPECTIVE (also called vanishing-point perspective) is a simple device for calculating the relative size of things in pictorial space. We use it to structure illusions of depth. It can be applied to any subject, but is most easily seen and understood in pictures of buildings and interiors. Invented by Italian artist and architect Brunelleschi in 1413 (late in the history of art), linear perspective is distinct from more ancient systems practiced in the East, and those of Naïve artists and children. It is also distinguished from aerial perspective (*see pp. 206–07*). All forms of perspective are of equal value.

Here Leonardo provides a superb example of a single vanishing point, Piranesi an example of two, and age eight, I contribute the child's perspective. Sometimes shared with Naïve artists, this perspective is often an imagined bird's-eye view in which details are mapped according to logic and importance rather than how they might appear in real life.

LEONARDO DA VINCI
One of the greatest artists, scientists, inventors, and thinkers ever to have lived. In his notebooks, Leonardo recorded constant streams of ideas, observations, and inventions—essential reading for inquiring minds.

Single-point perspective Tie a thread to a pin. Press the pin into Leonardo's vanishing point, found at the center of all converging lines. Pull the thread taut and rotate it slowly above the drawing. See how the thread corresponds to each converging line. Note how architectural features conform to lines and how human figures diminish in size toward the vanishing point.

Study of Perspective for the Adoration of the Magi
1481
6½ x 11½ in (165 x 290 mm)
LEONARDO DA VINCI

SARAH SIMBLET

I made this drawing (at age 8) in response to a local bookstore's request for children to draw their village. It shows how children usually map large scenes in flat layers one above the other, including all they recall about the subject. Children are uninhibited and problems with one element being obscured by another rarely arise.

Scale *Our farmhouse was in the woods. This drawing maps my experience and understanding of the nearby village; a logical narrative of memories. Young children typically ignore issues of scale when making room for important points in their story. Note the rather large rabbits and pheasants on the hills, which I saw from home every day.*

Breamore Village, New Forest, England
1980
9 x 16 in (228 x 405 mm)
SARAH SIMBLET

GIOVANNI BATTISTA PIRANESI

Italian artist, architect, and designer. Piranesi's prolific architectural drawings, visionary and practical understanding of ancient Rome, and theoretical writing strongly influenced neoclassicism.

Two-point perspective *Sunlight through this colonnade illuminates a great example of two-point perspective. Lightly marked vanishing points are located on either side of the drawing, at the top of each lateral column base. Mark these points with your pin and follow the converging lines of the drawing by rotating your thread.*

Two Courtyards
c.1740
5½ x 8⅜ in (141 x 212 mm)
GIOVANNI BATTISTA PIRANESI

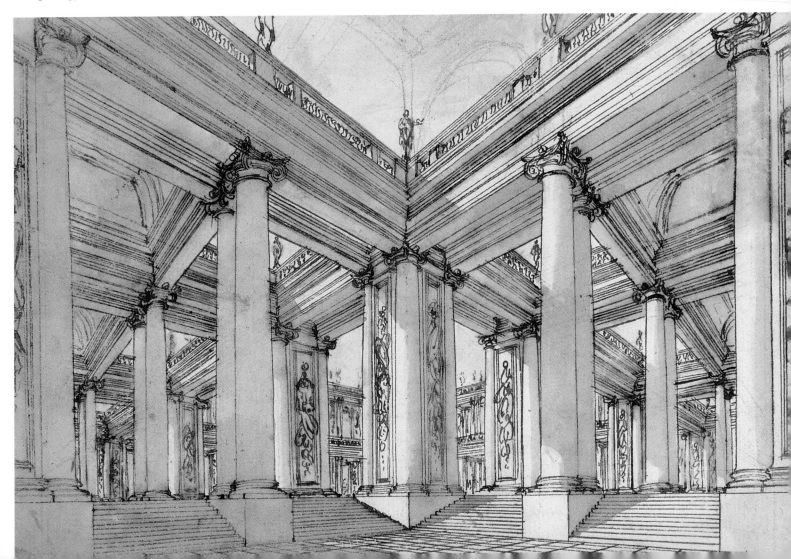

Single-Point Perspective

MASTERING LINEAR PERSPECTIVE is easier than you may imagine. On the previous page we looked at its essential mechanism through drawings by Leonardo and Piranesi. Study these pages first before embarking on this lesson. Leonardo began with a grid of many lines within which he invented his scene, discovering the image as it progressed. In contrast, Piranesi planned his drawing with only the essential lines needed. This is where we will begin.

First read through, then follow the ten steps below, using a sharp HB pencil and ruler. Draw each step over the preceding one to build up a single image. This lesson shows you how to make a simple illusion of space defined by two boxes and three flat boards, corresponding to a single vanishing point. Next, try composing your own space. Note that if you place large structures in the foreground and smaller ones closer to your vanishing point, you will amplify the illusion of distance.

DRAWING BOXES

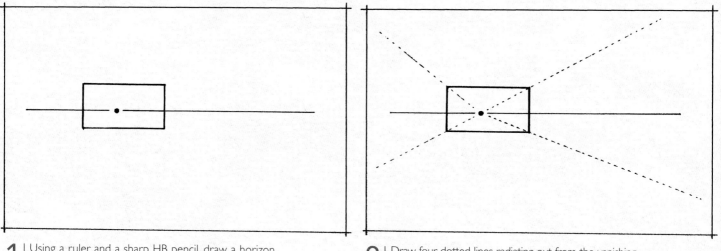

1 | Using a ruler and a sharp HB pencil, draw a horizon line across your paper. Mark a spot on the horizon line; this is your vanishing point. Surround the vanishing point with a small rectangle.

2 | Draw four dotted lines radiating out from the vanishing point. Each line should pass through one corner of the rectangle. Extend each dotted line to the edge of your drawing.

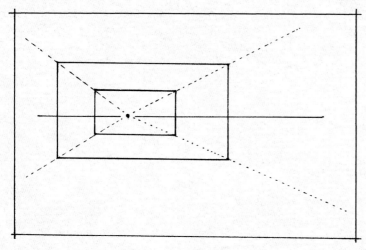

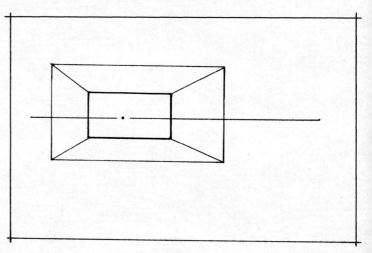

3 | Draw a second larger rectangle surrounding the first. The four corners must each touch a dotted line. This ensures that the second rectangle aligns with the shape and position of the first.

4 | Draw four short lines to connect the four corners of the two rectangles. Erase the dotted construction lines. You have completed your first box. (*See p.98 for an important note on oscillation.*)

5 | Draw a new rectangle. Note that this does not surround the vanishing point. In the future, when inventing your own compositions, you can place rectangles anywhere you wish in relation to a vanishing point.

6 | As in step 2, draw four dotted lines radiating from your vanishing point. Pass these through each corner of the new rectangle. Continue the dotted lines out toward the edge of your drawing.

7 | As in step 3, draw a second, larger rectangle. The four corners must each touch a dotted line to be sure it aligns with the first. The larger you make your second rectangle, the closer it will appear to the viewer.

8 | Complete the second box with short lines as in step 4, and erase the dotted lines. Next, draw a slanting line to mark the height of the first flat board. Connect this to the vanishing point—again, with two dotted lines.

9 | Use dotted lines connecting the slanting line to the vanishing point to locate the top, bottom, and far side of this first board. The board's sides should be parallel. Repeat this to add two more boards to the composition.

10 | Erase all of the dotted lines to see your finished boxes and boards in their spatial relationship to each other. Thickening their edges, as I have done here, will help to make them appear more solid.

Creating an Imaginary Space

THIS CLASS USES SINGLE-POINT PERSPECTIVE to create a simple imaginary room. It highlights the importance of having faith in your imagination and trusting your ability to invent. The mistaken belief that we should know exactly what our finished drawings will look like before we make them prevents many people from ever starting. As David Lynch, artist and film director, once said: "I never end up with what I set out to do, whether it is a film or a painting. I always start with a script but I don't follow it all the way through to the end. A lot more happens when you open yourself up to the work and let yourself act and react to it. Every work talks to you and if you listen to it, it will take you places you never dreamed of; it is this interaction that makes the work richer."

In this class, let simple lines suggest a simple space, then let the space suggest its contents and purpose. Linear perspective will support you by providing a frame in which to build your picture (as it did for Leonardo, p.74). On a fresh page in your drawing book, draw a box as shown opposite. Then follow the three given steps. If using a fiber-tip pen as I have done for this drawing, you will find white adhesive stationery labels are useful for covering errors or changing the direction of your idea.

APPLYING PERSPECTIVE

An Imagined Scaffold

"Enjoy your illusion as you make it and it will become more real."

DRAWING A SIMPLE ROOM

Essentials to remember: objects and people diminish in size as they move farther away; parallel planes such as walls converge toward the vanishing point; and floors and ceilings also converge and rise or lower toward the horizon.

1 First, draw the horizon line and vanishing point. Add an array of converging lines to provide a "scaffold" for vertical, horizontal, and leaning surfaces. This initial space will be transparent and open to change.

2 Draw the walls, floor, and ceiling first before adding furniture. Here, additional lines have established the different surfaces and how they relate to each other. The space has become more solid and real.

3 Remove the construction lines with an eraser and the room will become clearer. There is great pleasure to be found in spending time inventing interiors. With some practice, you will be able to draw more complex objects or people within them.

Further Aspects of Perspective

WE ARE ACCUSTOMED TO SEEING our environment from a relatively constant point of view. From our normal eye level, verticals appear perpendicular to the ground, and this is how we have drawn them so far (*see pp.76–79*). Only when our eye level is very high and we look down, or low and we look up, do verticals appear inclined. Think of standing at the top of a skyscraper and imagine how its parallel sides would appear to converge below you. To draw such a view you might employ three-point perspective (*shown opposite top*). Further aspects of three-point perspective are also illustrated opposite, showing you how to draw curved surfaces and a tiled floor. It is important to realize that you can have as many vanishing points as you wish, located anywhere inside or outside the pictorial space. They do not have to relate to each other, or to the horizon. This is demonstrated immediately below.

APPLICATION
Copy these drawings to see and feel how they work before inventing your own versions. Search for the application of these perspectives among works by other artists in this book and in galleries. Copying what you see in the work of others will help you to understand what they have done.

Free vanishing points
Vanishing points are commonly found on the horizon—our eye level. That is where we expect to find them, but they are not confined to this level. Potentially, they can be placed anywhere in space to describe the perspective of flying or tilted objects. The boxes drawn here are seen partly or entirely disassociated from a horizon line drawn across the bottom of the image.

Elaborations
On paper we can enjoy the freedom of fantastic structural invention without limitations of solid materials or gravity. Here, I have elaborated on the simple boxes above. These elaborations could continue indefinitely across a sheet of paper in pursuit of complex and intricate ideas. They could be drawn on any scale from miniature to monumental.

Three-point towers

This drawing depicts three-point perspective, useful for representing steep views looking up or down tall structures. (Turn the book around to see a view looking up.) By comparing this drawing to Piranesi's example of two-point perspective on p.75, you will see how, by adding a third point, you can achieve a sense of incline.

Three-point curves

Here, three vanishing points are evenly spaced along a horizon line. An array of curved lines (drawn freehand) link the two lateral points. I used these lines as a guide to draw the curvature of boxes and panels flying through space. Giving curvature, and therefore tension, to straight lines can amplify drama in a picture.

Three-point checkered floor

This drawing shows how to draw a checkered floor. I started with two parallel lines. I marked the top line with three evenly spaced points and the bottom line with seven. I then drew three fanned groups of lines connecting each of the three points above to the seven points below. Where the lines cross, they mark the corners of the floor tiles. Finally, I added horizontal lines to define the tiles. Note that altering the distance between the three dots above will tilt the level of the floor.

Theaters

RESEARCHING FOR MY PhD, I visited many anatomical theaters and museums, making drawings to resolve questions and express personal responses to the nature and history of anatomy. These walnut-skin ink pen and brush drawings show imagined views of theaters that do not exist but were inspired by places I studied.

Overleaf: Parisian Street

Venetian Life

THIS PEN-AND-INK DRAWING is one of a series I made while sitting next to the Rialto Bridge in Venice. The vanishing point of the drawing is directly opposite as we look across the water. The constancy of the bridge and surrounding buildings frames the movement in the life that flows past.

TABAC MAISON DE LA PRESSE

PAYANT PAYANT

PARISIAN STREET

Objects and Instruments

T HE THINGS WE INVENT describe our lives. Common items, from spoons and pens to chairs and bicycles, are all made bearing the signature of our time and place. History will be learned from the artifacts we leave behind. Engineers and designers of our objects and instruments make drawings for many reasons: to test an idea that is yet to be made, for example, to record an observed detail, or to explain and present a finished concept to a client.

The Industrial Revolution changed the traditional ways in which objects were designed, planned, and made. Previously, craftsmen had held plans in their memory, passing them on to others through the act of making. With the sudden onset of mass production, drawings were needed to instruct workers on the factory floor. Technical drawing was speedily developed as a meticulous international code of measurement and explanation. The precision of engineering drawings evolved alongside machine tools, each demanding more of the other as they increased in sophistication. It was in this era that the blueprint was born. Today, even more advanced drawings are made on computers.

Birds follow instinct to make a nest, and some apes use simple tools, but humans are the only creatures on Earth who actually design and create great ranges of things. Our items all have a purpose—practical or ornamental—and all have a meaning, or can be given meaning. Artists and actors use the meanings of things to communicate through metaphor. A chair, for example—whether, drawn, sculpted, or used on stage as a prop—imbued with enough energy or character can "become" a man.

Artists have for centuries studied and expressed composition, design, color, form, texture, and the behavior of light through making still-life paintings and drawings. In past eras, these, too, have often carried great weights of allegorical meaning. Artists also make images of objects that can never exist; fictional realities that test our logic with a sense of mystery. In this chapter, we look at the importance of light in the creation of pictorial illusions, and the way in which the brain reacts to visual stimulus and optical illusions. We also explore volume and form in the drawing classes by spinning lines to make vessels, illuminating snail shells, and creating a wire violin.

LEONARDO DA VINCI
In this beautiful red chalk drawing we see Leonardo da Vinci's precision as a speculative mechanic. He has described a casting hood for a mold to make the head of a horse for an equestrian statue. It is shaped in sections with hooked bars that can be pulled and tied closely together. He has described contour and function at once, making a clear instruction to his bronze-caster of how to make it and how it will work.

Head and Neck Sections of Female Mold for the Sforza Horse
c.1493
11⅞ × 8¼ in (300 × 210 mm)
LEONARDO DA VINCI

Still Life

THESE DRAWINGS REVEAL two opposite motivations in representing still life. Below, Braque's image is a Cubist collage. One of the great joys of this movement in art is the musicality of its multipoint view. Braque's "justly" arranged combination of cut black card, wood-look wallpaper, charcoal, and a journal jacket with words makes this drawing chatter about the moment. He takes us into the bustle of the Paris café, steaming with music and conversation. Even today we can still feel this projected moment. Opposite, Mucha's drawing glistens with possession, not of place but of things; perfect in their newly made availability. There is a fragile eloquence to these objects as they drift in slow motion past our gaze. This is a designer's drawing made to enthuse surface and style in its delicate brushing of china, silverware, and glass, objects of exquisite elegance for only the gentlest of touch and appreciation.

GEORGES BRAQUE

French painter who as a young man was influenced by the work of the Fauves and of Cezanne. Braque established Cubism in partnership with Picasso just before World War I. His work is characterized by calm and harmonious still-life compositions.

Clashes The art historian Ernst Gombrich said of Cubism, "I believe [it] is the most radical attempt to stamp out ambiguity and to enforce one reading of the picture—that of a manmade construction, a colored canvas. ...Braque marshals all the forces of perspective, texture, and shading, not to work in harmony, but to clash in virtual deadlock."

La Guitare, Statue D'Épouvante
1913
2 ft 5 in × 3 ft 5 in (0.73 × 1 m)
GEORGES BRAQUE

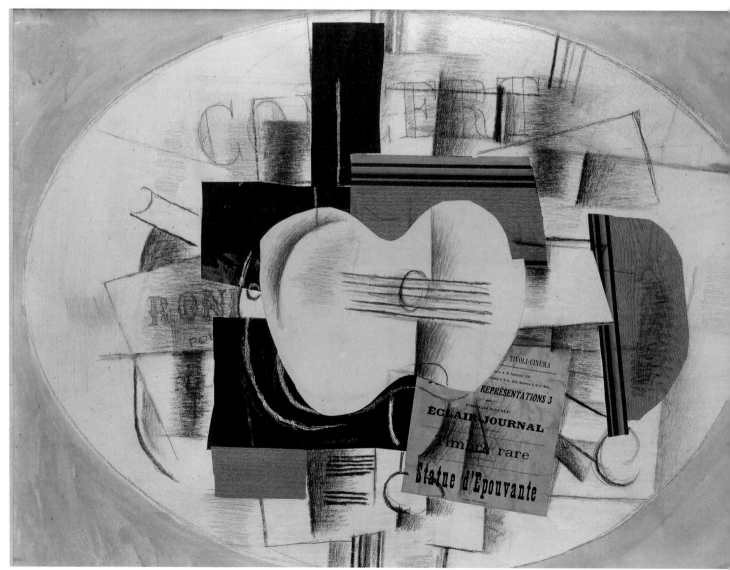

ALPHONSE MUCHA

Czech graphic artist and painter who worked in Prague, Paris, Chicago, and New York. For ten years Mucha designed theater posters exclusively for the actress Sarah Bernhardt. He designed the Austrian pavilion for the Paris World Fair in 1900, and also stamps and bank notes. He is best known for posters featuring ethereal women in typical Art Nouveau style.

Art Nouveau motifs This is a preliminary study for a subsequent print. Art Nouveau curling motifs of birds, fruit, flowers, and fish have been outlined using a sharp pencil. The three plates facing us were drawn with a compass. Black watercolor washes and lines of white gouache have been added with a fine brush.

Background color Between the delicate shadows and highlights of these glazed and metal surfaces we see a large amount of the background color of the paper. Look at the two spoons at top right and see how Mucha has suggested that they are so brilliantly shiny they reflect the background color.

Study for Plate 59 from "Documents Decoratifs"
1902
17 x 12¼ in (430 x 310 mm)
ALPHONSE MUCHA

Instruments of Vision

SCIENTIFIC INSTRUMENTS by their very nature must gauge or chronicle precision. Their delicate construction is only as valuable as the measurements they make. In the graphic work of these two great men of science, we see drawing shape the very cause and effect of investigatory thought. From the concept of capturing the infinite to the mapping of microscopic sight, drawing is there to pin the moment down. Newton's drawing of his first reflecting telescope is found among his letters. It is a diagrammatic explanation of how to catch and magnify a star in a mirrored tube.

Hooke's head of a drone fly seen through a microscope may represent the first time man and insect came face to face. The power of this drawing reflects the pure passion of discovery. He counted 14,000 perfect hemispheres, each reflecting a view of his own world—his window, a tree outside, and his hand moving across the light.

ISAAC NEWTON
English scientist, alchemist, mathematician, astronomer, and philosopher. Newton was President of the Royal Society, and Fellow of the University of Cambridge, where he developed his three greatest theories: the law of motion, the law of gravity, and the nature of light and color.

Transparent view Newton's reflecting telescope focused light in a parabolic mirror. It was then reflected up inside the tube and, via a second mirror, into the eyepiece. With dotted lines Newton has drawn his arrangement of elements inside the tube, offering a transparent view. A disembodied eye at the top of the drawing indicates where to look.

Ink lines Several drawings appear among Newton's letters, each one skillfully rendered with the alarmingly matter-of-fact ease of explaining the commonplace. Look how confidently he draws with ink the sphere of this wooden globe by which his telescope rotates. Newton used this instrument to calculate the speed required to escape earth's gravity.

Newton's Telescope
1672
ISAAC NEWTON

ROBERT HOOKE

An experimental scientist who drew many of his discoveries. Hooke invented the camera diaphragm, universal joint, a prototype respirator, clock balance, and anchor escarpment, and calculated the theory of combustion.

Magnifications This acutely detailed engraved drawing is taken from Hooke's Micrographia (pub. 1665), a breathtaking book containing many of his drawings showing some of the first microscopic and telescopic magnifications of our environment. Hooke's text and illustrations carry us to the moment of discovery. It is an exhilarating read.

The Eye and Head of a Drone Fly
1665
11½ × 10⅝ in
(294 × 270 mm)
ROBERT HOOKE

Schem:XXIV.

Bench Marks

WHEN WE DRAW A COMMON OBJECT like a chair, its character, craft, and place in the world are truly seen. From component parts we understand how to put it together and make it stand sensible in space. Sarah Woodfine's flat cut-out model plan is a witty and surprising drawing. A renegade from the paper dolls' house, this chair presents us with a clever visual contradiction: deeply drawn shadows tell us it must be solid, while the tabs make us see a flat paper cut-out.

We are left a little confused as to what we should do, and where the chair belongs.

With homey contrast, Van Gogh's tipsy seat is a metaphor for an absent person. Drawn in more-or-less conventional perspective, it has so much familiar personality that it seems to talk to us. Its wobbly gait and squashed symmetry mumble endless homey tales about the life it has seen.

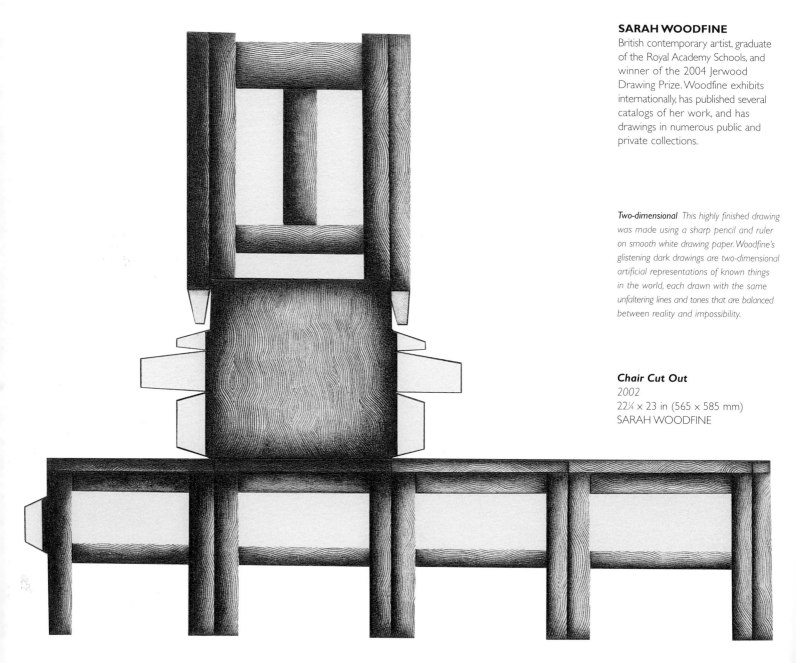

SARAH WOODFINE
British contemporary artist, graduate of the Royal Academy Schools, and winner of the 2004 Jerwood Drawing Prize. Woodfine exhibits internationally, has published several catalogs of her work, and has drawings in numerous public and private collections.

Two-dimensional This highly finished drawing was made using a sharp pencil and ruler on smooth white drawing paper. Woodfine's glistening dark drawings are two-dimensional artificial representations of known things in the world, each drawn with the same unfaltering lines and tones that are balanced between reality and impossibility.

Chair Cut Out
2002
22¼ × 23 in (565 × 585 mm)
SARAH WOODFINE

VINCENT VAN GOGH

Dutch painter who produced over 800 paintings and 850 drawings in only the last ten years of his life. Among van Gogh's best-known canvases are *Cornfield and Cypress Trees*, *Sunflowers*, and *Starry Night*. His passionate brush and pencil strokes are honest and direct in their recording of what he saw and felt, while also describing his inner turmoil and growing alarm at the world around him.

Fierce strokes This is a portrait of a meaningful chair, drawn in the opposite way of Woodfine's mechanical flat plan. Van Gogh drew immediately and almost harshly; he has marked the full emotion of the subject with a fierce grip of concentration. The floor is made present in only a few strokes and is subdued so as not to distract us from our engagement with the chair.

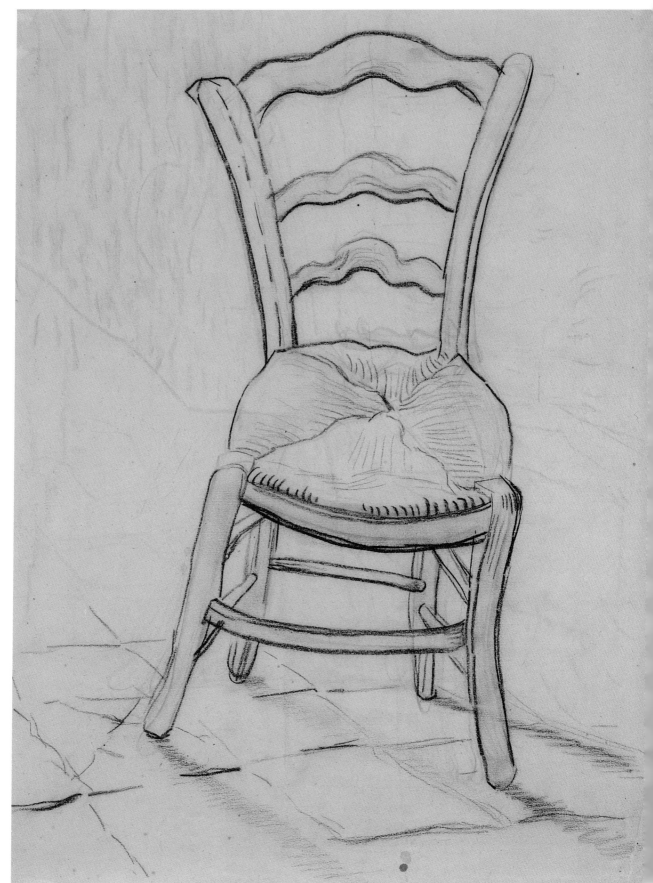

Chair
1890
13 × 9⅞ in (330 × 250 mm)
VINCENT VAN GOGH

Light and Illusions

SEEING IS MIRACULOUS. Upside-down patterns of light on our retinas, transmitted to the brain as chains of electrical impulses, are translated into a world of space, atmosphere, form, and movement. To interpret visual stimulus, our brains search for nameable things, and are quick to propose ideas. We will even see things that do not exist because minimal information suggests they are likely to be there. We only need small prompts; hence our recognition of a cartoon face composed of three lines, and our ability to see forms in clouds or fire.

The outermost edge of our vision, less developed than the center, reads only movement and can often make mistakes. Someone passes our open door, perhaps; we turn our head but no one was there. The slightest recognition is instantly matched to our wealth of experience and expectation, and we can be fooled. Here we look briefly at our perception of light and darkness and our interpretation of diagrammatic illusions. Through these we can enjoy witnessing our own deception and bafflement and understand certain factors that are very useful in picture-making.

LIGHT AND SHADOW

We learn to read light and shadow in our environment as indicators of solidity and depth of space. Artists emulate and manipulate this effect in their pictures. Before starting a tonal drawing of any subject, think about its illumination. Are you happy with what you see? Does the light enhance the subject? Could you alter and improve it? On pp.102–03 deep shadows cast across shells make their form easier to perceive. Below, a lit photograph of an egg shows essential points to observe in tonal drawing.

The egg's darkest region is seen against a lighter background. The two tones meet without a division or outline between.

The bottom-left quarter of the egg lightens slightly toward its "edge" when seen against the darker shadow cast on the paper. The rim of light on the egg is reflected light received from surrounding paper.

The egg's lightest region is seen against a darker background. Run your eye around the circumference of the egg. See how its "edge" smoothly changes from light against dark to dark against light.

Below the bottom "edge" of the egg there is a rim of light reflected onto the paper by the underside of the egg.

Gray squares

The perceived tone of a black, white, gray, or colored surface is never constant. Three factors change it: the amount of light it receives; the adjustment of our eyes (in growing accustomed to a level of light); and the proximity of contrasting tones. Here, two identical mid-gray squares are seen against black and paler gray squares. The small squares are identical in tone, but do not appear so. We perceive one to be lighter than the other. This effect is caused by the contrast of their surroundings.

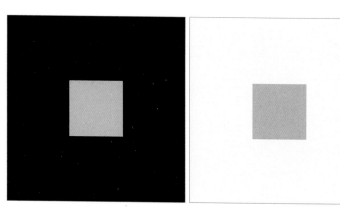

Card experiment

To further examine changes in tone, try this experiment. On a cloudy day, choose a window through which you can see the sky. Take two opaque cards the same size, one black and one white. Tape them to the glass. From across the room both will appear gray against the sky. Remove the black card and fold and retape it with half sticking out. Adjust the angle of the protruding part and again step back. At one point you will catch enough light on the black card to make it appear lighter than the white one.

LINE VERSUS TONE

In linear drawings, thicker lines appear to stand forward, while thinner lines recede. In a tonal drawing, lighter surfaces stand forward while darker surfaces recede. This fundamental opposite is a reason why linear and tonal drawing does not always combine well in the same image. There is no obligation to add blocks of tone to a linear drawing. Often doing so will spoil your work. If you wish to make a tonal drawing, start out with one.

Tonal width

These black and white bands are of equal thickness on either side of their central division. Observe how each white band appears thicker than its black counterpart. In this tonal image we read white as fatter than black.

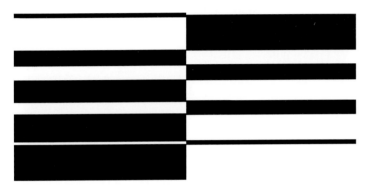

Linear distance

These two jugs have been drawn with lines of differing thicknesses. The jug drawn with a thin line appears farther away than the jug drawn with a thicker line. In this linear drawing we read thick as closer and thin as farther away.

Apparent lengths

These optical illusions show how lines of identical length can be made to look quite different from each other by the addition or association of other lines. Two horizontal lines of equal length are made to look longer and shorter, respectively, by directed arrows (A). An upright line stands in the center of a horizontal line. Both are identical in length, but the upright one looks taller (B). Short horizontal lines of identical length are made to look different by converging lines beside them (C).

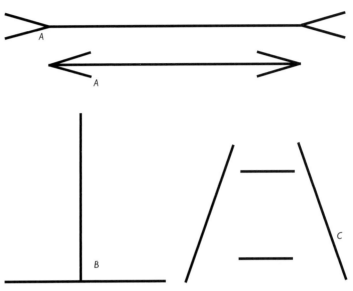

Bending straight lines

Seven parallel lines are made to tilt toward and away from each other by numerous short strokes crossing them diagonally (A). Two relatively thick parallel lines are made to bend away from each other as they pass in front of an array of converging fine lines (B). You may experience something similar happening when you make single-point perspective drawings with a large number of converging rays behind your horizontals.

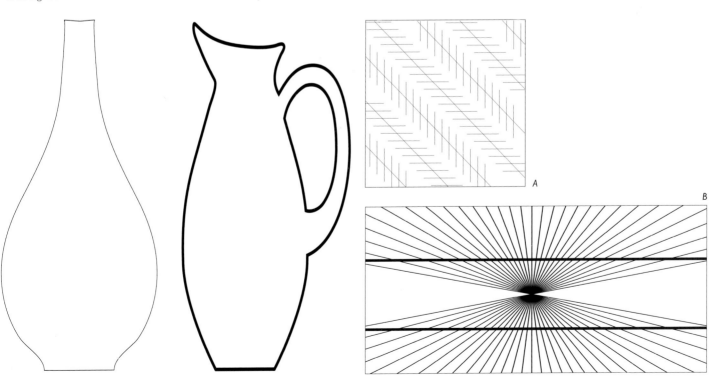

Further Illusions

PSYCHOLOGISTS AND PHYSIOLOGISTS have studied optical illusions for decades in pursuit of what they tell us about the brain. Yet many illusions, including some shown here, are still not agreeably understood. Artists make pictorial illusions when they paint or draw, and we learn to read the styles of diverse cultures and periods. Today we are bombarded with images but rarely have difficulty reading them.

Some artists use known optical illusions to make art; others adjust works to avoid their effects. Ancient Greek architects knew parallel upright lines appeared to bend toward each other in the middle, and so calculated precisely how much to fatten columns to make them appear straight. Michelangelo, among others, perfected the acceleration of perspective (*see pp.116–17*) to make painted figures look correct when viewed from below. In the 1960's, Op(tical) artists, such as Bridget Riley, made paintings that depended upon the physical sensation of our brain's reaction to known optical illusions.

SEEING TWO OPTIONS
Sometimes, when drawing the outline of a three-dimensional form, we will find that in terms of the direction it faces, it oscillates between two possibilities. It is a curious fact that we can never see both options at once; we can only look from one to the other. If an artist is not aware this can happen in their image, their picture could be ambiguous. A few suggestive marks will tip the decision one way or the other.

Closing the surface
When a transparent elliptical object has been drawn, such as the dish seen here on the left, it can oscillate between facing toward or away from us, as shown on the right. Closing the surface of the form seals our decision as to which way it faces.

Two ways of seeing
This is the box created in the fourth step on p.76. It is possible to read it two ways: as a truncated rectangular pyramid seen directly from above; or as a sloping-sided rectangular tray (both are illustrated far right.)

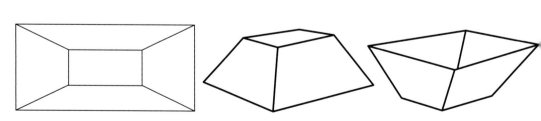

"The brain is so eager to name a fragment we see that we need only a suggestion to grasp the whole. Artists can communicate much in few lines and the viewer will do the rest of the work."

Impossible objects

These clever configurations of outlines and tonal surfaces convince us at a glance that we are seeing a solid three-dimensional triangle and a three-pronged fork. Only on closer inspection do we realize that these objects are fooling us. Yet still we try to resolve them. The artist M. C. Escher used this phenomenon to great effect in his many popular drawings of puzzles and impossible buildings.

Familiarity in random shapes

The Rorschach test was established by the 19th-century Swiss psychologist Hermann Rorschach. His highly disputed and imprecise science involves showing unprepared patients ten particular ink blots and asking them to interpret what they see. The patient's answers are then diagnosed as a psychological profile. The test explores our normal determination to find things we can name among random shapes. Some artists use ink blots to prompt the beginning of an image. We should remember that our brains will always search for a picture—in ink blots, clouds, smoke, etc.—and so the artist can create much out of an impression without overdescribing.

Seeing things that are not there

Here on the left, we see two overlapping triangles: one outlined in black beneath another in solid white. Neither triangle exists, but we believe we see them because enough fragmentary information is given for our brains to conclude they are very likely there. Below is a brightness contrast illusion. Count the number of dark spots you can see. This effect can occur naturally when looking at a brightly lit white grid such as a window frame against the night sky.

Perceiving a whole image from minimal lines

This is a widely reproduced visual joke attributed to the Carracci brothers,16th-century Italian painters. They are often credited with the invention of the comic cartoon. This simple five-line drawing is of a Capuchin priest asleep in his pulpit. Minimal-line jokes such as this rely upon the contemporary viewer's recognition of the shapes. Coupled with the Rorschach blot above, this is another example of the viewer's brain being willing to do a large amount of the work in deciphering a picture. These examples illustrate how little is needed to convey an image. Much can be expressed in only a few marks.

How to Draw Ellipses

WE VISUALIZE CYLINDRICAL VESSELS, such as bowls and cups, as essentially circular, since this is how we experience them in everyday use. However, when seen at an angle, circles change into ellipses, and these narrow or widen depending on the height of our view. To make a cylindrical object appear real in our pictorial space, we use ellipses to give a sense of perspective. Be aware, though, that this is only one way of seeing. Cubism, for example, (*see p.90*) takes a different view, describing many sides of an object simultaneously.

Ellipses are best drawn quickly, smoothly, and in one bold stroke, even if your hand wobbles a little at first. A wobbling but confident ellipse will still be more convincing than a slow, hesitant one that has edged its way nervously around the vessel's rim.

COMMON ERRORS

When drawing cylindrical objects in perspective, for example plates or bowls on a table, there are three common errors people stumble upon. I have drawn these for you here.

The first common error is to draw two pointed ellipses, giving the cylinder four corners, like a disposable plastic cup that has been crushed in your hand.

The second common error is to tilt the upper and lower ellipses at different angles, suggesting that the vessel is lopsided. I have exaggerated this error here.

The third common error is to draw upper and lower ellipses with different-sized apertures, as if the table surface slopes upward beneath the vessel, while its upper rim remains level.

WHERE TO START

In the air above a spacious sheet of scrap paper, spin your hand in a relaxed circle. Watch the tip of your pen and see it draw an ellipse in the air. Keep this movement going while gently lowering the pen onto the paper, like the needle of a record player closing on the disc (only it is your lowering hand that spins, not the paper!) As the pen touches down, keep it spinning. Don't worry if it is uneven—just try again; you will achieve steadiness with practice. Cover a sheet of paper with spinning, springlike forms like those I have drawn below.

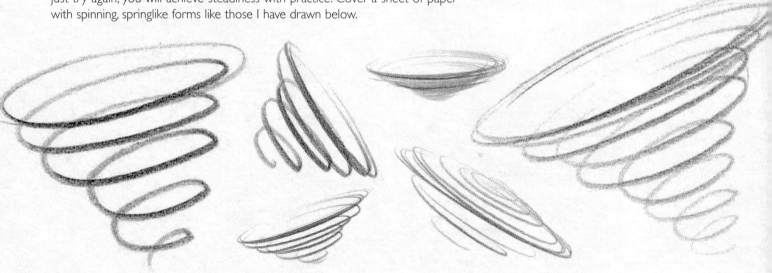

DRAWING VESSELS

Once you have mastered drawing free-hand springs, you can start to control your spinning ellipse to make a vessel.

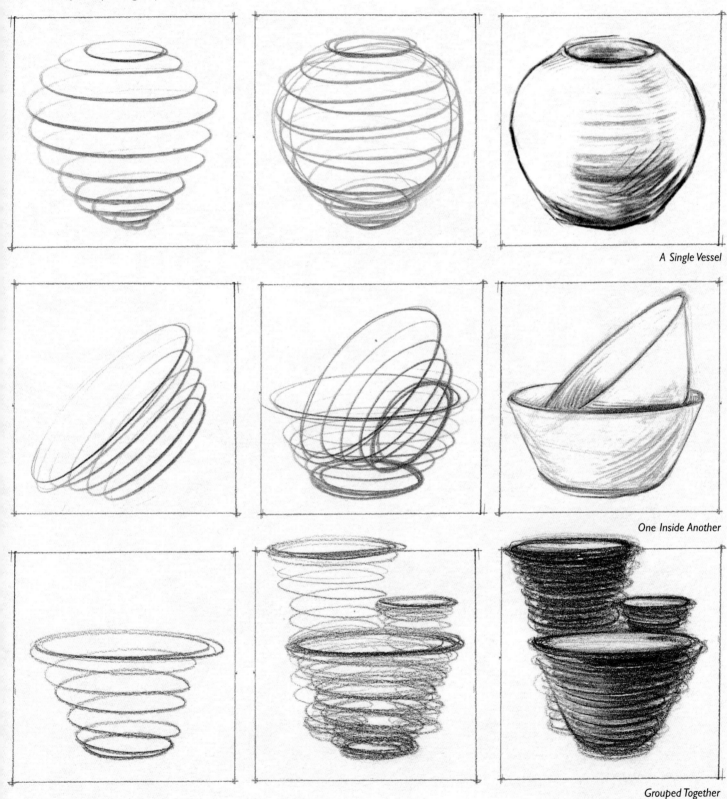

A Single Vessel

One Inside Another

Grouped Together

Finding Shape and Volume

Draw an imagined vessel in one continuous spinning line. Draw quickly, working from top to bottom, enlarging and diminishing the ellipse to determine the overall shape and volume.

Seeing Through

Allow lines to travel around each vessel as if it were transparent. Altering the pressure—and therefore tone—of the line as it spins gives the impression of light shining on one side.

Create a Solid Surface

Once you have drawn the shape and volume of each form, you can make it solid by building up highlights and tones on visible surfaces, thereby hiding lines that show the other sides.

Tonality

WHEN MAKING A TONAL DRAWING, there are principally two opposite methods of achieving the same result. You can begin with outlines and build slowly from light to dark (*see opposite top*), or you can begin with a mid-gray ground and model light out of darkness (*see opposite bottom*).

Start by arranging a choice of shells on a sheet of paper to your left if you are right-handed (or vice versa). It is important to place them on the correct side so as to draw comfortably (*see pp.22–23*). Illuminate them with a gooseneck lamp placed very close and directed away from your eyes; if light shines in them, it will inhibit your perception of tone.

Dramatic lighting emphasizes texture and contour, making complicated or subtle surfaces easier to see and understand. It maximizes the range of tones between black and white, and strong contrasts are easier to draw. Remember that shadows, beams of light, and solid objects are all of equal importance. In the finished drawing there should be few, if any, outlines, simply shapes and subtleties of light and dark meeting each other with no divisions in between. Draw the largest and most distinct areas of light and darkness first. Gradually hone your drawing, leaving detail until last. Relaxing your eyes out of focus as you draw will help to dissolve the distraction of detail.

LIGHT TO DARK

DARK TO LIGHT

LIGHT TO DARK (LINE TO TONE)

1 | Using a sharp HB pencil, draw a rectangle. Remember that its size, shape, and edges are important aspects of your composition (see pp.56–57). Use quick, loose, pale lines to roughly place the shells inside your frame.

2 | Hone the shapes and angles of the shells, defining the spacial relationships between them. Treat positive form and negative space with equal importance. Erase and make changes until you are happy with your composition.

3 | Gently dissolve outlines so that areas of light and dark meet without a line between them. Fill in broad areas first and leave all detail until last. Relaxing your eyes out of focus will help to eliminate distracting details.

DARK TO LIGHT (TONE TO TONE)

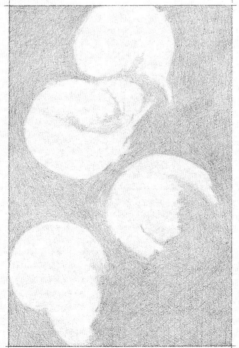

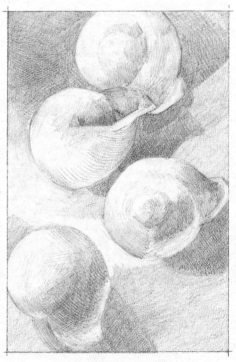

1 | Using the flattened tip of an HB pencil, gently layer marks to create an even tone of mid-gray within a rectangle. Avoid a rough texture and do not press the graphite hard into the paper or you will not be able to erase it.

2 | Let your eyes go out of focus while looking at your subject and paper. Draw the most significant areas of light in your gray rectangle with a white plastic eraser. Ignore all detail and draw boldly with broad sweeps of the eraser.

3 | Keeping your eyes out of focus, look at the main areas of darkness. Use your pencil to develop these in relation to the areas of light. Continue working between light and dark to refine the drawing. Draw in the details last of all.

Drawing with Wire

DRAWINGS DO NOT HAVE to be two-dimensional. They can also be made in space. On p.69 we see how the architect Antonio Gaudi drew proposed domes using suspended wires and weights, and on p.220 Mamoru Abe draws with forged steel rods. On p.176 the British artists Noble and Webster draw with domestic refuse in a beam of light, and on p.19 Picasso draws with a pen-light for the camera.

This class uses thin-gauge wire to create a three-dimensional violin. There are essentially three lessons to be learned. The first is that figurative and abstract drawings can be made in space. The second is that after achieving this simple example, you can create your own more ambitious works. Third, three-dimensional drawings teach us about the totality of forms in space, and physical relationships between them. When drawing anything viewed from one side on paper, our image is stronger if we understand and can visualize what is happening on the other side too. Seeing through a wire drawing of a known object such as a violin gives us a visual and tactile understanding of all its sides and shapes at once.

PEN LINES

Once you have created your three-dimensional violin (*opposite*), try drawing it with a pen on paper. Use bold, smooth, continuous lines. Place the instrument on a plain surface and illuminate it with a desk lamp to add the delicate dimension of shadows.

SETTING UP

Follow these steps to draw a three-dimensional violin. Choose a gauge of wire sturdy enough to hold the shape of your finished drawing, but thin enough to be easily manipulated in your fingers. Here, I used garden wire and cut it carefully with pruners.

1 | Decide how big to draw your violin relative to the gauge of your wire; thin wire will make a smaller drawing, and thick wire a larger one. Cut a length, and pinch and bend it to shape the base of the instrument.

2 | Repeat this process to make the identical upper side of the instrument. Join the two sides together with four short pieces of wire. These will hold the sides apart and help to keep the form in shape.

3 | If needed, brace the two ends of the violin with a length of wire along the back. Then begin to define its uppermost surface with S-curves and the bridge.

4 | Once you have completed the body, begin to shape the curvature of the fingerboard. Here, I started with the scroll at the top and fixed the four component wires with two drawings of tuning pegs.

Artifacts and Fictions

IN 1993 I WORKED with a group of schoolchildren who were responding to the astonishing objects in the collection of the Pitt Rivers Museum, Oxford, England. Using found materials, they invented new anthropological finds—objects that reflected the distant past and their immediate future. I had the privilege of drawing their inventions, some of which are shown here.

RIGHT: a tool for "stamping the ground after planting seeds".

BELOW: an electrical device for "encouraging sunflowers", both invented by girls.

This spiky horror is a
"whirling tooth extractor"
invented by a small boy.

Two different drawing styles
document each fictional object:
a technical explanatory line, and
expressive lines that crawl all over
the knurled surfaces.

The Body

OUR BODIES MAKE US TANGIBLE, and we draw ourselves to assert our existence. We are the only creatures on Earth that can make our own image. The human body, clothed or nude, is the most common subject in art. It gives physical and emotive form to religious narratives, myths and fables, history paintings and other stories, portraiture, and anatomical and erotic art.

Artists are thought to have begun drawing from the nude during the Italian Renaissance. In this period, the junior workshop apprentices posed as part of their duties. Drawings were usually made from the male nude to avoid offending the church, and because the female was deemed inferior. Look closely at Renaissance drawings of the female body and you will see that most are actually young men with minor adjustments. During this time, artists also tried to define ideal proportions in the body; Leonardo drew a man within a circle and square, while Dürer took his research further— he sought perfection in the infinitesimal measurement of the body and produced four volumes of illustrated explanation. Renaissance artists studying anatomy from dissection were decades ahead of their medical counterparts. Michelangelo attended dissections to perfect his understanding of surface form, while Leonardo opened the body to see and discover for himself our physical mechanisms. He even believed he had located the soul in the pituitary fossa beneath the brain and behind the eyes, giving physical foundation to the theory that the eyes are the windows of the soul.

Life drawing no longer dominates the art school curriculum, but the study of the body is still essential. These classes are popular around the world, and in San Francisco, the Bay Area Models' Guild holds a quarterly life-drawing marathon celebrating the great diversity of human proportion. The body remains at the core of much Western contemporary art. Strangely, in our privileged and comfortable society, focus has turned to the vulnerability of flesh: how it can be damaged, diseased, and surgically rebuilt. Artists now explore the interior of the body with new media and technology, from video and X-ray to thermal imaging. This chapter addresses issues that are most commonly faced by beginners attending life-drawing classes. It also looks at the representation of the body beyond traditional life drawing, explaining ranges of materials and techniques and showing diversities of thought and purpose in making.

A. R. WILLIAMS
Contemporary photographer, clinically trained and specialized as a medical illustrator. Williams made this image by light sectioning: fine beams of light projected onto a woman's body draw the celebratory contours of her form like a cartographer's map of undulating land. We understand every curve and balance of her impressive presence because we are given such a controlled, sculptural description of her form. She could easily be transferred into three dimensions. This finished image was produced as a print on Kodak transfer paper with green-colored dye added over the initially white lines.

Lateral Contour Map of a Full-Term Primipara Produced by Light
1979
11¾ x 7 in (300 x 180 mm)
A. R. WILLIAMS

Postures and Poses

THESE DISTINCTIVE WORKS show two strikingly different ways of modeling the body on paper. Raphael drew delicate tones of black chalk on tinted paper, while Matisse used scissors and glue to cut out and paste a flat collage of brilliant color. Principal figures mirror each other. They both raise one arm to cup their head in their hand, while supporting the weight of their body with the other. But the meanings of each gesture and the materials and methods by which they were made contrast greatly. Raphael's study of fallen men leaves no doubt that they are in anguish. In a single drawing we see equally observed studies of foreshortening (*see pp.116–17*), anatomy, and human defeat. By way of contrast, Matisse's blue nude sings with life and celebration. In this highly sophisticated abstraction, we see the essence of her beauty without a single detail. She unfolds and stretches shapely limbs, filling the page with her presence.

RAFFAELLO SANZIO (RAPHAEL)
Italian High Renaissance painter. Raphael is best known for his images of the Madonna and Child, altar pieces, and Vatican frescos. He trained under Perugino, and studied to learn from the works of Michelangelo and Leonardo besides whom he was soon ranked.

Sculptural frieze *This is a preparatory drawing for Raphael's painting of the Resurrection of Christ. Here three male nudes are compressed into very shallow pictorial space, so that we read this drawing like a sculptural frieze. Muscular dramatic postures reflect the influence of Michelangelo and the Renaissance celebration of the idealized male body.*

Three Guards
1500–20
9¼ x 14⅜ in (234 x 365 mm)
RAPHAEL

HENRY MATISSE

French painter, draftsman,
printmaker, sculptor, designer,
writer, teacher, and principal
exponent of Fauvism—a
movement established in
1905 in which bold color is
the most essential element.
Matisse became an artist
after studying law. His
calligraphic abstractions of
natural form grew brighter,
freer, and more energetic
as his work matured.

Color and form This collage is
one of a series of Blue Nudes,
found among many other groups
of spectacular and sometimes vast
papercut drawings. Matisse made
these works as an elderly man
confined to his bed or wheelchair.
They celebrate the culmination of
his lifelong love of brilliant color,
pattern, fabric, and Islamic art.

Soothing influence This drawing
expresses the achievement of
Matisse's personal aim: "What I
dream of is an art of balance, purity,
and serenity, devoid of troubling or
depressing subject matter…which
might be…like an appeasing
influence, a mental soother…or
like a good armchair in which
to rest from physical fatigue."

Blue Nude 1
1952
41¾ × 30¾ in (106 × 78 cm)
HENRY MATISSE

Choreographs

TIME IS A SIGNIFICANT ELEMENT in the making of all drawings. Here, we compare a skillful design that absorbed much time in its making with the quickness of an idea marked instantly.

In his famous paintings of social engagement, Seurat evolved a distinctive technique called pointillism—images literally made from myriad points of color. His drawings are similarly unique. Typically, he used black conté (*see p.162*) and an eraser to model teeming points of artificial light amid velvet darkness. Below, in a perfect example, it is as if the very atoms of air are made visible, agreeing to coalesce and show us the form of a waiting boy, who sits propped in the contradictory darkness of a hot summer's day.

Opposite, Beuys's magician, scratched in seconds, stands in counterpoise holding a dark globe and his thoughts in momentary balance. The space around him chatters with symbols, like small birds attendant on the meditation.

GEORGES SEURAT
French painter classically educated in the Ingres school of thought. Seurat engaged in lifelong studies of line, form, and color. His applied theories still influence painters in their manipulation and rendering of local, reflected, and complementary hues.

Tone and light In this black conté drawing, there are no outlines, only tones blending into, or abruptly meeting, other tones. Light is given by the paper alone. If Seurat had added white, it would have mixed with unseen black dust, turned gray, and muddied the brilliance of the drawing. Using the paper to create light is important for beginners to learn.

Seated Boy with a Straw Hat
1883–84
9½ x 12¼ in (241 x 312 mm)
GEORGES SEURAT

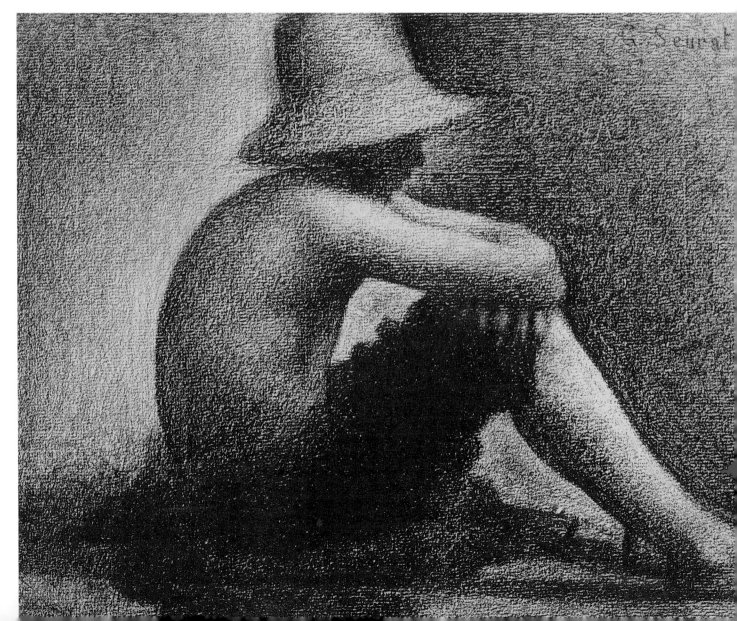

JOSEPH BEUYS

One of the most influential German artists of the 20th century. Beuys gave performances, taught workshops with a cult following, and made installations, video art, and drawings. He was a shaman who believed in the profound power of intuition and in the investment of materials with spiritual or healing force.

Free lines This pale pencil drawing is rather conventional for Joseph Beuys. Many of his other works on paper have been drawn with symbolic materials such as honey, iodine, gold, and blood. This figure is drawn intuitively, free from the constraint of immaculate representation. Perfectly modeled form (as we see in Seurat's drawing opposite) is irrelevant to the impetus and meaning of this work.

Focus Beuys's hand moved quickly to draw dotted lines flowing downward on either side of the figure. Unbroken lines stream from his shoulders. His arms are seen simultaneously in different positions. These aspects of the work convey movement, transience, and fractured visibility. Our focus joins that of the magician's on the globe.

The Secret Block for a Secret Person in Ireland
UNDATED
11¾ x 8¼ in (297 x 210 mm)
JOSEPH BEUYS

Passion

SUMMONING HUMANITY in a drawing of the nude is a subtle and emotional task. Our bodies radiate the passion of our thoughts and so become beacons of our frailty and power. In Rodin's work, the fierceness of the women's kiss is beautifully matched by the tenderness of his line. They whisper and writhe in a brushed and sultry embrace that devours our watching. We are involved not as a shabby voyeur but as a bystander engaged through our recognition of shared joy.

Opposite, Anita Taylor has drawn her protective body hug out of the darkly glistening compression of willow charcoal and the dynamism of her shy but momentous femininity. We are asked to gaze upon her flesh; its soft, flushed skin made ruddy and black with crushed cinders. In both drawings, the women are framed and caressed by long, sweeping lines—of either purple silk fabric or cool studio air—that imprint and amplify their past and future movements.

AUGUSTE RODIN
French Romantic sculptor and prolific draftsman employed as an ornamental mason until the age of 42. Achieving international acclaim in mid-life, Rodin produced portraits and statues of public and literary figures. Inspired by Michelangelo his work is characterized by deliberate un-finish and powerfully modeled emotion

Delicate strokes This is one of about 7,000 drawings shown in rotation at the Musée Rodin, Paris, and one of hundreds of rapid studies of nudes. Rodin employed models to move freely or pose together in his studio. As here, he typically drew them with a few delicate strokes of pencil and brushed watercolor.

Free lines Rodin's public audience was understandably shocked by the eroticism of his drawings. But what is stranger to us now is that they were also outraged by his free use of line. His exquisite flow of paint beyond "outlines," as seen here, was perceived as scandalous, and went on to inspire generations of artists.

Two Women Embracing
1911
12⅝ x 9 in (320 x 229 mm)
AUGUSTE RODIN

ANITA TAYLOR

Painter, draftsman, professor, and Vice Principal of Wimbledon School of Art, London. Taylor's immense self-portraits explore the relationship between the artist as maker and the artist as model, intimately reflecting upon the emotions and meaning of nudity, exposure, scrutiny, and gaze.

Charcoal *Taylor has drawn freely with charcoal and an eraser on thick, textured paper. The sturdy surface of the sheet has allowed her to press hard when needed, and rework rich depths of light and tone. A thinner sheet might have crumpled and torn under such vigorous force of making.*

Luminosity *Layered marks flicker like firelight as they sculpt the woman's body. Taylor has drawn, erased, and drawn again, leaving her lightest marks at the deepest level of the image and applying darker marks above. This order of light below and dark above gives the impression of luminosity glowing from within.*

All and Nothing
1999
67 × 44⅞ in (170 × 114 cm)
ANITA TAYLOR

Measurement and Foreshortening

FORESHORTENING IS AN ASPECT of perspective. In the life class it is the mechanism for ensuring that a drawn figure lies correctly in pictorial space – limbs happily receding, or coming forward, without taking off, plummeting, or shrivelling at odd, unfathomable angles. It is not so hard; patience, persistence, and a few measured comparisons are key. How to make and apply these is explained below and opposite.

We also look at another very interesting branch called accelerated (or anamorphic) perspective. This is chiefly a correcting device by which figurative painters and sculptors have for centuries countered the effects of our viewing their work from far below or on the curvature of a vault. Imagine Michelangelo's murals in the Sistine Chapel, Rome, with dramatic illusions of figures painted in normal proportion.

But if we could take a scaffold and climb up to the work, we would arrive to find many of the same figures strangely distorted, elongated as if stretched across the plaster. Up close on the scaffold we would witness Michelangelo's subtle application of accelerated perspective, which is imperceptible from below. Smaller, more extreme examples have been made for court entertainment, to be translated by mirrors or seen from only one point in the room; for example, the skull in Holbein's *The Ambassadors* (The National Gallery, London).

Accelerated perspective plays a great role in much art. It can also be a little demon in the life room, when beginners prop their board in their lap and look down at too steep an angle. To avoid its effects ensure you always look flat onto the surface of your page.

MEASURING

This is a simple method of making measured comparisons for relating the true size of one part to another. This is a tool to assist observation and thinking. It is not complicated, and measurements do not have to be carried to the paper and slavishly drawn the same size they appear on your pencil.

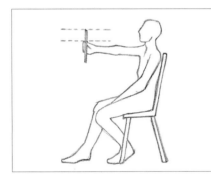

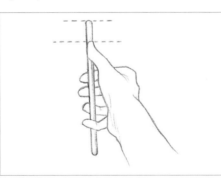

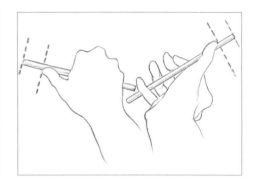

1 | Hold your arm straight. Lock your shoulder, elbow, and wrist joints. If your arm is not straight, you will make inconsistent and unrelated comparisons. Return to this posture every time.

2 | Hold your pencil upright. Align the top with a point on your subject. Close one eye. Move the tip of your thumb down to a second chosen point. The length of exposed pencil is your measurement.

3 | Keep your pencil perpendicular. Measure and compare at any angle. Spend time making comparisons before you draw. There is no need to mark them all down on paper; just making them helps you see.

"Simple measured comparisons reveal surprising truths about proportion, helping us to see more clearly, and to draw what we see, rather that what we believe we know from experience."

ACCELERATED PERSPECTIVE

To discover how this works, tape some paper to a board. Stand its bottom edge on your lap. Lean the top edge toward you and find a position where you can comfortably look down the paper at an angle of about 40 degrees. Keep the board steady and draw. To make forms look correct, your hand travels farther than you expect, which feels strange. Proportions will only look correct from the angle at which you make the drawing.

Tilt the top edge of this book toward you and look down on this figure from above. At a certain angle, her proportions will appear correct.

This is the same drawing photographed from above, looking down the paper at the angle at which I drew. We appear to be looking down on a woman standing beneath us.

FORESHORTENING

To foreshorten a figure, you must let go of what you know from experience about the relative sizes of body parts and trust your eyes. Look at your model as if he or she is a flat series of shapes one on top of another. Measure the height and width of each shape and compare it to its neighbor. Work around the figure, adjusting anonymous shapes. Soon the body will lie down in space, pleasingly foreshortened.

Compare the heights of the nose and eye shapes to those of the forearm, belly, and thighs. See how different the relative heights of these shapes are from what we might expect in real life.

Quick Poses

DRAWING QUICK POSES locks your concentration onto what is most essential, propelling you to make immediate assessments and trust them. Start each new drawing by lightly marking the model's height with a loose line in ten seconds, working from her center to her feet and to her head. This quick exploratory line does not perfectly describe shape but expresses a decision about overall flow of form, balance, and height. Be bold and dive into your drawing with confidence. Layered lines give depth, feeling, and energy. Leave first thoughts in place, and work over them with further observations.

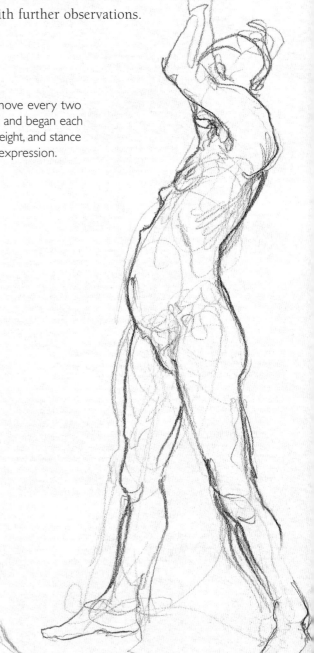

SEQUENCE OF POSES

Here the model was asked to move every two minutes. I used a sharp HB pencil and began each drawing by marking her outline, height, and stance before honing her balance and expression.

Outline
To outline a figure, work back and forth across the body. Avoid drawing up one side and down the other, because it results in two unrelated sides drifting apart.

Balance
When a model stands upright on both feet, her center of balance is normally found in a vertical line beneath her head. To see this, imagine holding up a plumb line.

Height
This pose leans away into space above our eye level. To draw this effect, make the upper body smaller, give your model a high waist, and slightly enlarge her legs and feet.

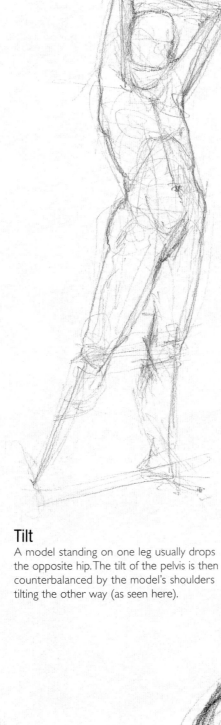

Twist
The twist of a model is most easily and expressively captured if it is exaggerated. Most of us have a tendency to over-straighten the drawn figure, and this should be avoided.

Tilt
A model standing on one leg usually drops the opposite hip. The tilt of the pelvis is then counterbalanced by the model's shoulders tilting the other way (as seen here).

Movement
Here, the activity of circular lines and the repetition of limbs suggest movement. This drawing shows how different observations can be overlaid to bring a drawing alive.

Hands and Feet

THERE ARE MANY different ways of approaching hands and feet, and they need not be daunting to draw. This exercise is useful when struggling with proportion. It also helps the beginner to progress from drawing outlines to drawing confidently across the surface of the whole form.

Practice by drawing your own hands and feet, or those of a friend. A mirror increases your range of views, and a gooseneck lamp casts shadows that clarify planes and depths of form. When starting, it is important to leave aside all details of the fingers and toes, especially the lengthwise divisions between them. Focus instead on how planes change direction across the knuckles from one side of the hand or foot to the other. These planes, drawn in relation to each other, express structure and gesture far more successfully and easily than ten worried outlines wandering up and down between the fingers and toes.

GESTURES OF THE HAND

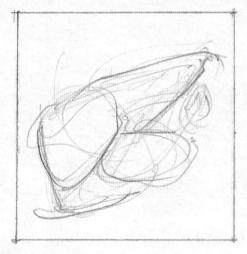

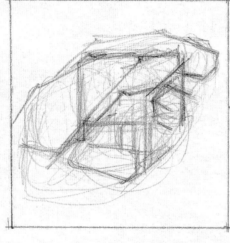

Curled Fingers

Open Palm

1 | Begin by drawing lines to encompass the whole hand, swiftly marking its essential gesture. Draw large shapes and their orientation. Group the fingers together as one mass. Do not separate them yet, and ignore all details.

2 | Start honing the shapes of the dominant planes, starting with the largest. Then subdivide each shape so that you work from large to small, general to specific. Keep lines open to change and take measurements if they help.

3 | Build your drawing gradually from light to dark. Don't worry about achieving perfect solutions, but regard these practice studies as ongoing processes of thought and observation. Add details such as nails last if you wish.

MOVEMENTS OF THE FOOT

Flat Stance

Raised Heel

Instep

1 | Let your first marks be light, loose, and rapid. Leave aside all detail, and don't worry about accuracy to begin with. Try to express the whole foot and to encapsulate its entire shape and direction in a few marks.

2 | Now imagine you are carving the foot inside the paper, as though out of wood. Hew it roughly at first in broad, flattened planes, as if with a chisel. Look for key angles without becoming distracted by detail.

3 | Use an eraser to refine decisions or to suggest areas of light. It can be a mistake, however, to remove too many early lines; these are what give a drawing its tangible structure, depth, and spontaneity.

Charcoal Hands

THESE DRAWINGS ARE MADE in compressed charcoal. Compare
its nature in close-up to that of willow charcoal used on pp.204–05.
Opposite, I also used white ink with a steel dip pen.
The white lines demonstrate what is often
called "bracelet shading."

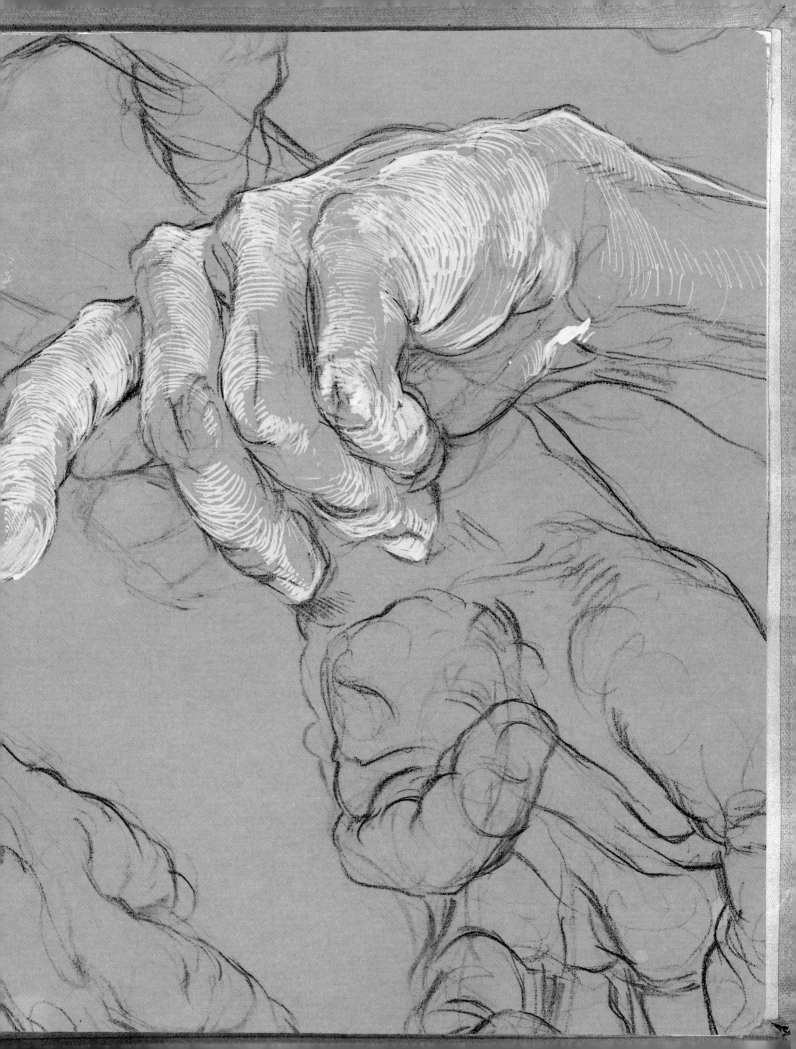

Phrasing Contours

HERE TRACES OF RAPID initial lines are still seen within and outside
each body. I make these lines in the first five to ten seconds of a drawing
to locate the presence, length, and posture of the model, before honing
his or her shape (*see pp.118–19*).

Note how details of this model's
face & hair are only loosely suggested and
kept a little out of focus so as <u>not</u> to
dominate the expression of the pose.

Lines drawn in close contact with each model's
skin are phrased in groups and layered in different
directions across the body. These locate surfaces, shadows, &
textures. They follow the contours of form, gently
varying in — pressure (TONE), length, crispness (FOCUS),
and number of layers.
Consequently, they never appear harshly crosshatched

The Visual Detective

DRAWING FROM MASTERWORKS was once a staple component of an artist's education. It is now viewed with some skepticism and often seen as academic. I draw in museums in support of written research and as an artist seeking answers to questions about the practicalities of image making. Drawing work by another artist enables you to discover and understand the inventive hand in their composition. Forms, characters, perspectives, and narrative pulse become vivid when you realize them in the middle of your study, feeling them through the attentive movements of your own hand.

Here I drew a painting by Rubens, to see how he twisted near life-size figures through his complex pictorial space. In my studio I was making enormous drawings of imaginary museums and was struggling to place near life-size figures within them.

What I learned from Rubens helped me to resolve particular challenges I faced in my own studio. From these studies I discovered a technique of looking up at, and down onto, different aspects of an active body simultaneously. Soon after, I achieved my first convincing standing figure (see pp.128–29).

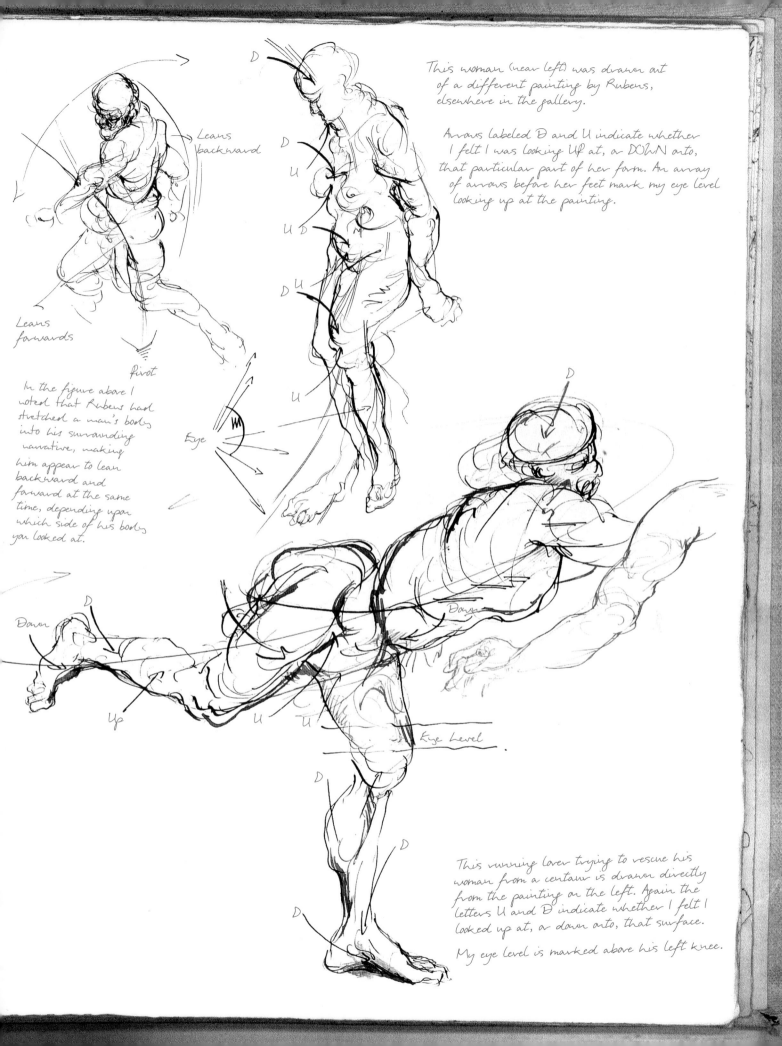

Leans
backward

L

Leans
forwards

Pivot

In the figure above I
noted that Rubens had
stretched a man's body
into his surrounding
narrative, making
him appear to lean
backward and
forward at the same
time, depending upon
which side of his body
you looked at.

D

D

U

U D

D U

U

Eye

This woman (near left) was drawn out
of a different painting by Rubens,
elsewhere in the gallery.

Arrows labeled D and U indicate whether
I felt I was looking Up at, or DOWN onto,
that particular part of her form. An array
of arrows before her feet mark my eye level
looking up at the painting.

D

Down

Down

Down

D

Up

U

U

Eye Level

D

D

This running lover trying to rescue his
woman from a centaur is drawn directly
from the painting on the left. Again the
letters U and D indicate whether I felt I
looked up at, or down onto, that surface.

My eye level is marked above his left knee.

La Specola

AT 17 VIA ROMANA, Florence, there is a unique museum of 18th-century anatomical waxes. Walls are lined with hundreds of faintly animated body parts, each modeled from dissection. Life-size women wearing wigs recline on beds of embroidered silk in cabinets of mahogany and Venetian glass. This is a detail of a compressed charcoal drawing measuring 14 x 10 ft (4.3 x 3 m) made in response to La Specola. These almost life-size figures were composed from my imagination and achieved with the help of studies discussed on *pp.126–27.*

Portraiture

IN PORTRAITURE WE MEET PEOPLE, usually strangers from past times, who, having been documented and preserved, look directly at us, or past us, or whose eyes can seem to follow us around the room. Portraiture is a constant, live, and lucrative genre for artists. The truth is that we all like looking at faces and observing the billions of variations that make us individuals. We are also reassured by keeping records of ourselves. Halls and palaces are filled with pictures of the mighty and significant. Our homes are filled with images of our loved ones and of those in our families who have gone before.

Past rulers sent painters across continents to bring back a likeness in advance of a prospective royal marriage. The returning image was of crucial consideration in any proposal. Portraits can be highly or loosely detailed, single or of groups, abstract or figurative, and satirical or metaphorical. We can mold and animate qualities of expression out of objects and fragments of disassociated things—for example, Man Ray's self-portrait of scored lines, bells, buttons, and a handprint (*see p.139*). To create a face is to see and interpret the essence of an identity. When drawing a person, the meaning of their face, their stance, and their posture can be changed with just one line. Equally, a single line can deliver an entire expression.

Goya, in a miniature self-portrait magnified opposite, gathered all that he knew about himself, and in a few scrolling rafts of pen lines and stubbled dots, is here to both meet and look through us. Self-portraiture gives every artist a constant, compliant subject to scrutinize. Rembrandt's famous multitude of self-portraits, made as he passed through the ages of man, became more poignant as he progressed. For centuries, painters have dropped discreet records of themselves into commissioned narratives so that they can remain a face in the crowd. Movie director Alfred Hitchcock similarly signed his films by playing a fleeting role: he walks through a scene as an extra, or a glimpse of him is caught in a photograph used as a prop. Beginners often draw themselves as a way of establishing their practice, and it is very rewarding. In this chapter, we use the delicate medium of silver point to look at foundation structures of the head, neck, throat, and shoulders. Once you understand and memorize the basic structure that we all share, you can capture the subtlety, character, and expression of the individual.

FRANCISCO DE GOYA
Visionary Spanish painter, draftsman, and printmaker. Goya's works include many royal and society portraits, historical, religious, and secular narratives, and social and political commentaries. This enlargement of his miniature portrait reveals the speed and agility of his pen and his changes in pressure and length of line. It also reminds us of both the intimacy and scrutiny of an honest portrait.

Self-Portrait in a Cocked Hat
c. 1790–92
4 x 3 in (102 x 76 mm)
FRANCISCO DE GOYA

Poise

THE BALANCE BETWEEN a mark and a blank space is often a tantalizing form of perfection. The aesthetic sense of a line being just right can make a drawing sing. The rightness of a line is felt in its speed, length, breadth, and pressure as it conducts our eye through the image. Here the grace and beauty of two young women are held forever. We can read so much about them by studying their gaze. Without faltering, Picasso strikes and scrolls his pencil, whisking a timeless girl onto the page. While with longer consideration, Holbein maps the still landscape of Dorothea's body in questioning marks, stealthily using his chalk to find contours and mass, adding smudges of tone for weight and solidity. Her face is drawn tenderly and with a luminous glow. It is the portrait of a countrywoman, caught in her last moments of youth, teetering on the brink of older age, one eye already cast askew into the autumn of her life.

PABLO PICASSO
Spanish Cubist painter (see also p.30). Picasso has left to posterity many hundreds of magnificent line drawings. Through exhibitions and copies in books, we can enjoy and learn from them. For the beginner, they serve as a great lesson that it is not always necessary to add tone to your drawing. How could the addition of shadows have enhanced this image?

Few strokes The simplicity of Picasso's line is breathtaking. He makes his flair and skill look easy. We can actually count that he struck the paper 40 times. There is a common misunderstanding that a drawing with only a few lines is both less finished and easier to make than a drawing with more. The truth is often the opposite. It takes a truly accomplished hand to capture something well in only a few strokes.

Françoise au Bandeau
1946
660 x 505 mm (26 x 19⅞ in)
PABLO PICASSO

HOLBEIN THE YOUNGER

German portrait painter, draftsman, and designer from Basel. Holbein was employed toward the end of his life by King Henry VIII of England. In addition to his numerous exquisite portraits in oil, he designed court costumes, made a popular series of woodcut prints titled *The Dance of Death*, and produced numerous society portraits such as this one here.

Blended colors In this portrait drawn with colored chalks on slightly textured paper, Holbein unified the woman with her background by gently blending colors from her clothes and face into the atmosphere around her. He outlined her nose but not her upper lip, which, gently flushed, presses against the binding across her face.

Cropping This regal composition fits its paper perfectly. Holbein has cropped and pinned his subject within the four outermost lines of the image—the edges of the page. The peak of her cap clips the uppermost edge, and its downward slope crowns the diagonal of the composition. Her folded forearms support and frame her weight above.

Portrait of Dorothea Kannengiesser
1516
15⅛ x 12¼ in (385 x 310 mm)
HOLBEIN THE YOUNGER

Anatomies

These highly finished drawings express the emotional power and physicality of the head and neck. Newsome's eerily shadowed form is smooth and bears a linear grain evocative of wood. It floats in space, solid above and almost hollow below. Psychological drama is contained behind a grid, while white painted flecks and wisps suggest electrical illumination.

The style of Durelli's drawing opposite sings with the confidence of truth and precision, its highly clarified detail claiming to be drawn from observation. In fact, the face is one of the hardest parts to dissect. Delicate muscles are integrated with the skin and fat that is to be removed. Nerves, blood vessels, and glands also complicate form. This is a marvelous interpretation of the truth. The real dissection would have been far more complex, confusing, distorted, and unpleasant to see. Anatomically, Durelli has made a few minor mistakes, but they are irrelevant here.

VICTOR NEWSOME

British sculptor, painter, and draftsman. Newsome was awarded the Prix de Rome in 1960, taught at numerous British art schools from 1962–77, continues to exhibit regularly, and has works in major collections including the Tate Gallery, London.

Contrasts Sharp, dark lines made with a pencil appear against smooth, dark tones of graphite blended into the paper, perhaps using a tortillon. Highlights of white gouache were applied late in the making, using a fine and relatively dry brush. This is one of a number of similar disembodied female heads seen behind, or defined by, the contours of a grid.

Profile Head
1982
13 x 18⅛ in (328 x 460 mm)
VICTOR NEWSOME

ANTONIO DURELLI

Little is known of this Milanese painter and engraver who came from a family of artists. Durelli's experience as an engraver is reflected in his stylized drawing of muscle fibers, which, when contracted, pull their points of attachment toward each other.

Linear perfection This is a red chalk drawing of extraordinary accomplishment. It is hard to think of a more difficult medium with which to achieve such linear perfection. Stylized parallel lines are reminiscent of engravings, and it is likely that this drawing was intended for reproduction as a print. Pencil numbers refer to the list of muscles written beneath.

Red Chalk and Pencil Drawing of the Muscles of the Head and Neck
1837
17⅜ x 14⅝ in (440 x 372 mm)
ANTONIO DURELLI

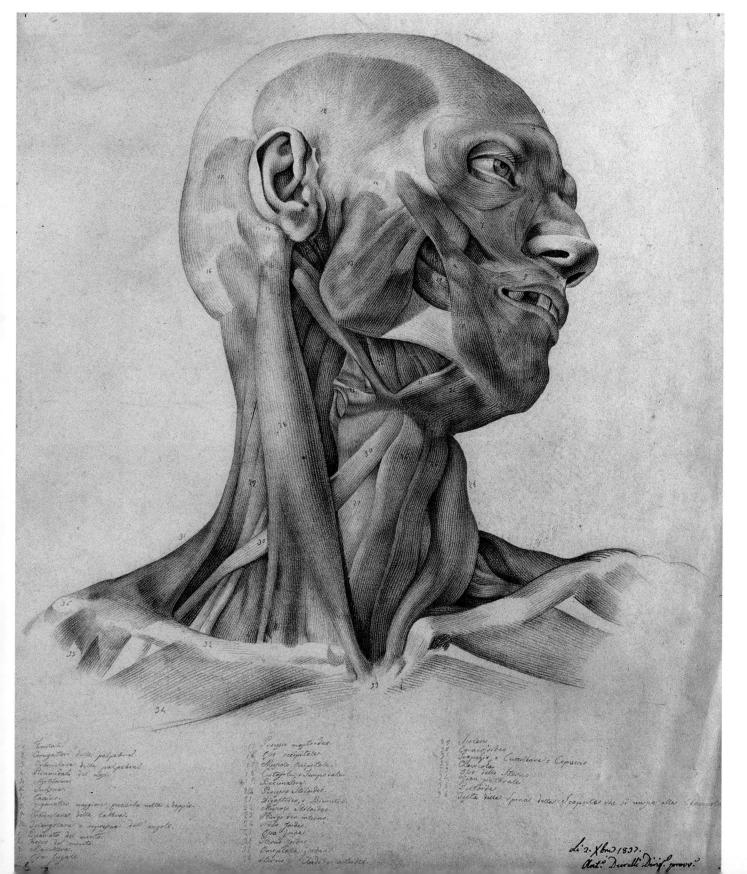

Revelations

THESE ARE DRAWINGS of shoulders, necks, and heads, each locked into a visionary gaze. Both works demonstrate how simple lines can be made complex by being intense. They show us clearly the bones of drawing. Without paint and with very little tone, each portrait is inscribed onto the page.

There is a film of Giacometti drawing. The camera watches him at work, and with staccato flinches his hyperactive eye moves from paper to model, while his hand stabs and thrusts like a conductor's baton. Similar movements sculpted the head below into its page. Agitated marks make patches of tone that cut away the space around the character. Flesh is built and personality carved simultaneously.

Opposite, Bellini gently conjures the features of his saint with soft marks that tease his presence out of shadows into the light. We are brought intimately close to this man gazing up to heaven; close enough to touch his hair and feel his breath.

ALBERTO GIACOMETTI
Swiss sculptor, painter, draftsman, and poet. After studying in Geneva and Italy, Giacometti settled in Paris. He is best known for his bronze sculptures of human form, which are characteristically elongated. They confuse our perception of scale by being intimately fragile and at the same time far removed, as if seen from a distance.

Energy This is a portrait of a woman drawn with black crayon on a plain page of a book. Lines search for the essence of form, cutting and carving the paper with matted and spiraling restless energy.

Speed Giacometti probably began with an oval shape placed in relation to the proportion of the page. Then, with speed and urgency, he drew over the whole image at once.

Portrait de Marie-Laure de Noailles
c. 1948
7⅞ × 6 in (200 × 150 mm)
ALBERTO GIACOMETTI

GIOVANNI BELLINI

A prominent member of a large family of Venetian painters, Bellini studied under his father, Jacopo, and brother-in-law, Mantegna. He preferred religious to classical themes, and his work is distinctively calm, lyrical, and contemplative. He taught Giorgione Barbarelli and Titian.

Transfer *This delicate chalk drawing is a cartoon—not a humorous image but a type of template used to plan the composition of a larger work. Look closely and you will see rows of tiny dots along every significant line in the picture. These are pinholes, which were made in the process of transferring the saint to his final place in the composition of a painting (see Glossary pp.256–59).*

Character *This is one of many cartoons produced by Bellini and his family. Sometimes the same character was reused in different narrative compositions.*

Head and Shoulders of a Man
UNDATED
7⅜ × 2¼ in (186 × 58 mm)
GIOVANNI BELLINI

Self-Portraits

THE MIRROR OF SELF-PORTRAITURE offers artists infinite reflections of, and confrontations with, their most immediate and best-known subject: themselves. It is an opportunity to look deep without the infringement of courtesies owed to a commissioning sitter. It has proved to be a subject of piercing scrutiny, political outcry, humor, and indulgence.

The incandescent New York painter Jean Michel Basquiat pictured himself here in naked silhouette; a tribal, skull-headed, spear-brandishing warrior. It is an image of confrontation—the ever-controversial young artist roars at us from his abstract city-scape.

Man Ray's playful silk-screen assembly of color blocks, scrolls, scratched lines, bells, and buttons rings with surrealist wit and agile improvisation. The artist has finished his portrait with the signature of his hand smacked in the middle like a kiss: a declaration of existence as old as man's first drawing.

JEAN MICHEL BASQUIAT
Short-lived American painter and graffiti artist who began his blazing nine-year career drawing on lower Manhattan subway trains with a friend, Al Diaz, signing their work SAMO. Later, Basquiat sold drawings on T-shirts, postcards, and sheet metal before being snapped up by the New York contemporary art scene. In 1986 he traveled to Africa and showed his work in Abidjan on the Ivory Coast. He also exhibited in Germany and France.

Signs and symbols This painting shudders with symbols that are written, drawn, and scratched into its surface. The figure's position is unequivocal and defiant, while everything around him is in a state of cultural flux. Without the essential figure we would be looking at a sophisticated and elegant painting of signs, marks, and attitudes, similar to work by Cy Twombly (see p.221). Islands of graphic marks, made with great energy, float and shimmer in the shallow pictorial space.

Self Portrait
1982
94 x 76 in (239 x 193 cm)
JEAN MICHEL BASQUIAT

MAN RAY

American surrealist photographer, painter, printmaker, and cofounder of the New York Dada movement. During the 1920's and 30's, Man Ray lived and worked in Paris, where he collaborated with the artist Lásló Moholy-Nagy. They experimented with camera-free photography, working directly onto photographic paper.

Silk and ink This is a silk-screen print made through the following process: the paper was laid on a flat surface and a frame stretched with fine silk was placed on top. The first part of the stenciled image was already marked on the silk. The screen and paper were then held tightly together, while a squeegee was used to drag thick lilac-brown ink across the silk, pushing it though exposed areas onto the paper below. Black ink was printed next and then white. The handprint appears to be made directly, last of all. Man Ray probably used his own hand, caked in thick printing ink or paint.

Frame White lines are seemingly (though not actually) scratched through ink to frame this face. They suggest speed and make the picture look immediate and spontaneous.

Autoportrait
1916
19⅝ x 15 in (500 x 380 mm)
MAN RAY

Silver Point

SILVER OR METAL POINT was familiar to illuminators of medieval manuscripts, who used it to outline initials and border characters before painting. Numerous early European artists also enjoyed its fine qualities (see p.156). Metal point is simply a strip of metal bound in a holder. Drawn across a prepared surface, it leaves a deposit, which quickly oxidizes into a gray line. This browns with age unless sealed by fixative (see pp.54–55). Metal point does not work on ordinary paper; the surface must be primed with a ground such as gouache. Historically, artists mixed white lead, bone, or eggshells with animal glue, laid on paper, parchment, or wood. The most common metal has always been silver—hence the term "silver point." Lead, copper, platinum, and gold have also been used, and alloys work on matt emulsion. Note how domestic paintwork marks with a coin, key, or ring; an exciting indication of how large-scale drawings could be made on a wall.

Opposite, I combined silver point with painted white gouache on a pink ground. This is called a three-tone drawing. Pages 142 to 147 are illustrated in silver point and techniques are explained on pp.144–45.

STRETCHING PAPER

A sheet of paper that has been made wet with the strokes of a paintbrush will buckle due to its uneven expansion. Stretched paper remains taut as a drum, and is therefore useful when using watercolor as well as silver point. Lay a clean drawing board on a flat surface. Take a sheet of any type of paper (for example, white drawing paper) and cut it to fit your drawing board with a generous border around its edges. Tear off four lengths of brown paper gum tape, one to fit each side of the board—these will make the glued frame that holds your paper in place.

MATERIALS

To begin, you will need to stretch paper and lay a wash (see right and opposite), purchase silver wire, and make or buy a holder. If working on an emulsion-painted wall, choose a silver object.

1. SOFT FULL BRUSH: When laying a wash, choose a soft full brush that can carry plenty of liquid. Make sure it is completely clean to avoid unwanted streaks.

2. ZINC WHITE GOUACHE: Dilute with water. Add color if required (as opposite) before priming stretched paper. Gesso or matt emulsion can also be used. It is available from all art shops.

3. SILVER POINT WIRE HOLDER: These can be purchased and tend to be heavy. I make my own from old dip pens. Empty mechanical pencils designed for thick leads (see p.54) can also be used.

4. SILVER WIRE: Purchase different gauge lengths from a traditional art supplier or jeweler. For important advice on preparation and use, see p.144.

5. METAL OBJECTS: All metal objects mark a prepared surface, some more effectively than others. Silver is best. Find an item that you can hold and draw with comfortably.

1 | Find a clean sponge and bowl or deep tray and fill it with water. Wet the paper evenly in the tray or on the board. Lightly sponge off the excess. The paper will look buckled, but don't worry.

2 | Straighten the worst buckles. Wet one length of gum-strip and use it to fix one side of the paper to the board. Wet and fix a second strip to the opposite side, and the third and fourth strips above and below. Be swift and firm.

3 | Leave the paper to dry flat. It will slowly straighten and become taut. Beware of the tape's coming loose at any point while drying, as the paper will be ruined by a raised ridge. Dry thoroughly before laying a wash.

LAYING A WASH

It is necessary to lay a wash on your stretched paper so as to prime it for silver point. Mix a very wet but not weak solution of gouache in a jar with a lid (add pigment at this stage for a three-tone drawing). Make enough to cover your paper; any extra will keep. Prop up your board of dry, stretched paper at a 45-degree angle. The next step will make a small mess, so put newspaper under the lower edge. Dip a soft, full brush into the gouache and start in the top left corner. Make an even line across to the right. Reload the brush and add a second line overlapping it beneath. Keep adding smooth, overlapping lines until you reach the bottom. Runs blend into each other evenly, leaving a smooth surface. Leave the wash to dry thoroughly before you begin to draw.

Three-tone When coloring ground, slowly add powder pigment or gouache from a tube, very little at a time. Keep testing on spare paper, and let tests dry before deciding to change the mixture. Here, I used a powder pigment called Caput Mortuum.

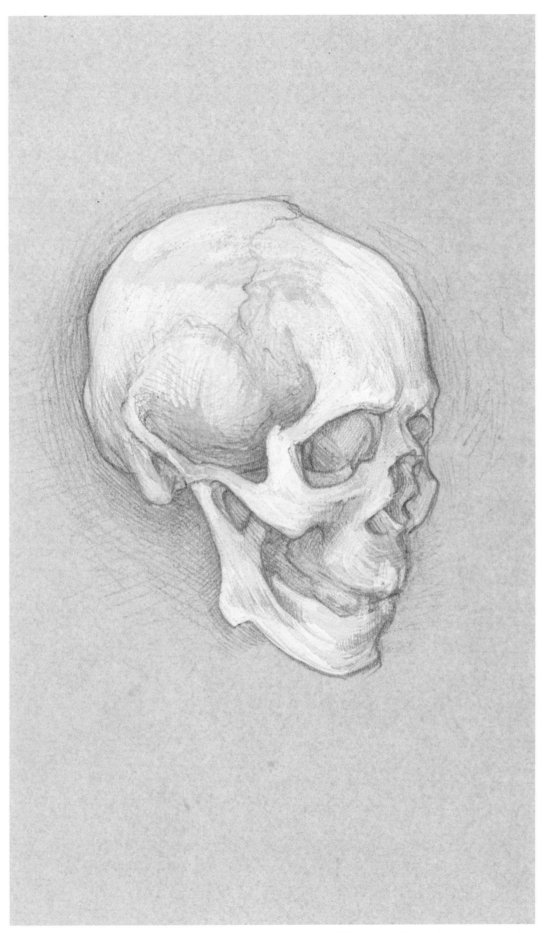

Three-tone silver point drawing of a skull

Head and Neck

THE HEAD AND NECK are best conceived as one unit arranged in four parts: cranium, face, neck, and throat. Each is of equal importance. The cranium is essentially egg-shaped and pivots on the first vertebra. The face is suspended beneath, like a softly curved triangle. The neck—a powerful, shapely column of layered muscles rigged to vertebrae—adjusts and holds the angle and expression of the head. The throat is delicate, hard, and lumpy to the touch, formed of cartilaginous rings, glands, thin muscles, and looser skin. Framing the throat, two columnar neck muscles (sternomastoids) project the head forward and also turn it to the opposite side.

Shorthand diagram

This is a simple shorthand diagram representing the cranium, face, neck, and throat. It can be learned and visualized in different positions very easily, giving the novice a firm footing on which to stand and develop their drawings of the head and neck.

Cranium Begin with an egg shape. Tilt it on the paper to change the position of the head.

Face Draw a rounded triangular shape below the forward point of the egg to represent the face.

Neck This shape represents the trapezius; the largest surface muscle of the neck and shoulders.

Throat A triangular shape represents the throat. (The nose makes the diagram clearer.)

Applied shorthand

After copying the diagram above, animate it. Practice drawing the cranium at different angles, add the face beneath, then the neck, shoulders, and throat. Shape your diagrams so they are more lifelike, but avoid adding detailed features too soon.

The skull and the frame of the throat

These three drawings demonstrate (from left to right) the following: why the cranium may be considered egg-shaped; how the face can be seen as a curved triangle suspended beneath and where the division lies between the two; and the form of sternomastoid muscles that frame the throat so distinctly when the head is turned and inclined forward.

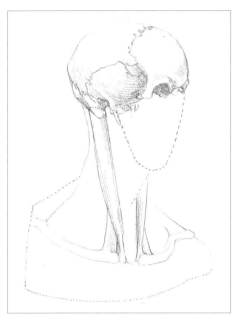

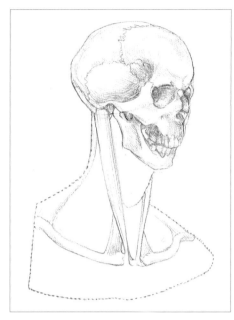

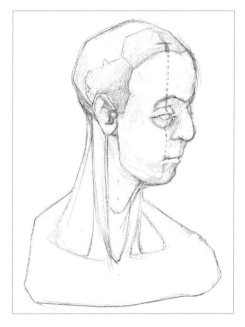

Bones of the cranium are locked together by jagged joints. Sinuses in the frontal (forehead) bone between and beneath the eyebrows are larger in men, making their brows pronounced and often ridged compared to those of women.

Bones of the face house our sight, smell, taste, and speech. Cartilage extending from nasal bones shapes the nose. Pads of fat resting on the base of each eye socket support the eyeballs in position. If the fat is reduced by old age, eyes look sunken.

The skull pivots on the first vertebra or "atlas," after the Greek god condemned to carry the Earth. The jaw hinges in front of the ears. Behind, bony ridges give anchor to the sternomastoid muscles rising from the breast- and collarbones.

Three useful generalizations

General rules about the relative positions of body parts can hinder artists as much as help them, since they are often based on classical ideals rather than the diversity of life. However, some generalizations can help as a rough guide to start with, so long as good observation takes over as soon as possible.

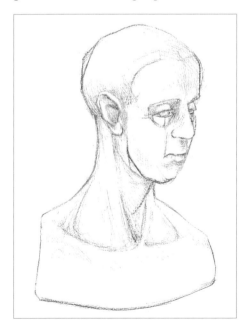

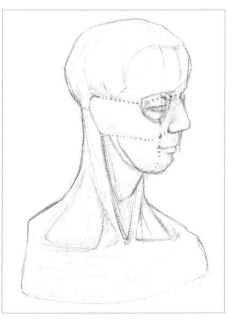

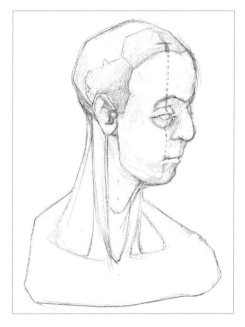

In general, when the face is relaxed (not smiling or frowning), the corners of the mouth are found directly beneath the pupils of the eyes. Vertical lines can be drawn down from the pupils to meet the corners of the mouth.

The height of a young adult's ear is often the same as their nose and found on the same level. There is no general rule for growing children, and remember that ears grow again in old age, which is most obvious in men.

The height of the face is about the length of the handspan and the eye is normally halfway down the total height of the head. A common error is to draw the eyes too high up on the face.

Essential Observations

THE DELICACY OF SILVER POINT (*see pp.140–41*) is perfect for small, detailed drawings. The drawings below and opposite show useful observations of the head and neck, which are explained in the captions below. Each drawing was made with a silver wire held in a large-gauge mechanical pencil. Newly clipped wires are sharp and cut rather than draw. Before use, they need to be rubbed and smoothed on a stone

such as a beach pebble. Here, I stretched drawing paper and laid a wash of white gouache (*see pp.140–41*). As you can see, the line and tone of silver point varies with pressure, but only slightly. Too much pressure cuts the ground. Silver point erases, but so does ground. Erased ground can be repaired gently with extra gouache. You can also use gouache to paint over mistakes and make corrections.

Contours

Here I imagined placing my silver point wire against the skin of each head and neck and, working in parallel bands from the crown downward, I traced the undulation of surfaces. Linear bands imagined around the head and neck can help you to clearly see the tilt of the head and relative levels of the features. Ask a friend to model for you and try this exercise life-size using a pencil and eraser.

Tilted forward

Tilted backward

Three-quarter view

Seeing that the face is never flat

Drawings below left and center are summaries of the generalizations given on p.143. Far right is an image to remind us that the face is never flat. It slopes back to varying degrees among individuals, from the tip of the nose to the ears. For example, note that the innermost corners of the eyes are farther forward in space than the outermost corners.

General measurements, side

General measurements, front

View from above

Male and female head and neck

Men's necks are generally shorter and thicker than women's because the angles and levels of certain bones are different between the sexes (indicated here by dotted lines) and men are normally more muscular. The male thyroid cartilage (Adam's apple) is larger and more visible than the female. Larger female thyroid glands also soften the appearance of the throat.

Male skeleton

Male skull

Female skull

Trapezius muscle

The largest muscle of the shoulders and neck is called the trapezius. Arranged on either side of the spine, it shapes the upper back and neck above the shoulder blades. Contracting in conjunction with deeper and surrounding muscles, it raises and lowers the shoulders and draws the head back to either side.

The whole muscle

Upper half with sternomastoids

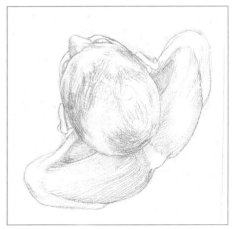

Above with head straight

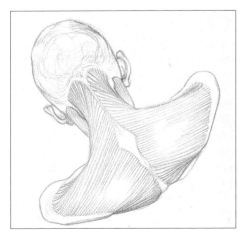

Above with head forward

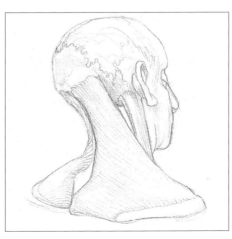

Side with sternomastoid

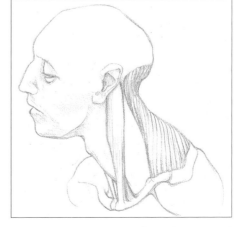

Front with sternomastoid

Drawing Portraits

USING A SHARP 3B PENCIL, I drew this head quickly from imagination, evolving its character and expression from the scheme of four parts: cranium, face, neck, and throat (*see p.142*). Here, five steps show you how to practice doing the same. This approach can be used to draw from imagination or from life. Keep your wrist loose and hold your pencil away from its point (*see pp.22–23*). Build the layers of your drawing from pale to dark, and from general balance and form to specific detail. Remember that successful drawings are built on foundations of "seeing the whole," then dividing the whole into smaller parts, with details brought in last of all. Phrased tonal marks modeling this girl's skin and hair follow the technique demonstrated by Goya in his self-portrait on p.130. Turn to Goya's drawing and study how, in a circle beginning across his hat, moving down his hair, and around his coat, he flows lines over surfaces to describe their contour. As you build from steps 1 to 5, bring phrased groups of lines across the surfaces of your form, using their directions to capture the expression of the head and neck. If unsure, copy my steps until you gain the confidence to make your own decisions.

BALANCED POSE

This drawing is the final stage of the four steps opposite. Here, I have enlarged the eye, and moved it back into the head by trimming the length of the upper lid and adding a more pronounced lower lid. It is important to set eyes far enough back from the relatively prominent nose; too close to it and the face flattens. Hair swept back and extended behind the cranium balances the regal pose. Lines shaping the hair echo those marking the cranium in step 1. Here, the lower part of step 1 comes through as wisps of hair across her face and ear.

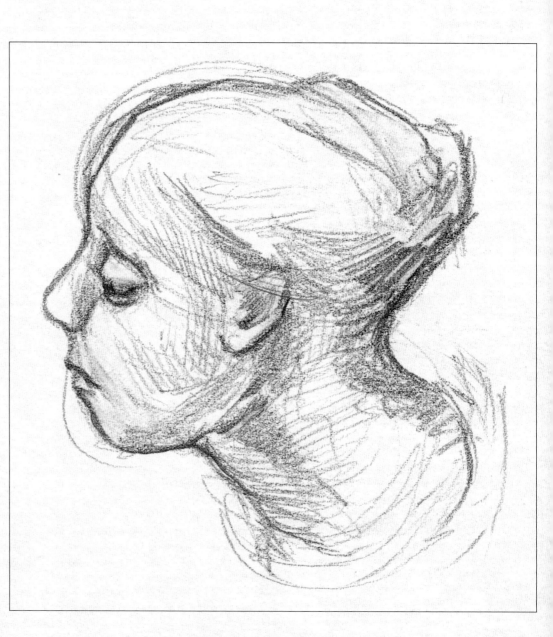

Portrait of a Young Girl

Building up the portrait

1 | Gently spin pale lines in a softly drawn shape representing the cranium. The angle at which you draw this shape on the paper will determine the angle of the finished head. Keep your first lines light; avoid drawing too dark, too soon.

2 | Rapidly add shorthand shapes to represent the face, neck, and throat. First lines will remain visible in the final drawing, so it is important to the life of the image that while controlled, they are also still sweeping and confident.

3 | Place the eye beneath the cranium. Here, I used light to describe the upper lid first with a shadow beneath for the lower lid and open eye. The eye announces the nature and expression of the emerging person. The nose and ear begin to shape the head.

4 | Moving from the back of the neck, over the cranium, down the face to the throat, I modeled the outline of the character. I imagined light shining from above and in front and adjusted the pressure of lines to reflect this.

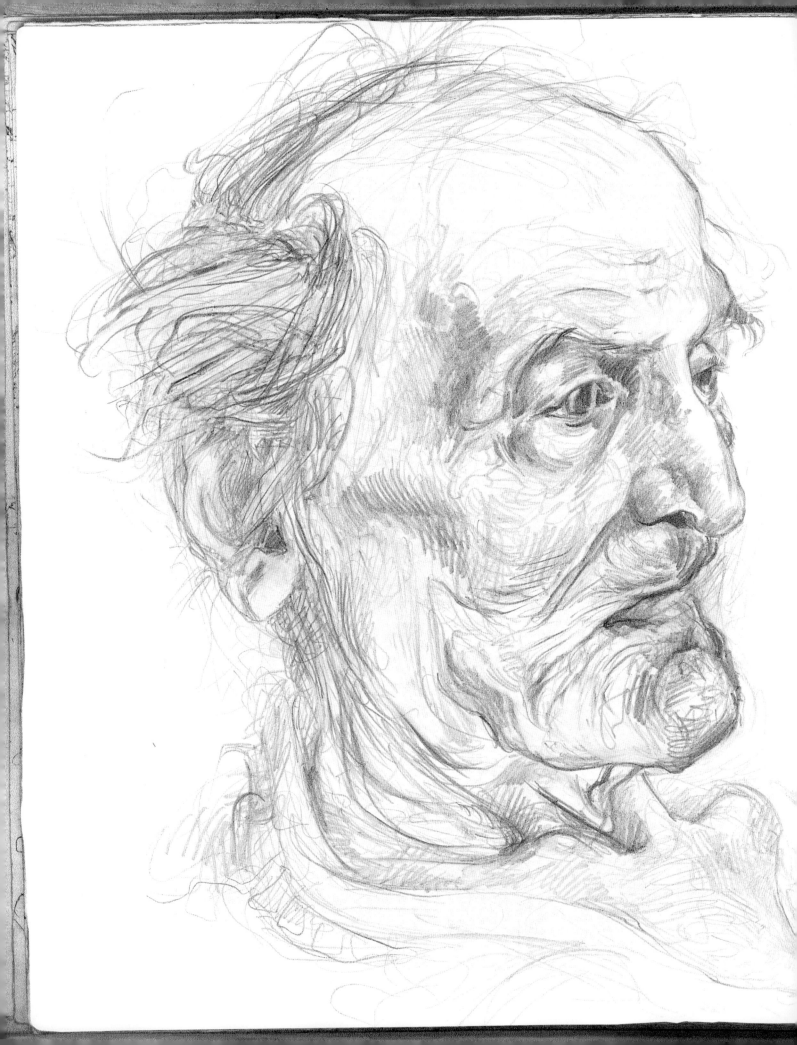

Generations

TO DRAW PEOPLE OF DIFFERENT AGES, and those who are asleep (*see overleaf*), be aware of the subtle differences in skin surface, the texture of hair, muscular tension, and gravity. Above all, empathize.

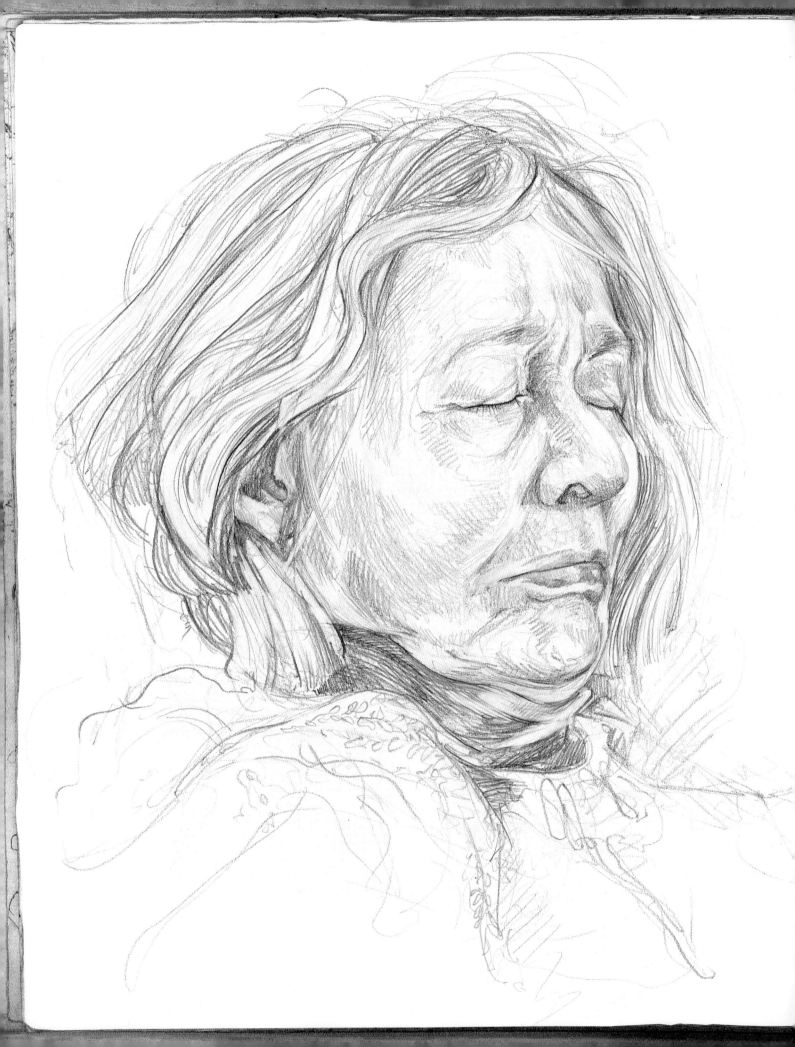

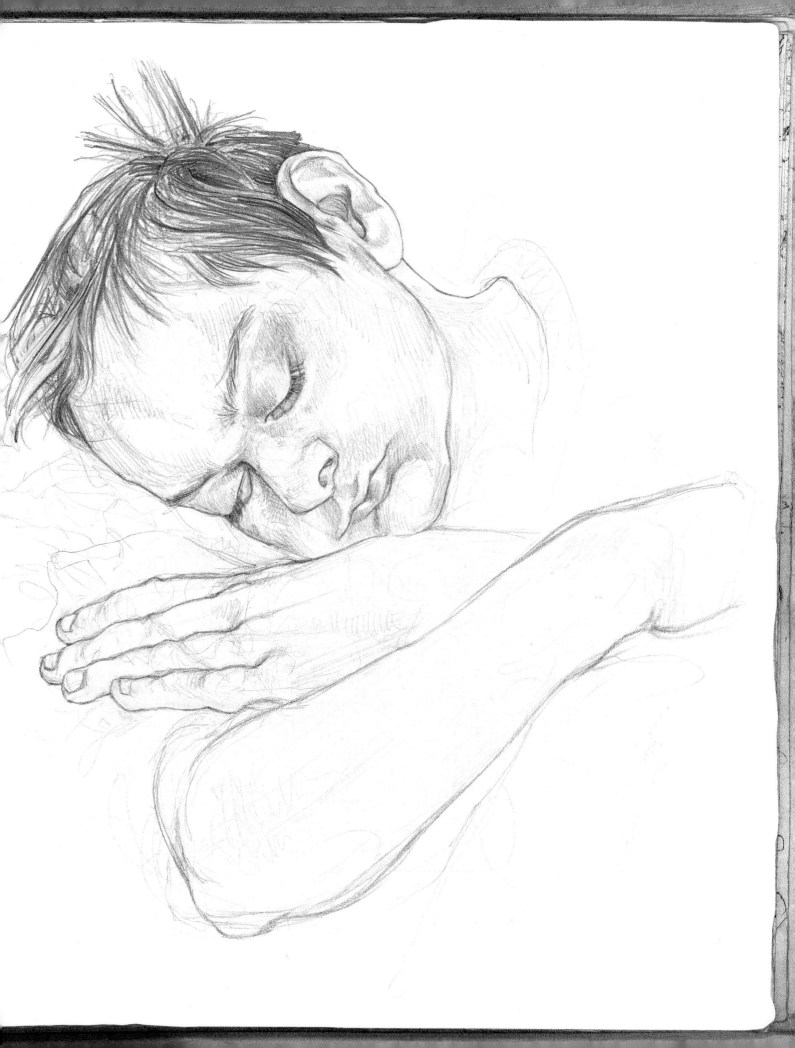

Castings

DRAWING IN THE PRADO MUSEUM, Madrid, with a steel dip pen and acrylic ink, I used the nib upside down to gain needle-sharp precision. Fast lines carve out the features of Goya's soup-slurping hag. Van Dyke's noble cast of characters was modeled more finely, seeking the dominant contours of each individual expression.

This character is found among Goya's Black Paintings. I drew her repeatedly. Studying a great artist's abstraction of an active head teaches you to see what is most essential in its expression.

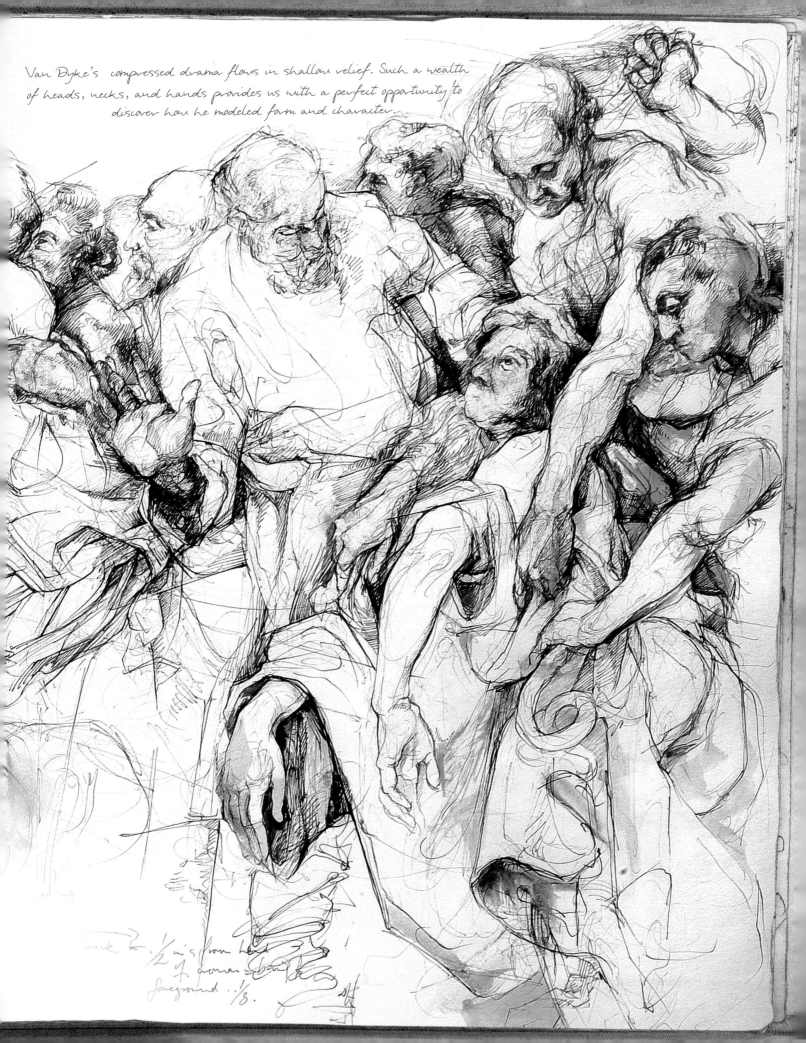

Van Dyke's compressed drama flows in shallow relief. Such a wealth of heads, necks, and hands provides us with a perfect opportunity to discover how he modeled form and character.

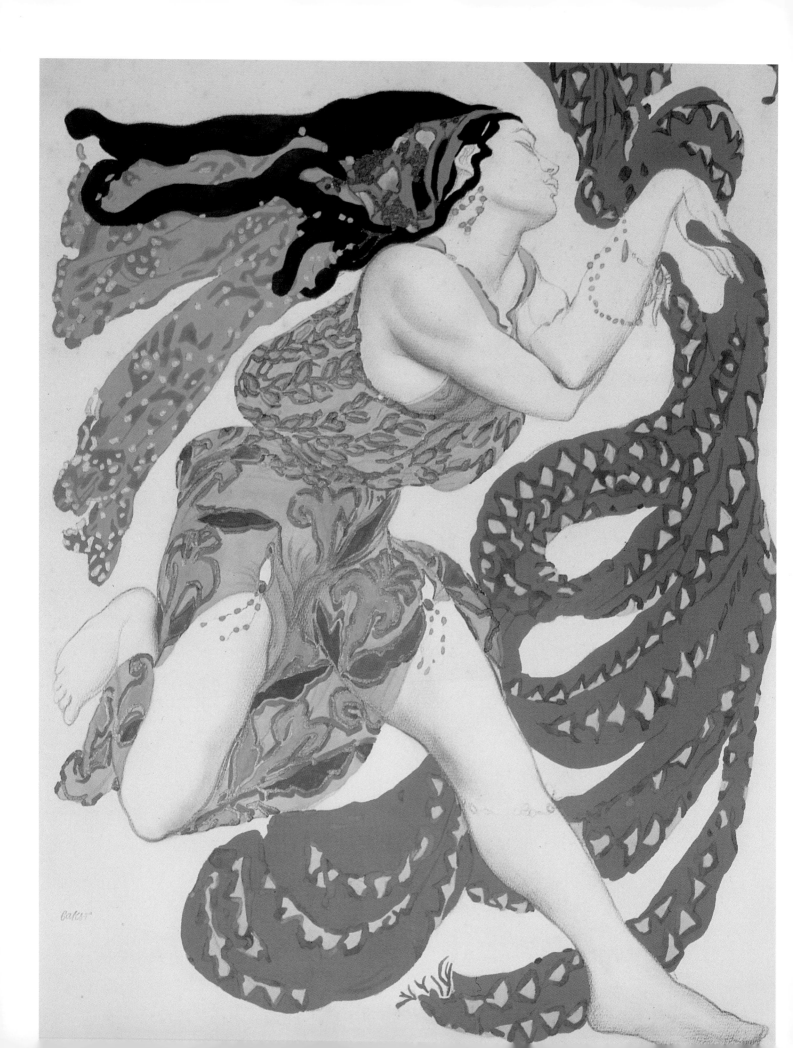

Costume

W E MAKE OURSELVES EXOTIC, outrageous, intriguing, and even invisible by the way we dress. Like it or not, it is the public sign by which we are judged, and everything we have chosen for our wardrobes—reflectors of our taste, personality, culture, and profession—began life as a drawing. Designers all over the world continually pen and brush lines to lash us with color, warmth, and exuberance, or calm us with chic, cool, and subtle tones. Popular fashion design exploded with the Industrial Revolution. Previously, only the wealthy could afford to have costumes specially made. The rural masses wore homespun simplicity, while court painters—Michelangelo and Holbein, for example—designed the wardrobes of popes and kings, and courtier tailors followed suit. Cities changed all, so that choice, variety, and indeed image became the property also of the industrial classes.

The paper pattern is perhaps the most widely known of costume drawings: a formalized plan of lines, shapes, and symbols that lets men and women in all countries and areas have working access to the latest fashions. The entourage of the theatrical stage often leads the catwalk. Designers create masterpieces of *haute couture* for Hollywood stars, fulfilling lavish and spectacular briefs, which in turn feed consumer fantasies and desires to immediately possess a version of the same. We dress ourselves in designers' ideas and are surprised and delighted by their continual flow of inspiration. It is shocking to think how many millions of drawings must be made and discarded each year in the industrial frenzy of creating our image and aspirations.

To the fine artist, costume offers a rich vocabulary of textures and color, but above all a physical puppet with which to animate character and narrate personality, psychology, and intent. Artists do this not so much by the style of a figure's garment, but by the way it speaks with its flying, glossy folds, caricatured plumes, crumples, or bulges. In this chapter we see how clothing can seem to possess the weight and monumentality of stone, articulate a dangerous satirical joke, and be so expressive of temperament that it overtakes the need for an occupying human form. Practical classes look at ranges of colored materials including pastels and felt-tip pens. Structure is studied though the invention of shoes, and we will collect patterns, emulate textures, and explore the characterization of fabric through movement, gesture, and atmosphere.

LÉON BAKST

Lev Samoylovich Rosenberg, known as Léon Bakst, was a Belarussian Art Deco theater and costume designer trained in St. Petersburg and later exiled to Paris. As artistic director of the Ballet Russe, he and cofounder Serge Diaghilev took Paris by storm in 1910 with their production of *Scheherazade*. Bakst's designs and costumes immediately influenced Parisian fashion and interior decor. This voluptuous woman was drawn by Bakst one year later, for the ballet *Narcisse*. In a rich and unusual combination of pencil, charcoal, and gouache, the dancer leaps through swaths of golden cloth.

Bacchante
1911
11¼ × 8½ in (285 × 220 mm)
LÉON BAKST

Cloth and Drapery

EACH OF THESE FIGURES is ninety percent cloth. Sculpted folds and patterns of material speak more resolutely of their wearers than any small glimpses of body we can see.

In Van Eyck's drawing below, the Madonna and her architecture are both dressed in the same manner; her marble garment holds up the infant Christ in a fountain of compressed line. Above them, the vaulted stone roof echoes and crowns the moment. Church and deities are drawn as

one, and the kneeling abbot is a ghost by comparison. Opposite, Keisai Eisen's intense, swirling printed fabrics, with their jagged edges, dragons, and snakelike marks, resonate with their wearer's startled expression. Below this, Flaxman's sleeper—perhaps a pilgrim or a soldier resting between campaigns—has wedged himself into the cleft of some great building to grab a moment of peace. The quiet stillness of this image is achieved by a masterly economy of stylized line.

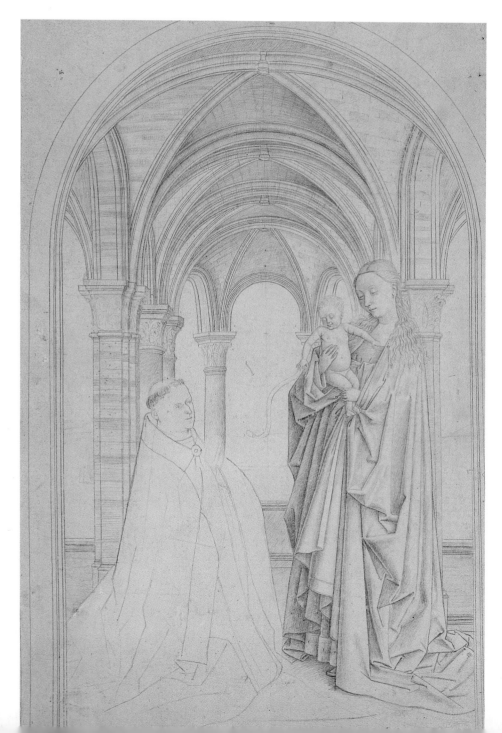

JAN VAN EYCK
Flemish oil painter from Limbourg, best known for his Ghent altarpiece (1432) and marriage portrait of Giovanni Arnolfini and his wife (1434). Van Eyck's highly polished work is celebrated for its disguised symbolism. He meticulously arranged subjects to convey deeper meaning.

Delicate marks Silver (or metal) point is the most delicate of traditional drawing media (see pp.140–41). With a stylus such as Van Eyck used here, it is only possible to create very thin, delicate lines. He has layered these slowly and carefully so as not to cut through the ground and produce a white mark just where he intended a dark one.

Vertical lines The highly controlled lines of this drawing cascade from top to bottom of the image. Their uninterrupted emphasis is entirely vertical. Short and subtle horizontal punctuations are only given in the background by sections of floor, bands around the columns, and implied striation in the stone of the architecture.

Marble gown We will never know if Van Eyck considered this drawing unfinished or intended the kneeling abbot to remain transient and ghostly. However, the carefully composed outline of his cloak shows us how the artist would have also begun his immaculate rendering of the Virgin's clothes. Her gown is carved and polished as if made from marble.

Maelbeke Madonna
1441
11 x 7 in (278 x 180 mm)
JAN VAN EYCK

KEISAI EISEN

Japanese draftsman, writer, and printmaker. Keisai Eisen took his name from the masters Kanô Hakkeisai and Kikugawa Eizan. Respected for his sumptuous images of geisha and editions of erotic prints, he also co-edited and expanded the *Ukiyo-e Ruiko* (History of Prints of the Floating World), an 18th–19th century document on the lives of the ukiyo-e artists.

Relief printing This is a wood-block print made by a relief process. Images are drawn onto smooth, flat sheets of wood, which are sometimes also cut into pieces like a jigsaw puzzle. Parts of the image to be left unprinted are gouged out with a metal tool. Remaining raised areas of wood are rolled with colored inks. The inked block is laid face-down on damp paper and pressed to make the print. This complex image may have been made with numerous blocks prepared and printed separately, one over the other, each delivering a different part and color of the design.

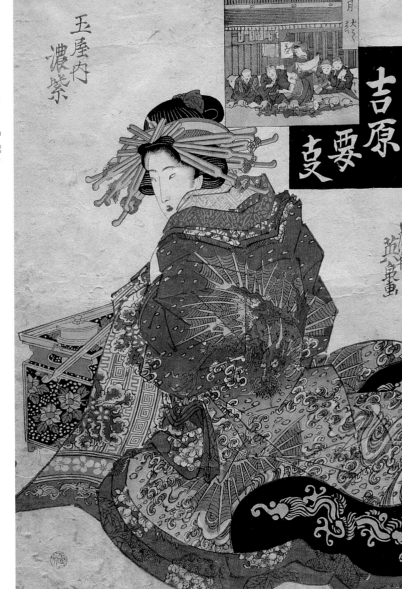

The Courtesan Koimurasaki of Tama-ya
1810–50
15 × 10¼ in (381 × 260 mm)
KEISAI EISEN

JOHN FLAXMAN

English late 18th-century neoclassical sculptor, designer, draftsman, and teacher. Distinctive linear illustrations for the works of Homer, Danté, and Aeschylus earned Flaxman an international reputation.

Position In this pen and ink drawing, the angle of the head, the cloak sliding to the ground, and the feet notched against the pillar tell us that this sleeper's position is momentary. A stone wall of downward-stroked lines holds him into the cleft.

Man Lying Down in a Cloak
1787–94
2¼ × 4⅛ in (57 × 105 mm)
JOHN FLAXMAN

COSTUME

Character Costumes

CHARACTER COSTUMES REPRESENT an extreme form of the clothed figure. A flamboyant territory, where sometimes there just might not be anybody inside. Details and voices are worn externally with great imagination. Fine examples can be plucked from fashion, cartoon, theater, cinema, and even formal portraiture.

Anthony Van Dyke's *Man in Armor* is a masterpiece of drawn surface. The metal, cloth, lace, and feather were all observed with closely crafted conviction. The slight uncertainty of the pose and the limp cloak suggest a little more metal than man. Opposite is a dangerous drawing, a scurrilous cartoon by a courtier of Queen Elizabeth I. The aged queen is compared to an overdressed bird, all ruffs and wrinkles. It is presumed Her Royal Highness never saw it, for she would not have been amused and William Wodall might have been stretching his luck.

ANTHONY VAN DYKE
Flemish painter and draftsman. As a young man, Van Dyke was chief assistant to Rubens for two years, before traveling to Italy, where, through numerous portrait and Church commissions, he cooled and redefined his style. In 1632 he moved permanently to London, and was employed as court painter to King Charles I.

Pen and wash In the graphic accuracy of this armored knight we see the idealized identity of a warrior from another time; a gleaming defender of the realm. He has been rendered on this olive-colored page with pen and gray wash worked over a red and black under-drawing.

Flowing scarf The knight's scarf of gilded blue is drawn in a pale wash over red ink lines. Its warm surface flows in contrast to the stiff metal armor. Its color is also reflected in the metal.

Leg section Compare the section of white boots cropped mid-shin to the section of similarly cropped trousers in Gruau's drawing on p.160. Leg sections in both drawings support the figure without taking our attention away from the main garment above.

Man in Armor
UNDATED
16 x 9½ in (405 x 240 mm)
ANTHONY VAN DYKE

WILLIAM WODALL

Author and illustrator of *The Actes of Queene Elizabeth Allegorized*, a manuscript poem comprising six cantos. The poem recounts the six major crises of Elizabeth's reign: the Spanish Armada, the Ridolfi Plot, the Babington Plot, the Jesuit Mission, the Northern Rising, and her pride.

Satire This is a quill-and-ink satire of the elderly queen's pride. As head of state and fashion, she is shown as a grossly disproportioned bird, with an overinflated fluffy ruff displaying a fan of daggers. A hooded eye pins us, while a raised foot pauses to assess the next move.

Ruffs and feathers Starched white ruffs worn at court and by English society grew steadily larger as Elizabeth's reign progressed. By her old age, it was customary to wear up to three tiers supported on sticks. Beneath the lethal fan drawn here is the body of a bird of prey; dark trimmed feathers suggest a tawny owl.

Iron-gall ink Wodall's dangerous caricature steps daintily between the written lines of her dedicated page. Top-heavy, the queen is masterfully rebalanced by words at her feet. The whole drawing's blackened, bitten nature, and saturations showing through from the other side, suggest the use of iron-gall ink (see p.35).

Satire of the Queen's Dress
c.1599
7½ × 5¼ in (190 × 134 mm)
WILLIAM WODALL

Femmes Fatales

THESE DEVASTATING *femmes fatales* force back the onlooker with their demure, elegant chic and svelte, muscular aggression. Fashion and fantasy drawings invent prototypes of ideals and perfection—be they for the catwalk or the fast-paced pages of comic books.

Rene Gruau's bold gouache drawing of smoothly swaying sophistication captures a brilliantly cut garment and frames it with great dynamism in a white, studio-like rectangle of paper. His model is outlined, as is Batgirl opposite, and both share the power of scarlet and black. Gruau uses starkly cut negative space (*see pp.58–59*) and a three-spoke balance of cuffs and cropped trousers to create an almost flaglike emblem of power.

Batgirl leaps like a black chrome panther through her whip of rope. She swoops into our perspective, which is confused by the lit-up canyons of Gotham City behind her. She is all airbrushed costume and power; catlike in her control of this dramatic composition.

RENE GRUAU
Italian-French fashion illustrator who in his long and esteemed career worked with many of the greatest designers of 20th-century *haute couture*. Gruau's highly distinctive drawings have appeared in numerous magazines including *Elle*, *Vogue*, *Harpers & Queen*, and *L'Officiel de la Couture*.

India ink and gouache This swish of confidence and style enters the page turning everyone's head. Gruau's model regally swans to the fore with cool pride, demanding our attention with gesture and flair. She has been drawn with brushes dipped into India ink and gouache, possibly over a pencil outline. The black, red, and gray pigments were applied separately. Drying time in between applications ensured that the colors did not run into each other.

Composition Look how well this image is framed in pictorial space. The horizontal line cropping the trousers below her knee is parallel to the bottom edge of the image. The outermost upright borders of her cuffs are similarly parallel to the sides of the image, and tilted to the same degree. Space above her head is a little deeper than space beneath her knees to give her gravity. Compare the compositional device of cropped trousers here to the device of the white boots beneath Van Dyke's study of armor on p.158.

Illustration for Jacques Fath
in L'Officiel de la Couture
1949
RENE GRUAU

DC COMICS

One of the oldest comics publishers, established in 1935. Today DC Comics produces over 80 titles a month. It invented the action comic, detective comic, and superhero characters such as Superman, Batman, Wonder Woman, and countless more who went on to feature in movies, musicals, and television.

Airbrushed color This Batgirl is created through the traditional process of a pencil outline over-drawn with ink and airbrushed with color before text is finally added. Each stage is done by a different person. Airbrushed color and tonal modeling give the image a sleek and mechanical gravity, a great characteristic of DC Comics.

Sharp focus The black, gray, and brown outlines around every part of this image create a hyper-real dynamic, where all things—architecture, sky, foreground, and figure—are locked in equally sharp focus. To understand and recreate this effect of looking up, take a ruler and work out where the single vanishing point lies (see pp.74–77), approximately 9 in (23 cm) above the center of the image, out of the picture.

Batgirl
2004
10¼ × 6¼ in (260 × 160 mm)
DC COMICS

Colored Materials

ART STORES BRIM OVER with the many colored materials available. Seemingly infinite choices of texture, hue, size, shape, quality, and cost are laid out for our pleasure and perusal. Many products are sold individually and in boxed sets. The higher the quality (and cost), the finer and more subtle the texture and color should be. Most stores leave small pads of paper on their counters for customers to test materials, and wherever permitted, I suggest you do so. Often, there are disparities between the apparent nature or color of what you hold in your hand and its performance on paper. Try materials that are new and unfamiliar; you may be pleasantly surprised to discover something you could not have imagined using. Before making substantial investments, purchase a small selection of different items you think you will like. See how they work and return later for more of what proved best for you.

CHALK PASTELS

Pastel pencils make fine lines (as above). Sticks and conté crayons make thicker marks (as below). Bright pastels are more brilliant on colored paper. Store loose pastels in dry rice to keep them clean. Be aware that fixative dulls pastel. Many artists apply fixative to the back of their work, allowing it to fix slightly from behind. Degas built his pastels in layers, fixing each layer on the front, except the final layer, which he left unfixed to retain its brightness.

PIGMENTS

Pigments, used to make colors, are derived from many sources: rocks, minerals, plants, animals, insects, and synthetics. They vary hugely in cost, intensity, and subtlety. Beware—some are toxic. The nontoxic range below represents a suggested starting point for experiment.

1. OIL PASTELS: Many colors, including iridescents, are made in brands of diverse quality and cost. The best are paper-wrapped sticks of sumptuous, soft, oily pigment. The worst are like revolting old lipsticks that get everywhere except where you intend. Children's wax crayons are relatives, and can be a great rediscovery for bold drawings.

2. CHALK PASTELS: Blackboard chalk is the basic member of the family, great for sidewalk work. Pastels are finer; chalk-based but very subtle, slightly oily to the touch, crumbly, paper-wrapped, and sold in many colors. Pastel pencils are slender and in wood casing. Conté crayons are square-formed, unwrapped harder pastels, made in about 80 colors.

3. COLORED PENCILS: Dry pigments ground together with chalk, clay, or wax and a binder are shaped into fine strips and encased in wood like a graphite pencil.

4. FELT-TIP PENS: Instant-drying alcohol- or water-based inks stored in the barrels of the pens are delivered via smooth nylon or felt tips of varying shapes and thicknesses.

OIL PASTELS

Oil-based, these work best when slightly warm, and can be softened and manipulated with degrees of heat. Use them to draw lightly (as above left) or thickly, mixed on the paper and scratched into (as below). Dissolve in turpentine or mineral spirits to produce oil paint or wash. They work well on tinted or dark paper, though lines can develop greasy stains around the edges if the paper is not first stretched and treated with a gelatin paste laid as a wash.

1

2

FELT-TIP PENS

Brands made for designers sold in enormous ranges of colors are far more subtle and sophisticated than those made for children. If you love smooth blocks and lines of color, felt-tip pens are perfect. Think of Matisse's *Blue Nude* (see p.111). Although not made with felt-tip pen, it is still a great champion and support for those beginners feeling shyly obligated to tone down their love of color to conform with what others say they should use.

COLORED PENCILS

These are wax- or clay-based thin crayons in wood casing. Diverse brands are harder or softer, greasier or chalkier in use. Some give richer lines than others, so it is best to test them before buying. Some are non-soluble, others dissolve in water or turpentine to make a wash. Fine lines can be achieved (as above). Colors can be blended (as shown right) and tones graded by altering pressure, leaving the paper to shine through for highlights (as below).

3

4

COSTUME

Study and Design

SHOES TELL LIFE STORIES; they reflect our age, personality, style, values, social and economic status, the era in which we live, and how we stand and walk. Superstitions and fetishes are attached to them: we are told never to put new shoes on a table, and they have been concealed in buildings to ward off misfortune. As artifacts in museums, they record and reflect our common history, while artists have painted their boots or those of others as personal portraits and memorials.

This class takes the shoe as its subject in building on earlier lessons concerned with seeing through objects to understand their function, structure, and volume in space (*see pp.100–01 and pp.104–07*). Here we go one step further, and after studying familiar shoes we use the information learned to invent new ones. To set up, you will need several large sheets of drawing paper, a range of colored felt-tip pens with both fine and broad tips, and a selection of shoes.

REPEATED STUDY
To illustrate this class, I made numerous sheets of drawings, enjoying the study and invention of shoes. You, too, will discover more, and experience visible progress, if you make plenty of drawings as opposed to only a few.

Linear Outline
Using fine pens, cover a large sheet of paper with line drawings of several shoes. Turn them in different directions and observe their structure and form. Draw each one first as a solid object, then again as if transparent, imagining you can see through it.

The Surface

Next, study the surface contours using fine- and broad-tipped felt-tip pens. For best results, it is important to be bold and brief. Draw firmly, fast, and with as few strokes as possible. Build up each shoe from light to dark and leave some paper showing through to create highlights.

Design Your Own

Using what you have learned from the previous steps about the structures of your shoes, and about the use of pens, invent new designs from your imagination. Start with fine outlines and progress to colored and textured surfaces. Modify your ideas by rotating the views.

The Structure of Costume

MUSEUMS ARE AN INFINITELY rich resource for the artist and designer. They often give quite unexpected gems of ideas and information—whatever the subject. These drawings, made in a costume museum, demonstrate ways of recording structural information and detail for later use in the studio. They could form the basis of new designs for a fashion project or theater production, for example. Drawings of shoes on pp.164–65 show how new designs can be evolved from the structural information given by a period style. Arrange to visit a costume museum or ask a friend to model clothes for you at home.

Using fine felt-tip pens, begin with quick, pale impressions of each garment's shape before homing in on its borders and seams. Try to draw transparent views wherever possible to record the relationships between all component parts. Aim to draw enough information for it to be possible to make up a version of the garment using paper pinned to a tailor's dummy.

OBSERVATION

It is usually best when collecting information for reference to apply the restraint of dispassionate observation. Set yourself the test of drawing facts with as little artistic license or embellishment as possible. Here I chose fine felt-tip pens because they are at their best when used swiftly, and therefore encourage bold, unhesitant decisions.

Swift lines record the hanging weight of this gentleman's coat, the relative proportions of its layers, and minimal details of the buttons and cuffs.

Thick velvet fabric is pulled tight beneath and across the bust by a single button. This transparent view shows how the fabric falls loosely in straight panels beneath the level of the sleeve.

LIGHTING
When visiting museums, be prepared for low lighting, which can make it hard to see and draw. A small reading light designed to clip onto a book can help if attached to your drawing board.

Adding stripes and dashes of color with a thicker pen brings out the glossy sheen and sculptural rigidity of this dress, which would have been worn over a whalebone corset.

In small drawings such as these, use thick pens to color entire sections with a few marks, as I did here down the side of the bodice.

The light, frilly bulk of this crinoline dress is propelled forward with fleets of quick lines, pinching its gathers and sways that are hiding a horsehair bustle.

Textures and Patterns

THIS CLASS FOCUSES ON how to draw textures through the collection of fabric, pattern, and embroidery samples from a costume museum. This formal method, using ruled squares, can create an invaluable library of ideas and information for future reference—when painting a clothed figure, or preparing a textile project, for example. However, if making a book of samples for a project, remember that it is important to also include collages of found materials (*see pp.230–31*) and to experiment more loosely with mixed media.

To draw a fabric texture, begin by concentrating on how you imagine it would feel if you touched it. Decide if it would be rough, smooth, warm, cold, thick, thin, tough, or fragile, for example. As you draw, believe you can feel these qualities at your fingertips and that your pencil is responding to the sensation. Undulate the pressure of your lines and marks according to the feeling of the fabric rather than its appearance. Let your pencil enact the sensation of touching its surface.

INVENTING COSTUMES

This starchy, quilted, bowed creation started life as an imagined corset. I intended to draw together in one sculptural form a range of the details opposite. The garment quickly got out of hand. There is great enjoyment in letting your imagination run wild when inventing costumes. If you are unable to visit a costume museum, many exciting fabric details and textures can be found in your own closet or home.

COSTUME

COLORED PENCILS

Colored pencils give precision and tonal range; they can be faded but not erased. Lightly use an HB graphite pencil if you wish to plan a design first. Pressed hard, colored pencils build up a waxy finish of brilliant color. Used lightly, they appear powdery and show the texture of the paper.

Silk and braid

Ribbon

Wool

Embroidered leather

Feathers

Pearls

Knit

Tassels

Outline stitch

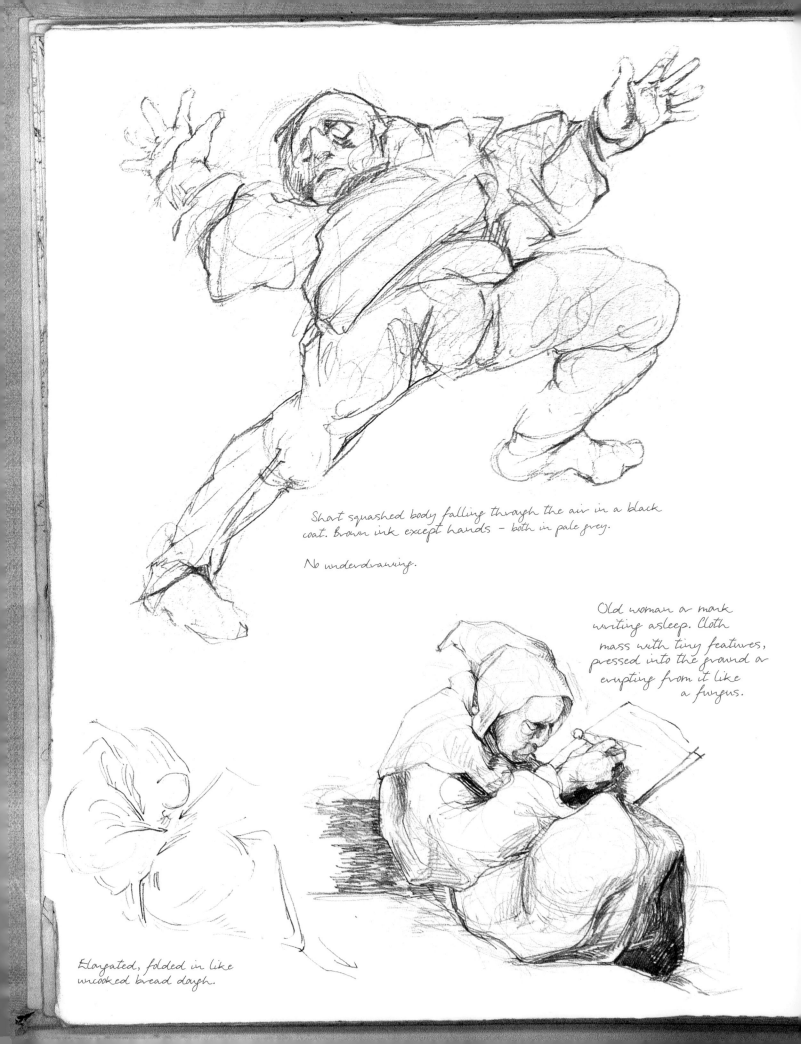

Short squashed body falling through the air in a black
coat. Brown ink except hands – both in pale grey.

No underdrawing.

Old woman or monk
writing asleep. Cloth
mass with tiny features,
pressed into the ground or
erupting from it like
a fungus.

Elongated, folded in like
uncooked bread dough.

Dressing Character

I ONCE SPENT THREE MONTHS researching the work of Francisco de Goya at the Prado Museum, Madrid. I made a drawing book full of studies seeking to understand how he composed drama and pathos in his narratives (*see also pp.126–27, 172–73, and 252–53*). These characters, selected from different pages of my original book, look at how Goya delineated volumes of thick fabric to express the posture, shape, identity, and motivation of an individual.

Weight pressed down onto her knees.

Body stretched back and forward simultaneously.

Whole action expressed in the tension of the cloth. Exaggerated view from below.

Power is sucked into the center of the body.

Twist of the pelvis counterbalanced by shoulders. Inverted right foot.

This skater leaps, wrapped and gathered in her costume. Curves and volumes forcefully drive her forward.

Posture Carving

THESE PENCIL STUDIES, also taken from my Madrid drawing book (*see pp.170–71*), are copies
of works by Goya in which he makes air seem heavier than flesh, and visible, and tangible,
as it rushes and carves fabric-wrapped forms like rivers and desert winds shaping the earth.
To understand how he did this, I carefully copied the direction of each of his lines.

DISSOLVING FABRIC: The figure below is
composed of rushing lines and open spaces
that together dissolve his form and suggest
that he is moving with force and
momentum. The man is a smudge of fabric,
a blurred impression—as much as we would
grasp of someone running past in real life.

FABRIC-WRAPPED FORM: Left and
right are two studies of the same
drawing showing witches huddled in a
tree. They represent another example of
characters composed more of fabric than
of flesh. My lines dissect the folded
planes of Goya's composition.

RUSHING LINES: Here I copied Goya's strokes to see how he generated a sense of lateral vertigo. Looking at the drawing, we feel we are falling sideways. This nauseating movement is made by a visible wind that carves the rush of night creatures.

FLYING WITCH: This witch is an extract drawn out of the image above. My lines carefully copied the direction of Goya's to see how he wrapped flapping cloth over the form of a body.

Gatherings

ALL DRAWINGS TELL STORIES, but drawings of gathered people tell them most directly. We read tensions and exchanges between people, and instantly engage with the action of the scene. Storytelling and people-watching are obsessive human activities. Blockbuster movies, television documentaries, soap operas, paintings depicting scenes from history, daily newspapers, comics, and novels—our staple cultural diet—are driven by a fascination with shared experience and the detail of what happens in other people's lives.

Here, Rembrandt's bored and frustrated wife, Saskia, stares out from her gloomy sickbed. Her all-too-clear expression shows annoyance and irritation with her husband, presumably while he is making this drawing. He in turn scorches the paper with his view and a certain speed of seeing all. Later in their lives, Saskia died after childbirth, and so, in spite of how it may seem, this is not the portrait of an old woman. Seeing through Rembrandt's eyes, we, too, are implicated in this marital exchange made over the head of the anonymous nurse.

The spaces between people and the positions they occupy on a page are vital to our understanding of the psychology or emotion of an event. As artists, we can heighten or subdue drama with subtleties of exaggeration or caricature. We can direct the viewer's attention in a scene by the format of its composition, the speed and density of its lines, and its illumination. We can also use clothes, furniture, and other props to add layers of meaning and attitude.

Just as there are three parts to a traditional landscape drawing—the foreground, middle, and distance—so drawings of gathered people can be loosely arranged in three types. First, the direct exchange (*as shown here*) where one or more characters hold eye contact with, and therefore seem to see, the viewer. Second, the viewer is not directly engaged and as a natural voyeur can feel invisible while watching the scene, even up close. Third, a crowd tells the story from a distance; there are no longer individuals but one significant group or mass action. Drawings selected for this chapter explore these ranges of proximity in the delivery of narrative. With a pocket full of disposable pens and a travel journal, we also go out and draw the expressions of gathered people, finding corners in crowded places to inscribe their action and energy onto the page.

REMBRANDT VAN RIJN
Dutch painter, draftsman, printmaker, and one of the greatest and most influential masters of Western Art. He is also the artist from whom we can learn most about handling pen and ink. This vivid portrait of his wife captures our attention. It took only minutes to make and yet it lives for centuries. A reed produced the thicker lines of the nurse, while a quill made the finer lines of Saskia. Washes of shadow behind her were laid with a brush.

Saskia Lying in Bed and a Nurse
1638
9 x 6½ in (227 x 164 mm)
REMBRANDT VAN RIJN

Projections

SOME DRAWINGS ARE MADE entirely of illumination that floods drama into the viewer's gaze. Here, garbage and chaos are piled and exploded in rooms full of event. Noble and Webster's witty and often subversive drawings are also contemporary art installations. For each work, they select and arrange familiar items of street detritus into what appears to be an unpleasant pile. The immaculate drawing is only revealed when the beam of a projector casts the shadow of the heap onto a wall. Below, composed garbage produces a calm, haloed portrait of the artists seated back to back.

In one of Rackham's great illustrations for Lewis Carroll's *Alice in Wonderland*, a kitchen explodes in our faces. Pans fly off the stove, plates shatter, hearth implements crash at our feet, and smoke billows around the agitated jives of the Duchess, the Cook, the Cat, and Alice. In both works, narrative is delivered through the air, via the animated clutter of our material lives.

TIM NOBLE AND SUE WEBSTER
British artists who collaborate using neon, refuse, and projectors to create their anarchic punk satires of modern life. "Anything that…kicks against the mundane things that close down your mind is a refreshing and good thing." (Tim Noble)

Drawing with light It is important to think about what you can draw with, and on, and in. Pencil on paper is timelessly important but only the beginning of possibility. Here we see the combination of three-dimensional space, junk, and a projector. Think about what else you could use: a laser in smoke, for example, or even the office photocopier.

Real Life is Rubbish
2002
Dimensions variable
TIM NOBLE AND SUE WEBSTER

ARTHUR RACKHAM

British watercolorist and children's book illustrator. Rackham's work is characterized by vivid fantasy, humor, and an unmistakable graphic style. He is best known for illustrating Irving's *Rip van Winkle*, Stowe's *Queer Little Folks*, and Poe's *Tales of Mystery and Imagination*.

Depth Billows of smoke expand and are lighter as they come forward. Refer back to the drawing class on p.100 to see for yourself how to make elliptical objects like pots and pans fly through the air. In the foreground, Rackham has also drawn objects and elements that are very large compared to those behind. This makes the story appear to leap out at us.

Vanishing point In this marvelous drama made with pen, ink, and watercolor, we find several devices already explored through our drawing classes. Find the single-perspective vanishing point (see pp.76–77) that is about ¾ in (2 cm) above Alice's shoulder. See how the oak beams, tabletop, and floorboards converge at this point. The wood grain acts like marks of speed behind the scene, amplifying movement outward from the vanishing point.

In the Duchess's Kitchen
1907
7⅞ x 6 in (200 x 150 mm)
ARTHUR RACKHAM

Magnetic Fields

OF ALL THE CONTRASTS we have seen in the pairs and trios of drawings by masters and makers, perhaps these two are the most extreme. In culture, meaning, and composition they are polar opposites. The mournful gray landscape of Henry Moore's northern British field has gathered by night an overcoated audience to stand and wait before a wrapped and roped monument. This is an ironic drawing from Moore, a sculptor, expressing his dry humor about sculpture, audiences, and art in the landscape. The image stands out among his more usual graphic works in which he hones and carves semi-abstract human forms.

Opposite, as if Moore's wrapping has been literally outstretched, a great Shoshone drawing blazes with the color, heat, and action of a buffalo hunt. This is just one of many precious artifacts from a lost time, which still narrates vivid days in the lives of an energetic nation.

HENRY MOORE
British sculptor who trained and taught at the RCA, London. Moore toured Italy as a young man, and loved to draw in the British Museum. The human form was the vehicle of his expression and he was the official World War II artist.

Chalk and graphite This fog-bound but humorous gathering of souls is made in graphite and colored chalk with gray wash. Moore's spectators appear to have walked a long way from nowhere to witness and wait beside this mysterious obelisque. A glimmer of gold light appears from the left. No explanation is given, and we, as fellow watchers, join in the waiting.

Crowd Looking at Tied-up Object
1942
17⅜ × 22½ in (442 × 571 mm)
HENRY MOORE

SHOSHONE SCHOOL
Members of the Shoshone community wishing to learn how to paint a scene on a hide are instructed to sit and watch. Skills are taught not with words but through silent demonstration.

Stylized characters This vital image of a buffalo hunt is made with pigment painted within dark outlines on a stretched elk hide. Stylized hunters, horses, and buffalo circle and charge the perimeters of a skin "field." Men at the center chant or dance to the beat of a drum. Each color is evenly distributed throughout the scene, creating harmonious balance and helping our eye to dart around.

Horses It is interesting to note how the outstretched limbs of these horses echo European images of the running horse before the sequence-photographer Muybridge taught us to understand their movement differently.

Buffalo Hunt
19TH CENTURY
SHOSHONE SCHOOL

The Human Condition

IN THE SPECTRUM of these vastly different gatherings of people, we find a spiritual vision, a death charge of brutality, and the gentle humor of sedate ridicule. We also see qualities of line, mark, color, texture, and focus, which by their choice and handling actually become the force and spirit of each image. Blake has illuminated his saddened Virgil on the shores of a dark world, where he watches a turbulent spiral of punishment for the damned.

Misted in translucent layers of paint, pale souls of the lustful are being spun into yet another realm of hell.

Käthe Kollwitz scratched and engraved her army of clay-footed troglodytes who rage into war like a mudslide of revenge. Heath Robinson lived through the same war-torn era as Kollwitz, and sweetened the often bleak years with his impractical inventions. Opposite, a pink-inked cinema wobbles along with string, inextinguishable in its fortitude and humor.

WILLIAM BLAKE
British visionary, poet, writer, artist, and engraver who powerfully illustrated his own texts in addition to Dante's *Divine Comedy*, the Bible, and other works. Blake was driven by a passion for justice and a profound belief in his visitations from angels.

Brushed line and wash This is an ink-outlined drawing made with a fine brush on paper with added washes of watercolor. The image was subsequently redrawn as a line engraving. It illustrates a scene from Dante's *Divine Comedy*. The muscularity of Blake's figures was inspired by Michelangelo's works.

The Circle of the Lustful (The Whirlwind of Lovers)
1824
14¾ × 20⅞ in (374 × 530 mm)
WILLIAM BLAKE

KÄTHE KOLLWITZ

German printmaker, sculptor, and draftsman, who lived in a poor district of Berlin. Kollwitz survived the two World Wars, and her powerful and sensitive drawings center on nurture, poverty, and the impact of death and war upon women, children, and the family home.

Scratched lines This is a dry-point etching with monoprint. The image was scratched directly onto a metal plate. Ink rolled over was selectively polished off using a rag. What remained in scratched grooves printed on damp paper as lines, and controlled smears on the metal surface printed as tones. White marks were made with a dusting of French chalk on the artist's finger to wipe away ink, leaving clean metal.

Losbruch (The Outbreak)
1955
20 × 23⅜ in (507 × 592 mm)
KÄTHE KOLLWITZ

HEATH ROBINSON

British humorous illustrator and a regular contributor to magazines and journals such as *The Sketch* and *The Bystander*. Robinson and Kollwitz (*above*) share almost identical life dates and their work expresses a shared history from opposite sides of the world wars.

Pen and wash This is a pen-and-watercolor drawing made for a color-plate reproduction in an edition of The Bystander. With masterful gentility, Heath Robinson shows England in a past era, plodding along with hazy, stoical bemusement. He created humor by making his characters earnest, sincere, and clearly focused, however meager or ridiculous their activity.

The Kinecar
1926
10⅜ × 15 in (262 × 380 mm)
HEATH ROBINSON

Disposable Pens

DISPOSABLE PENS (ballpoints, fiber-tips, rollerballs, gel pens) are the most convenient of all materials with which to travel. Unlike pencils, which can snap or pierce through your clothes, a disposable pen with its clip-on cap goes anywhere, dropped in your pocket and forgotten till needed. So many stores sell them, they can be obtained within minutes.

I keep quantities at home, in the studio, in the car, and in most pockets so I can always record a thought or idea. Quick-drying, these pens enable you to sketch, jot notes, turn the page, shut your book, or put the paper in your pocket instantly without fear of smudging. Available in blacks and ranges of colors, they each offer distinct and sometimes unexpected qualities. For example, a ballpoint will make faint lines, indent paper, build to a rich, dark sheen, blob when old, or turn into washes and make monoprints if flooded with an alcohol-based substance such as hairspray.

QUICK NOTES

On a cold day in Venice, two tourists and their gondolier drifted past me on a canal. There were only seconds to snatch this impression between their emergence from one bridge and disappearance beneath the next.

Fine fiber-tip *Drawing with a fine fiber-tip pen, I swiftly focused on gesture, trusting shape and form to follow. At a time like this, aiming for correct outlines would result in drawing too slowly to catch the moment.*

CHOICES AVAILABLE

There are many disposable pens to choose from. The four illustrated here represent a basic range. Remember, if you wish your drawings to last and not fade or blur with time and exposure to light, choose pens labeled "permanent" or "lightfast."

1. BALLPOINT: Black and bold colors offer diverse qualities. Lines thicken as the pen wears out. Grand Canal (see pp.188–89) and Caravans (see pp.192–93) were both made with a ballpoint.

2. ROLLERBALL: A constant ink flow is delivered through a metal tube over a tiny ball bearing. Insensitive to pressure; lines do not vary in width or tone.

3. FIBER-TIP: Manufactured for artists and designers in a range of widths, they are lightfast, water-resistant, permanent, and pressure-sensitive. Ideal for precision work (see pp.76–77 and 214–15).

4. GEL PEN: Produced in black, white, and ranges of colors, including luminous and metallic. White gel pens are very effective on dark papers.

1

2

3

4

FROM MEMORY

Here I used the same fiber-tip pen to compose a scene from memory. Earlier I had witnessed a crowd of fellow travelers crammed en masse in a fleet of hired gondolas complete with musicians and choir.

Fast lines These scribbled lines model the mass and shadows of heads belonging to passengers packed into the boat. Fast lines focus on action, not form. Compare this to Klee's mules on p.31.

The Travel Journal

I CANNOT OVERSTATE THE JOY of making a travel journal. Every drawing writes an indelible memory of place, activity, and companionship. No camera can tie you to a time or people in the same way. However, when out drawing, life will not slow and wait for you to catch it. You must learn to trust your memory and to draw what impressed you most. Exaggeration helps; if a person was stout, make them stouter, if animated, animate them more. Push toward caricature and this will draw out of your memory what was most important. Above all, focus on the action of the event, not its outline. You will make outlines, of course, but they should not be what you dwell on. Each line acts its part in the narrative; let it enter the stage and perform. Let the line of the flying coat fly and the hanging arm hang. Don't worry about measuring angles, just draw the action; angles will happen as a matter of course.

FLEETING MOMENTS

Walking through Venice with a small, black, pocket notebook and a fiber-tip pen, I caught fleeting glimpses of gathered people and solitary souls going about their affairs. Each one was witnessed and drawn immediately from the afterimage of what I had just seen.

Movement

Circular lines buzz around a man puzzling at the end of a train platform (*left*). A curatorial assistant flies to do a chore (*right*); all action is in the line of his coat and directed by his nose.

Observation

A large lady is photographed in front of a delicate work of art. In turn, I am watched by the aggravated guard, eager to herd us all from his house of responsibility.

Expression

The same willowy assistant dashes about his work. I drew him three times on the same page to catch a range of his physical expressions. The rush of his legs is amplified by their blurred lines.

Catching the Moment

ON A BITTERLY COLD November day, I took refuge in a church in Venice, and there met this sullen custodian. He and his simpering assistant would not allow me in, forcing me to remain at the back and look at them, rather than the works of art they guarded. Here I have recreated my drawing in steps to show you how to set about capturing such a scene.

When your attention has been caught, and you decide to draw the moment, start by focusing on its action, emotion, and reason for happening. Identify the principal character and draw him or her first. Place the person carefully. For example, if they are being haughty, elevate them in the pictorial space; if they are being devious, you might place them lower down. Be aware that their placement on the page is part of the narrative. Here the custodian projects fastidious ownership of his desk and pamphlets by pushing from behind the center of the space and challenging our entry to his image.

ACTION AND DETAIL

When drawing people, focus on action, not outline, and let every detail speak by its size, placement, and involvement in the story. For example, decide how faces and bodies contort; furniture leans, pulls, or pushes; and clothing or bags hang, flap, or bulge.

The custodian

Identify your principal character and their psychological role in the scene. Decide where you will place them on the paper to emphasize their action and intent. Draw their action, together with any immediate props they are using, such as the desk and pamphlets seen here.

The assistant

Identify the antagonist (or second character) in the scene. Decide where to place them to emphasize their role. Draw their action and props. Here, I added the assistant, who is largely expressed through the shape and fall of his raincoat and his way of using a note pad. If drawing a more complex scene, continue adding characters. In the final step (*left*) I reinforced the custodian's desk, which is pushed toward us in a gesture of confrontation. With a few strokes, a pillar locates the scene in a depth of space.

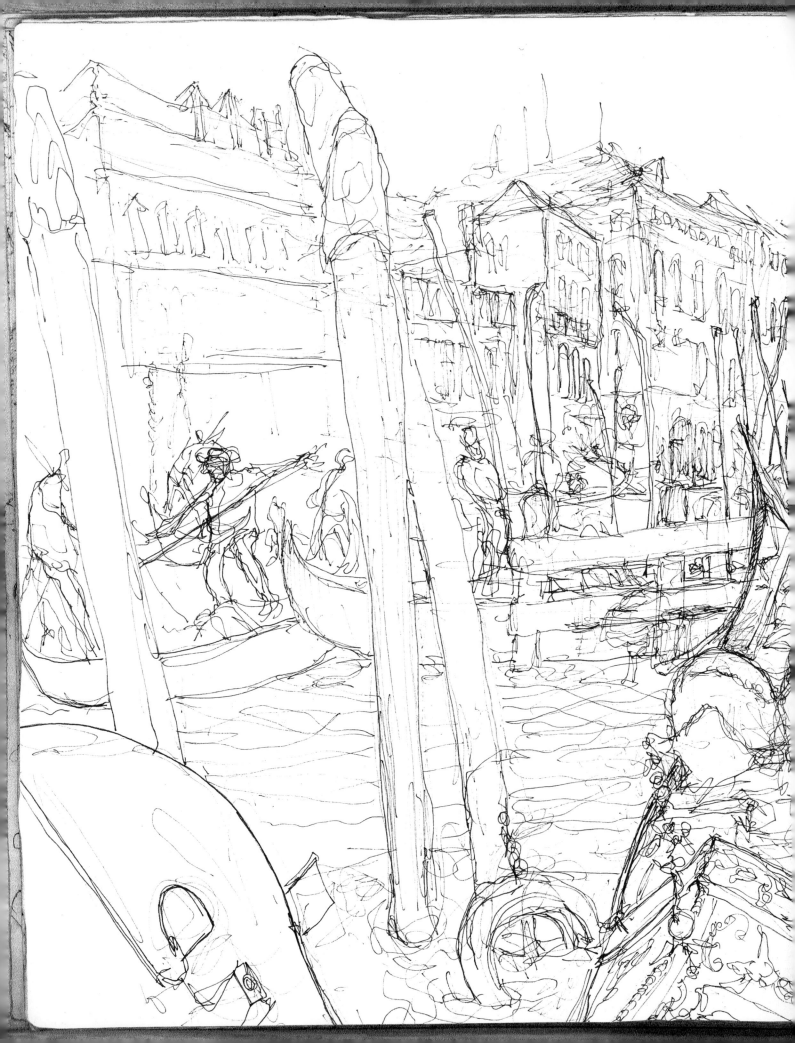

Grand Canal

THE CANALS OF VENICE are bustling places full of occupation, where vertical mooring poles give space and pulse to the horizontal speed of water and buildings. An imminent deluge of tourists urged me to work quickly, catching no more than the skeleton of the view. I developed the detail of this drawing from memory using a ballpoint pen.

Crossings

DURING THIS RUSH HOUR, Venetians flow across a stepped
bridge and cascade into the streets beyond. Characters in the
foreground were drawn first, then the bridge beneath them,
followed by the streets. Each person was glimpsed in an
instant, and drawn immediately from memory.
To catch characters like this, note
only their most essential action
and feature. Caricature each
person slightly.

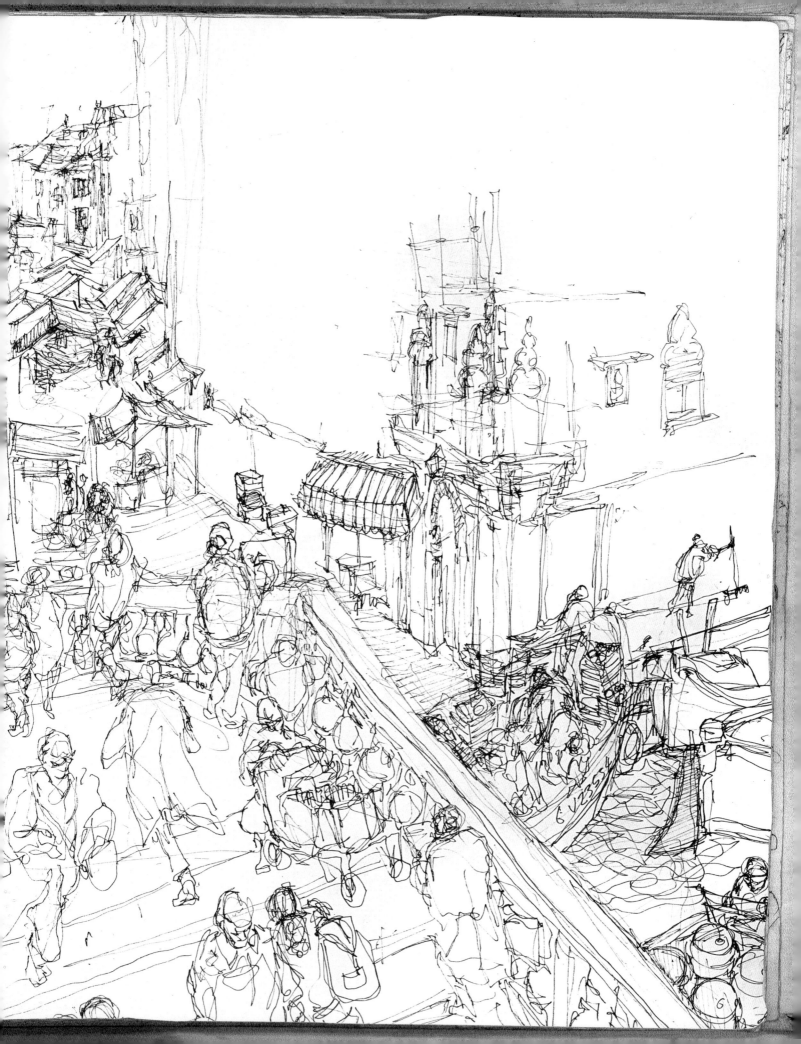

Caravans

THE PARAPHERNALIA OF TRAVEL is an intriguing
part of circus life, and a great subject to draw.
Caravans and other backstage activity convey
expectations of energy and repose. I found
this circus by chance in the Swiss mountains.
Sitting at a distance on a hot, quiet
afternoon, I used a ballpoint pen to
compose a series of scenes.

Overleaf: The Big Top

Earth and the Elements

IT MAY SEEM PERVERSE to start a chapter titled "Earth and the Elements" with an image of the Moon, but it can be seen as a lens to our observation of this planet. It is Earth's satellite, our companion, and its draws the tides of the seas. Just as NASA photographs of Earth have had a profound effect on the way we view our fragile home, so John Russell's *tour de force* drawing (*opposite*) was a masterpiece of observation in his time. This is the world's first accurate image of the Moon. It now hangs on the staircase of the History of Science Museum, Oxford, England, surrounded by the bright instruments of centuries of navigation, speculation, and experiment. The pastel drawing was constructed from myriad telescopic observations almost 200 years before the Apollo Moon landing.

The forces of nature, as opposed the physicality of Earth, are the real subjects in great landscape drawings. Look closely at works by many artists and you will see that they have not represented hills, trees, rivers, and the sea. What they have drawn is the force of nature on these properties: how the wind heaves the night ocean; how the mountain cut by ice and rain is now fleetingly lit; how the soil is scorched, or has cracked and fallen under the weight of water; and even how the Sun illuminates, and meteor impacts have scarred, the face of the Moon. By drawing such momentous and everyday events, artists see for themselves that which is momentary and eternal.

William Turner is said to have had himself lashed to a ship's mast to comprehend the storm (*see p.199*). Richard Long, a contemporary environmental artist, makes his work by the act of walking, marking the ground with lines of footprints or by turning stones, arranging them in perfect circles on the mountainside or in lines drifting out of sight beneath low clouds. There is a sense of the heroic in drawing outside—we race to catch a form before the tide engulfs it, the sun comes out to blind it, or the wind carries it away.

Weather is essential in all landscape drawing. Beginners will often choose calm, sunny days, when little stirs and empty blue skies offer even less to latch lines to. These conditions are very difficult to express well. It is better to get up before dawn; to be ready to draw the new light as it breaks across the land. Take chances against the rain and work with the wind or fog; they are the animators of your subject. In this chapter we experiment with charcoal, learning to draw light out of dark, and take bold steps in emulating the swell of clouds and the forces of torrential water.

JOHN RUSSELL
A portrait pastelist to King George III of England, and an astronomer who dedicated 20 years to studying the Moon. Russell drew this, the first-ever accurate image of the Moon's surface, two engraved maps known as the *Lunar Planispheres*, and a moon globe called the *Selenographia*. He also produced an album of 180 exquisite pencil drawings; pages of softly illuminated craters and lunar "seas" covered in mathematical and shorthand calculations.

Moon Pastel Drawing
1795
5 ft x 5 ft 6 in (152 × 168 cm)
JOHN RUSSELL

Air in Motion

THE GREAT INVISIBLE SUBJECT of these drawings is the wind. By seeing how it shakes, lifts, and gives motion to each image, and by observing its tides and eddies in our own environment, we can soon learn to draw its force. Below, Daumier's cartoon shines with the brilliance of his comic memory. He knew how the world bends and stutters under such gusts. This wife, like an umbrella forced inside-out, has become a hysterical kite, fluttering heavily; a sail broken loose in a stormy marriage.

Turner carries us to the heart of the maelstrom. Terrifying waves of merciless nature roar across the paper. The great master of English seascape is conducting with his graphic energy. The ship, a scratched ghost, is already lost.

Hokusai's sedate wind presses reeds and the journeys of young ladies. Flapping kimonos and an onlooker turning his back have the magic of a moment caught, undramatic but brimming with stylized realism.

HONORÉ DAUMIER
French satirical cartoonist, lithographer, painter, sculptor, and pioneer of expressionism. Through political drawings he fired his sharp wit at the king, the government, the bourgeoisie, and the legal profession, serving a prison sentence for his views.

Crayon and limestone This is a lithograph. A hard waxy crayon was drawn across a heavy limestone. Varying definitions of line and depths of tone conspire to give volume, distance, speed, and solidity. Fluid strokes inflate the woman's dress and pin shadows to the ground. Hazy vertical marks reveal buildings receding into the mist. Dots and dashes suggest trees out of focus.

Danger of Wearing Balloon Petticoats
UNDATED
HONORÉ DAUMIER

J. M. W. TURNER
British landscape, seascape, and history painter whose primary interest above all was light. Turner worked in oils and watercolors and sketched copiously on his travels. There are many stories of his passionate working methods, including being lashed to a ship's mast in order to study a storm.

Pencil and watercolor Stains of subdued watercolor are splashed, brushed, and pressed into this absorbent sheet. The paper's very own color is brought through as banks of mist and fog. A penciled outline of a skeletal ship is scratched into the waves, while the whole composition leans and swells around its fateful center.

Ship in a Storm
c. 1826
9½ x 11¾ in (241 x 300 mm)
J. M. W. TURNER

KATSUSHIKA HOKUSAI
Prolific Japanese color wood-block printmaker, painter, designer, and book illustrator, influenced by examples of Western art obtained through Dutch trading in Nagasaki. Hokusai in turn has since significantly influenced European art. Landscape and city life were his principal subjects, and his best-loved works include 100 views of Mount Fuji and 12 volumes of Manga.

Wind direction This is a colored wood-block print. To represent wind, Hokusai has chosen the direction from which it blows (from the right), then lifted clothing horizontally and flowed it into the stream of the wind. Plants also bend and flow from right to left.

Coup de Vent à Asajigahare
1802
8½ x 13½ in (217 x 343 mm)
HOKUSAI KATSUSHIKA

Storms

STORMS CAN BE SEEN and drawn in two ways: first, as a subject and second, as a gestural storm on the paper. The very nature of both is turmoil and an interweaving of elements, inks, marks, water, and tossed objects— a perfect subject in which artists can forget themselves, grab their brush, ink, or charcoal, and swim into the page.

The menacing darkness of Hugo's storm below is so convincing, it is difficult to contemplate its brooding and

night-soaked heart. He brings us to stare into a place that no sane human would enter. Opposite, Leonardo's *Cloudburst of Material Possessions* is one of his most enigmatic and mysterious works. It looks so contemporary, as if drawn just this year. Domestic objects we can own and name fall from the clouds, lines of rain escorting them to bounce and clatter. An update on biblical showers of fish and frogs, this is a bombardment from our homes.

VICTOR HUGO
French novelist and artist (*see also p.28*). In periods between writing, drawing was Hugo's principal means of expression. His subjects include ruins, fantasy palaces, haunted shadows, and the sea studied from his home in Guernsey in the Channel Islands.

Pen and brush Hugo drew first with pen and ink, composing banks of waves and dense, active surfaces of water. Then, with a brush, he blanketed the drawing in darkness, leaving nothing but a glimpse of moonlight glistening on the froth below. Turner (*see p.198*) admires the majesty of nature. By contrast, this is a writer's narrative of terror.

Le Bateau-Vision
1864
7½ × 10 in (192 × 255 mm)
VICTOR HUGO

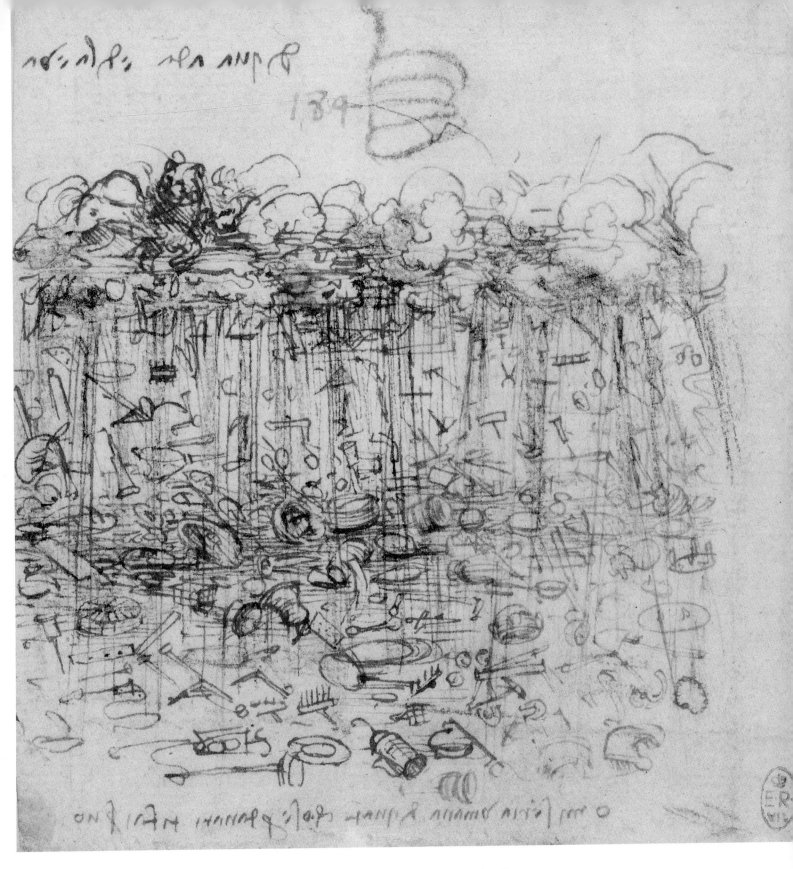

LEONARDO DA VINCI

Leonardo devised many artifacts of our modern lives, envisioning machines centuries before their making (helicopters and bicycles, for example). He bequeathed his drawings to a friend, and they passed through private hands for 400 years before becoming widely known. It is interesting to speculate how engineering might have developed if his ideas had been shared with the world earlier.

Ink and chalk This is a pen and ink drawing with touches of black chalk. Each item that has crashed from heaven is drawn in such a way that we can feel Leonardo's nib picking it up in the speed of a doodle. There is a little magic in recognizing many items from our homes — something like a rake, a hook, a bell, and a wheel, together with half the contents of our garage. Above and below are examples of his mirror handwriting. He was left-handed and wrote backwards in Italian from left to right.

Cloudburst of Material Possessions
1510–12
4⅝ x 4⅜ in (117 x 111 mm)
LEONARDO DA VINCI

Nature Profiles

THE PROFILE OF A HORIZON is a line we immediately recognize and respond to. Whether land-, sea-, or cityscape, it is the unique calligraphic signature of the place in which we stand. Claude Lorrain drew directly on location, and we can imagine standing over his shoulder, watching his hand and eye at work together, rapidly layering contours to shape place, atmosphere, and mood simultaneously. Even distilled from all other detail, a horizon line can trigger our recognition.

Opposite below, Clare Bryan took panoramic photographs of the English South Downs, and after tracing her captured line, transferred it to a scroll. Drawing with a scalpel, she teased away fragments of paper to illuminate her view. In a very different work (*opposite above*), made inside a book, Bryan cut the profile of a city. She was inspired by her research of aerial plans of London and the story of an alien map butterfly (*see caption*).

CLAUDE LORRAIN
French classical landscape painter, draftsman, and etcher, who lived most of his life in 17th-century Rome. Claude is distinguished by, and famed for, his unsurpassed handling of light, which he used to unify his compositions.

Segments The top half of the drawing is a view as we enter the valley. Claude has used a fine nib to delineate segments of land as they recede into space. In the lower half, he has walked downhill a little, and across to the right. Over first lines, rich, thick, and dry marks in the foreground appear to be made with his finger. Paler, cooler tones receding into the distance are applied with a brush.

Views from Velletri
c.1638
8⅝ × 12½ in (219 × 320 mm)
CLAUDE LORRAIN

Scalpel-drawn This book-bound drawing was inspired by the story of a foreign butterfly wrongly introduced to Great Britain in 1912, then hunted down and destroyed. Ideas of introduction and removal led Clare Bryan to research historical plans and aerial drawings of London showing its population growth since Roman times. On turning the pages of City, progressively more and more paper is drawn away with a scalpel to show the expansion of human settlement around the river. The edges of each page (cropped here) fade into the solid paper of an unpopulated landscape.

City
2001
11⅞ × 11½ in (300 × 290 mm)
CLARE BRYAN

CLARE BRYAN

British artist, printmaker, graphic designer, specialty bookbinder, and visiting professor at numerous art schools. Her recent paper, photographic, and digital print-based works reflect upon the histories and poetry of "left behind and in-between spaces."

Cut line This is a small section of a preparatory 5-ft (1.5-m) scroll. The horizon was drawn with a scalpel, undulating a cut ⅟₁₆–⅛ in (2–3 mm) wide. The work is illuminated by standing its lower edge on a source of light.

Landline
2003
27½ × 59 in (70 × 150 cm)
CLARE BRYAN

Charcoal

CHARCOAL IS PRODUCED from wood baked slowly without exposure to air, so it chars black as opposed to igniting and turning to ash. Willow is the most common wood. Artists have also used lime, beech, maple, vine, and plum. Bundles of twigs were traditionally sealed into earthenware jars or wet clay and heated slowly and intensely in a fire or kiln.

Charcoal lifts away from paper easily with the very light touch of an eraser, a piece of fresh bread, the heel of your hand, a rag, feather, or fingertip. Lines are achieved by depositing particles in the grain of paper. Smooth paper accepts few particles, resulting in a pale line. Rough paper can be loaded, and offers a rich, black finish.

Charcoal naturally glistens. It can be made duller, blacker, and more indelible by soaking it in linseed oil. Alternatively, you can purchase machine-made compressed charcoal. As its name implies, it is compressed and molded at high pressure, resulting in a stick that gives a blacker, harder line. It does not erase easily, leaving undertraces of first thoughts.

RANGE AVAILABLE

Charcoal (in its several forms shown here) is loved or loathed by the beginner to whom it is often recommended because it produces pleasing results quickly. It is also easily erased if the maker of the mark is not happy with the result.

1. THIN WILLOW CHARCOAL: I used a piece like this to make the drawing opposite. The tip snaps easily to renew a sharp edge if required.

2. MEDIUM WILLOW CHARCOAL: The same as above, only a little thicker. Boxes often contain a range of thicknesses to choose for different needs.

3. THICK WILLOW CHARCOAL: Big pieces are perfect for very large-scale drawings—even larger than yourself. Try it working on big paper covering a wall.

4. CHARCOAL PENCIL: Types made by different manufacturers vary in quality and density of line. Essentially, they are all intended for fine work.

5. COMPRESSED CHARCOAL: Machine-made, cylindrical, blacker, and heavier than willow. Not to be confused with square conté sticks (see p.162) or graphite (see p.54).

6. CHALK CHARCOAL: Technically, this does not exist. Beware of cheap brands selling dyed chalk as compressed charcoal. In use, it looks gray and feels like chalk.

7. SQUARE COMPRESSED CHARCOAL: Not often sold, but some specialists stock compressed charcoal in delicate square sticks. A great find when available.

LIFTING OUT

This technique is a very easy method of drawing a crisp, fine, white line into the black- or grayness of willow charcoal. It allows you greater precision in your mark-making than if you rub away the charcoal with an eraser.

1 | Suspend a length of masking tape, sticky side down, between your middle finger and thumb. Hold it over your drawing without touching the surface.

2 | Keep the tape above your drawing. Use any fine-point pen or pencil (I used a ballpoint) to draw a firm line on the back of the tape. Then lift it away.

3 | A white line is lifted out by the tape. Slightly dull the tape's stickiness before use to prevent it from lifting out more than you intend.

ERASING

Thickly applied charcoal quickly overcomes a plastic eraser. A warm (soft and tacky) putty eraser is more effective, as is fresh (unbuttered!) bread. Here, I used a plastic eraser effectively on thinly applied charcoal.

Lifting out This detail shows an example of where I used the lifting-out technique demonstrated opposite to draw flashes of lightning against rain clouds. Different tones seen throughout the main drawing on pp.212–13 were made by altering the pressure applied to the charcoal.

8. TORTILLON: This is a tight roll of paper used to blend charcoal, graphite, pastels, or any other dry media. Layers can be peeled away to refresh its surface. Cotton swabs also work.

9. PEN: Any fine pen or pencil can be used to draw on the back of masking tape when lifting out. Here we used a ballpoint. Lift out broader marks with a larger implement.

10. MASKING TAPE: An invaluable resource, sold in several widths. Use high quality (very sticky) to fix paper to walls and boards. Use cheaper (less sticky) for lifting out.

8

9 10

Landscapes

TREES ALONE OFFER MARVELOUS shapes to draw. They are also good markers of receding space, especially when making first excursions into aerial perspective. This term simply means that as land rolls away into the distance, details blur and colors grow paler and bluer. It is the visible effect of the atmosphere between where you stand and what you see in the distance.

Landscape drawings are traditionally arranged in three parts: a detailed foreground; a less distinct middle ground composed of shapes and textures; and an abstract, hazy distance. Successful drawings often only suggest the qualities of the scene without overdescribing them. On

pp.98–99 we noted that in response to visual stimulus, our brains search for nameable things and will perceive complete pictures from very little information. Ironically, the less you describe, the more you encourage the viewer's imagination to join in and see. Excessive detail can be admired for its skill and achievement, but is often less evocative and engaging. At its worst, it results in flat planes of clutter. To experiment with drawing landscapes and the use of charcoal, pack your materials (as advised below) and set off for a local view, or your nearest arboretum. Don't worry if it is cloudy; clouds add drama and perspective and make good subjects in themselves (*see pp.212–13*).

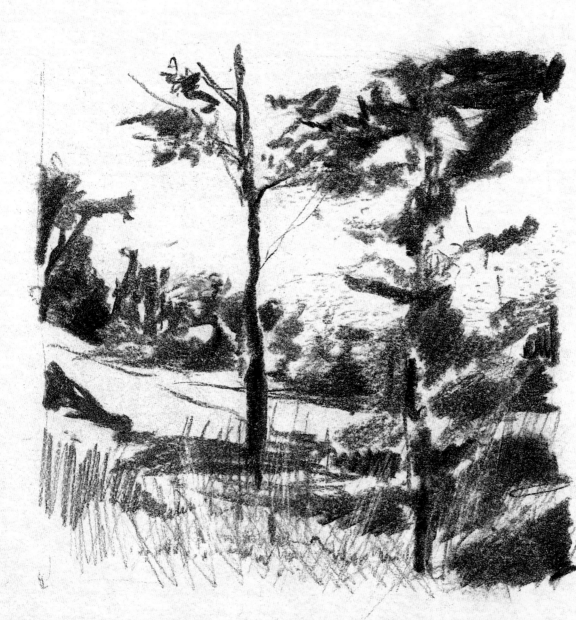

MATERIALS

Pack several thick and thin sticks of willow charcoal, a reel of masking tape, an eraser, your drawing book or a board and paper, fixative (or hairspray), and a cushion in a plastic bag to sit on. When you arrive, begin by marking out several small squares on your paper, to contain each of your compositions.

Seeing tones

In this first view there is only a foreground and middle distance. The long view is hidden behind trees. I relaxed my eyes out of focus to dissolve distracting detail into abstract patches of light and darkness. Then I drew the shape of the tonal patches I perceived.

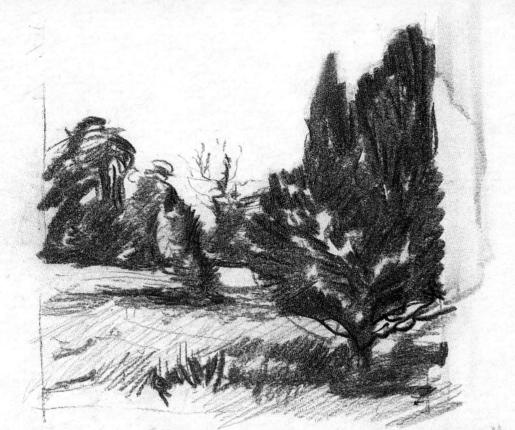

Exploring the view

In my second square I explored a simple view contrasting soft, rounded, dark trees with bright, horizontal regions of grass. This composition turned out a little flat because I have an almost even quantity of earth and sky. It is better to give distinctly more pictorial space to one or the other (*see below*).

Inventing drama

Redrawing the scene above, I have invented drama with diagonals set against each other. I tilted the earth, shadows, the trunk of a bare tree, and broke a view through the hedge into the distance with a dark sky threatening rain. Remember, your view is your inspiration, full of information you can use to create what you want!

Drawing in the Round

WHEN DRAWING IN THE LANDSCAPE, seek places in light shade out of the glare of the sun, so the paper is not made blinding and your hand cannot cast a shadow on your work. I usually begin by making an image of the whole view. This first drawing serves as a process of arrival, settling my concentration, and seeing what the real choice of subject is.

After my first drawing, I am then able to home in on what interests me most for further study. For example, making the scene below led me to focus on the decaying boat opposite. Similarly, on pp.214–15 my first drawing of the whole view of the Tiber led me to see the real subject of the day, which was the flow of water over rocks.

FINDING THE SUBJECT

Finding a remarkable subject is even better when you can circumnavigate it in an arena of space. The mud of the tidal shore in Rye, England has embedded within it the decaying skeleton of a burned fishing boat, bare ribs, engine, and tiller still standing proud. Circling a subject and drawing it from several views imprints on your memory a better understanding of its three-dimensional form. Building on earlier studies of structure in space using shoes (*pp.164–65*) and a wire violin (*pp.104–05*), your challenge now is to find a sculptural subject in the landscape, taking with you your drawing book and pen.

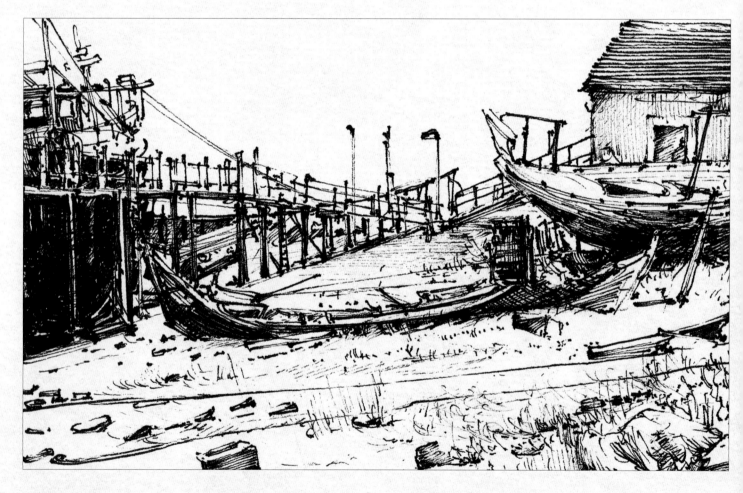

"Drawing in the round means to literally walk around your subject, observing it from several views so as to better understand it as a whole."

SERIES OF STUDIES

This stunning ghost of a boat comes into view twice a day, when the sea recedes. When you have found your subject, make a series of drawings from different positions. Each new drawing gives a different insight.

1 | Here, I spent equal time looking at the subject and the paper, marking straight, careful lines to establish the skeleton that gives this wreck its distinct form, character, and structure.

2 | In this tail-end view, I looked more boldly at the planes and the dynamic of the sculptural craft. My lines have become darker and more forceful as confidence in my understanding of the vessel grew.

3 | This impression notes the angle of the broken boat, its overall balance, and the order and shape of its component parts. I drew with quick, unfussy lines, looking more at the boat than at the paper.

4 | From this low position I have emphasized how the boat is swallowed in mud by outlining its shadow on the ground. The outline ties a shape of darkness to the boat like a weight so that it becomes part of its form.

Overleaf: Decaying Boat

Cloudburst

THIS STORM DRAWING, made on smooth,
hot-pressed drawing paper (*see pp.20–21*)
using a thin stick of willow charcoal, was
made with gentle but unhesitating speed.
Looking back and forth from the heavens
to firmly taped-down paper, I worked quickly
to catch and weave the turbulent contrasts
of rising wind and approaching water before
the drawing could be washed away.

Notes of Force

THE GREAT FLOWING TIBER RIVER has cut through Rome, shaping the city, since
ancient times. On the pages of a small, black, pocket-sized notebook, I drew with
a needle-fine fiber-tip pen, focusing on the river's eddies, pulse, and rhythmic
detail as it passed through the ancient gully of the city.

Mountains

SITTING IN THE SHADE of a tree on the Greek island of Antiparos,
I used a dip pen and waterproof India ink with brushed watercolor to
draw the view. The strong diagonal of the composition from bottom left
to top right carries the eye through changes of height and focus from
the foreground to the mountains beyond.

23rd

Abstract Lines

THE DEVELOPMENT OF WESTERN abstract art at the beginning of the 20th century significantly paralleled major changes in world thought, belief, and history. The growing rise of Darwinian ideas coupled with Freudian and Marxist perspectives forced Western society to reconsider its origins and future. Internal workings of the mind were suddenly free to find a new language of expression. Artists were given a different tool—a line threaded directly from their subconscious to their hand—and with it they began to map a bold new landscape of marks and concepts that would dramatically and forever change the face of Western art. The fate of Old World thinking was finally sealed with the brutality of World War I. Afterward, picturing a stabilized world was impossible and Modernism rode forth with vigor.

However, abstraction is not so easy to define, and it has always been with us. It was not invented in the 20th century, only rediscovered. From one point of view, all pictorial representations are abstractions of reality. From another viewpoint, many non-Western cultures have highly sophisticated abstractions at the core of their art, and have been making abstract drawings for centuries—Japanese calligraphy, for example, Indian mandalas, and Aboriginal art. Perhaps in Western culture we bred this intuitive freedom out of ourselves in our insistence on complex figuration. Outsider artists, such as Adolf Wolfli, opposite, and young children show us that abstract, expressive marks and shapes are at the core of natural, spontaneous image-making.

Not everything we know has a physical form in the world. Many concepts and feelings can only be expressed through marks, sounds, actions, or gestures. An abstract mark is often a better conductor of a thought or feeling, precisely because it does not have to represent a physical object; it is simply itself. People are often scared by abstraction and see it as the enemy of figurative art. It is actually its foundation and its infrastructure. My own work is firmly centered in figuration, yet my kinship to abstraction is fundamental. I begin every image by feeling its meaning, direction, and emotion. First marks, which are essentially abstract, strike the paper to find form. As you approach the classes in this chapter, don't be timid; be brave and enjoy them. Abstraction is a direct, liberating, and independent means of communication. It also underpins and gives strength and unity to all figurative work.

ADOLF WOLFLI
One of the greatest masters of Art Brut, Wolfli was a Swiss draftsman, poet, writer, and composer who suffered from paranoid schizophrenia and was resident in the Waldau Aslyum near Berne. He made thousands of drawings to chronicle his complex life. Swirling, writhing torrents of color, fictional language, drawn sound, and poetic myth roar and cascade within his tightly framed pages. His drawings are collected and exhibited internationally and held by the Adolf Wolfli Foundation, Museum of Fine Arts, Berne.

Saint-Mary-Castle-Giant-Grape
1915
41⅜ x 28⅝ in (105 x 72.8 cm)
ADOLF WOLFLI

Process and Harmony

SOMETIMES A DRAWN LINE sings on the surface of its support. Sometimes it smolders like a deep shadow. It can proclaim mood, silence, and sensitivity with its thickness and pressure of touch. A line can be finished in a second, or, as Twombly shows us opposite, it can keep reforming through the inherent repetition of a process. A Neolithic chalk tablet bears cut lines that were slowly carved. Below, Mamoru Abe prepares an image that will appear through the chemistry of iron, water,

and patient watching. Abe's physical drawing is a sculptural installation. Damp Japanese paper was laid over carefully arranged iron bars. Moisture produced rust, staining red-brown lines into the white surface. Five forged steel shapes, akin to stones in a Zen garden, sit in silent harmony, quoting ink marks on a page. Twombly's mesmeric wax line worked over house paint is like a signature, rhythmically engaged with itself, scrolling across the canvas in an intimate crescendo.

MAMORU ABE

Japanese sculptor and installation artist, and Assistant Professor of Fine Art at Fukuoka University. Abe works with materials such as soil, forged steel, brass, ice, salt, and plaster in galleries and landscapes. He travels widely to research ancient sacred sites.

Lines, tone, and texture Pillars of the gallery are made part of this drawing by their inclusion in the paper. This amplifies their bracing separation of the floor from the ceiling. Iron rods reaching from beneath the paper rest within the framelike rim of floor space. Changes in tone, texture, and temperature between paper, iron, and wood are also part of the work.

The Physical Space
1990
30 x 30 ft (914 x 914 cm)
MAMORU ABE

ANCIENT CARVINGS

Many ancient cultures have made and left behind drawings and texts carved into stones or animal bone, such as the Rosetta stone, the Babylonian world map, and American Indian petroglyphs (*see p.241*). This example is one of two chalk tablets found in a Late-Neolithic pit, close to Stonehenge in Wiltshire, England. The site's purpose is unknown; theories suggest astrological observations, burials, and the worship of the sun and ancient gods.

Cut lines Chalk carves easily. Precise lines suggest the use of a sharp flint. The framed rectangle of this image is echoed in that of Abe's installation. The central pictorial space is also similarly cut and divided by the considered arrangement of straight lines.

Neolithic Chalk Tablet
3,000–2,400BCE
2¼ x 2¼ in (58 x 58 mm)
ARTIST UNKNOWN

CY TWOMBLY

Contemporary American artist who emerged through the 1950s New York art scene in the heyday of Abstract Expressionism and Action Painting. At the 2001 Venice Biennale, Twombly was presented with a Golden Lion award for lifetime achievement.

Language Over the course of fifty years, Twombly has evolved a raw, energetic, emotive, and sensuous language that challenges the separation of word from image, and drawing from painting. Many of his graffiti-like works combine abstract gestures with statements. Here we might seek to grasp letters in the turning of his line.

Untitled
1970
CY TWOMBLY

Writing Time

SINCE THE EARLY 20TH CENTURY, abstract artists and composers have striven to break down old pictorial and musical structures to explore new and unfettered modes of expression. Both abstract drawing and composition involve the perfect sequencing of sounds and marks against space and silence.

Bussotti, opposite, broke new ground in the 1950s with graphic scores now considered among the most extreme, beautiful, and inventive of his time. A graphic score is a unique, abstract, music manuscript requiring instrumentalists to improvise, interpret, and participate in the composition. The scores are also exhibited in galleries as visual art.

Hugo, below, said, "There is nothing like dream to create the future." An innovator who never fails to surprise, here he anticipates abstract expressionism by 100 years. His drawing writes the time of its own physical process by expressing the extreme concentration of the moment in which it was made.

VICTOR HUGO
French novelist who made many drawings in mixed media (see also p.28). Hugo's abstract drawing here can be described in terms of *Gestalt*, a German philosophical idea about the power of moment, often expressed in visual terms. *Gestalt* is the instant recognition of an unnameable thing, a configuration, or a pattern of elements so unified as a whole they cannot be explained as a sum of parts.

Ink impressions When drawing nightscapes Hugo often laid paper disks in place of the moon, brushed night skies over them with ink, then lifted the disks to reveal white moons. Here he appears to have saturated the cut-out moon disks with gritty pigment, pressed them face down, and lifted them away to leave impressions of watery planets and seas.

Texture Compare this drawing to Hugo's octopus on p.28. Similarity in gritty texture suggests that here, too, he mixed graphite into ink, and let the drying meniscus deposit granules in linear drifts such as we would see in the satellite photographic mapping of rivers. Marks across the center appear to be made with his fingers.

Two Impressions from a Cut-Out Paper Disk
1853–55
VICTOR HUGO

SYLVANO BUSSOTTI
Italian avant-garde composer and principal 20th-century exponent of the graphic score. This is a page from *Due Voci*, Bussotti's first mature work. His later works become increasingly abstract; a far cry from any recognized musical notation.

Sound and rhythm This flickering rondo of sound written in pen on a hand-ruled stave can be heard in our imaginations as much as seen. Following the notes, we can feel their rhythm and easily attach sounds to them. Compare this work to that of Libeskind on p.70 in relation to Bussotti's clustered notes to the left of his rondo and open space to the right.

Circular Score for "Due Voci"
c. 1958
SYLVANO BUSSOTTI

Chants and Prayers

WHEN ABSTRACT LINES are organized in repetition, they make a visual and physical echo that touches some deep part of the human spirit. This takes a form in most cultures. Visually, it is found in the regularity of ordered lines or a pattern. In music it can be felt in the diversity of plainsong and African drumming, for example. These photographs document the meditative drawings of two women living worlds apart in different countries, cultures, centuries, and circumstances. In the late 19th century, Marie Lieb was a psychiatric patient in the Heidelberg Asylum, Germany. She tore cloth into strips and used these to draw patterns and symbols on her cell floor. Opposite, an anonymous woman in the southeast Indian state of Tamil Nadu makes a ritual drawing on the brick courtyard of her home, dipping her fingers into a pot of rice flour. It will protect the place from evil and make a pleasing invitation to good spirits.

MARIE LIEB
Little is known of this woman for whom the act of drawing was essential. Lieb is one of countless thousands of "Outsider" artists—diverse individuals including ordinary citizens, social outcasts, and sufferers of psychiatric illnesses—who have always existed, making objects and images outside of mainstream culture.

Torn cloth This is one of two published photographs showing Marie Leib's torn cloth strips significantly placed on her cell floor. Cloth is the simple instrument with which she has conducted and ordered her universe. Compositional rightness (see pp.228–29) has been adjusted with each movement of the rags to draw a cosmos of balance and perfection.

Cell Floor With Torn Strips of Cloth
1894
MARIE LIEB

STEPHEN P. HUYLER

Photographer, art historian, cultural anthropologist, lecturer on the subjects of Indian art and Indian women's identity, at the University of London and Ohio State University, among others. Huyler is the author of *Painted Prayers*, and for over 30 years has traveled extensively through the Indian subcontinent, creating an edited archive of 200,000 images. These are widely published in journals and are the subjects of international exhibitions.

Designs and motifs Rangoli (or mandalas) are ritual drawings made by many millions of women across rural India. Materials such as rice flour, chalk, lime, or flowers are marked or arranged on the ground or on the walls of homes, and in places of worship and celebration. Skills are handed down through generations and from friend to friend. Popular magazines feature new ideas each week, and on special occasions there may be contests. In daily practice, women pride themselves on never repeating a design. Motifs are geometrical or based on plants, animals, and birds.

Painted Prayers
UNDATED
STEPHEN P. HUYLER

Compositions

ABSTRACT DRAWINGS ARE LARGELY or entirely free from figurative representation—that is, free from the direct imaging of known physical things. Their energy can therefore be a purer expression of an idea or emotion.

These two works present complex compositions with differing intensions and methods of making, but similarities in mood, structure, and choice of hues. They each find their pathways and equilibrium in atmosphere and suggestion, using the viewer's eye to track and unfold layers of meaning. Catling's torn paper shapes and shadows spill light out of their frame like a fractured mirror. Oval moons eclipse each other and oscillate between landforms and portraiture; rocks or heads in a subdued atmosphere of dream. Klee's mathematical maze of thinly washed surface resonates with meticulous planning. With no depth of field, it is ruled and contained in one dimension by its interlocking ink-lined borders.

BRIAN CATLING
British sculptor, poet, performance and installation artist, filmmaker, Professor of Fine Art, Ruskin School, and Fellow of Linacre College, Oxford. Catling's works made for international galleries and museums involve drawing as a tool in their development and making.

Mixed media This is a collage of torn white and gray tissue paper previously stained with ink; gold paint and iridescent gouache mixed with water; and water-resistant layers of spray and enamel paint on thick paper. Catling's abstract drawings are usually made in series and in parallel to written poetry and sculptural installations.

Untitled 2001
2001
15¾ x 21⅝ in (400 x 550 mm)
BRIAN CATLING

PAUL KLEE

Swiss painter and sculptor (*see also p.31*). Klee painted, drew, philosophized, and wrote copiously about the natures and relationships of color and form. He explained his polyphonic painting as "a harmony of several color voices" searching for a visual parallel to music.

Geometric harmony This is a work on paper made with a sharp ink pen, ruler, watercolor, and brush. It is a geometric harmony of straight lines and tonally graded flat colors that by their arrangement draw our eyes inward to their white center.

Line and surface Klee observed the visual capacity of lines to push or pull within an image. We can see some diagrammatic examples of this among the optical illusions on pp.97–99. Klee also felt that a line represents the passing of time, whereas tonal surfaces are perceived more immediately as a whole, and might be read as active or passive.

Polyphon Gefasstes Weiss (White Framed Polyphonically)
1930
13⅛ × 9⅝ in (333 × 245 mm)
Paul-Klee-Stiftung,
Kunstmuseum Bern
PAUL KLEE

Being "Just"

A SENSE OF "JUST" (or rightness) is a difficult concept to explain, but an easy one to understand. When moving objects around in your yard, or home, or on a page, there is a clear feeling when, after being continuously adjusted, they reach a perfect position. There is a single moment when all proportions, angles, and elements settle in definitive balance. This balance is what every artist and designer searches and feels for when making an image. In his book *The Education of a Gardener*, the late garden designer Russell Page explains, "I have experimented endlessly with this idea. Take, for instance, a glass, a bunch of keys, and an apple, and put them on a tray. As you move them around, their impact, the impression you receive from them, will change with every rearrangement. Many of their inter-relationships will be meaningless, some will be more or less harmonious, but every now and again you will hit on an arrangement which appears just."

SETTING UP

Justness can be harmonious or deliberately discordant. It is found in all great art and design, regardless of style, culture, media, or degree of figuration. It is also found in nature. Seek it when looking at other artists' work and in your everyday environment. Feel for it when you draw. This exercise will help you start. Set up a sheet of paper with a rectangle drawn on it, and ten straight sticks painted black.

"When all pictorial elements come together in pleasing and perfect balance, they are just."







WHERE TO START

Take ten sticks of equal length, painted black. Within a rectangle on a flat sheet of paper, set about making a composition using no other rule than a sense of "just." Move the sticks to find alignments and imagined perspectives. When the composition falls into place, fix it with glue.

1 | Arrange your ten sticks in two groups of five, as shown here. Feel for the rightness of their grouping and their relationships to surrounding spaces. Remember, the drawn rectangle is a part of the composition (see *pp.56–57*).

2 | Move the sticks out into the rectangle, which now becomes a tight frame. Arrange them so they touch or cross in a series of intersecting balances. A stick touching the rectangle links the composition to the frame.

3 | In the step above, horizontals dominate the lower area, suggesting a horizon. Here, horizontals dominate the top, making the composition seem to float beneath. In the final step (*left*) there is an even balance.

Collage

HERE WE EXPERIMENT with collage, which is the shifting, overlapping placement of materials on a flat plane. Cut or torn layers and shapes, found or made items, colors and textures can be manipulated until their pictorial harmony, or discordance, feels "just" (*see pp.228–29*). This principal also applies to three-dimensional drawings such as Gaudi's work with wire and weights on p.69 and Abe's installation on p.220. Collage offers the artist a liberating palette of ready-made depths and surfaces; an infinite range of voices and meaning. Images and fragments torn from day-to-day life can be brought together to make a chorus of ideas and emotions. Returning to Russell Page, he went on to say "… you start composing by adding or subtracting shapes and textures and using colors and tones to achieve the impression you want to make—whether dramatic or subdued, hard or soft, harmonious, or even strident."

SETTING UP

This lesson in collage is a direct continuation of the compositional lines made in the previous class. Once the ten painted black sticks are set and glued in place, they become a scaffold for the addition of further textures, colors, and tones. To prepare for this lesson, stain and dry a sheet of tissue paper using blue ink. You will also need spare white paper, scissors, glue, a compass, correction fluid or white paint, and black ink.

"My understanding is that every object [or shape] emanates—sends out vibrations beyond its physical body which are specific to itself."

(Russell Page)

WHAT TO DO

Lay the final step of the previous lesson (*p.228*) in front of you. Cut six small rectangles the same proportion as your whole image, and with a compass and scissors, draw, then cut out, four circles of blue tissue paper.

1 | Regular-sized pieces of white paper are moved over the surface to disrupt the even lines. This can also give a sense of fragmentation or punctuation to the composition. Glue them in place once they feel "just."

2 | Translucent circular disks of tissue paper give color, tone, solidity, and shadow to the picture. The single disk that is folded with its straight edge facing up appears heavier than those that are flat.

3 | Torn white paper moved over the surface adds masks of rough-edged irregular volume. Obscuring the blue disks, they deepen pictorial space. In the last step (*left*), correction fluid and ink marks add further dimensions.

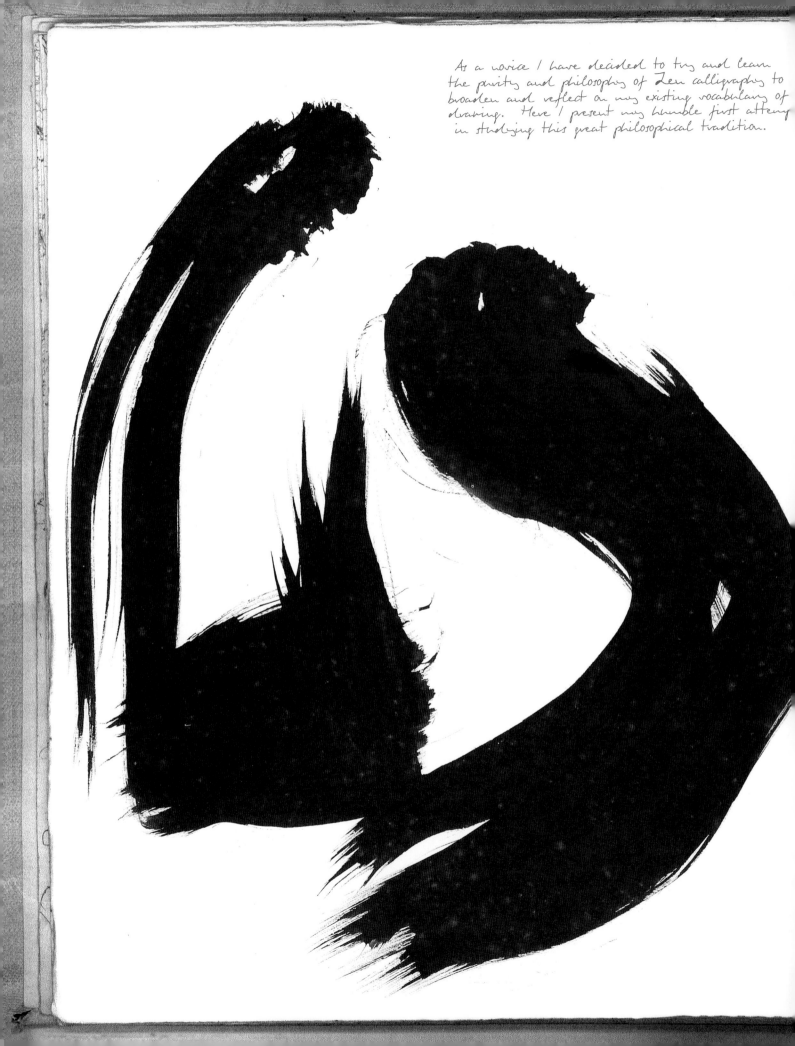

As a novice I have decided to try and learn the purity and philosophy of Zen calligraphy to broaden and reflect on my existing vocabulary of drawing. Here I present my humble first attempt in studying this great philosophical tradition.

Zen Calligraphy

HITSUZENDO, A MODERN JAPANESE meditative art form inspired by the teachings of Yamaoka Tesshu (1836–1888), is the practice of Zen through the calligraphic marks of a brush dipped in carbon ink. Hitsuzendo drawings aspire to "breathe with the energy and vitality of eternal life" achieved through "a state of no mind—beyond thought, emotion, and expectation." [Tanchu Terayama, *Zen Brushwork*].

Nocturnes

IN THIS QUARTET of semi-abstract drawings made with
India ink, discord is balanced against rhythm to create
mood. Lines made with a steel dip pen take on a scratchy
nervousness. These vibrate against washes of shadow and
pitch-black mass. I flicked spatters of ink and rubbed the
paper with a wet and a dry brush to achieve these effects.

M✝S

Gods and Monsters

MARTIN SCHONGAUER
German painter and engraver who settled to work in Colmar, Alsace. Schongauer is best known for his prints, which were widely distributed and influential in his time. Here, our eye circulates around a flutter of leather and scaly wings, a catherine wheel of drawn sparks spiraling around the quietly resolute saint.

Saint Anthony Tormented by Demons
1485
12¼ × 9 in (312 × 230 mm)
MARTIN SCHONGAUER

OUR SACRED AND SECULAR need to visualize demons, beasts, aliens, angels, and the faces of God have for centuries given artists a feast for the extremes of their imagination. Images we are now surrounded by bear testimony to the power and resourcefulness of their collective imagination. Depictions of God or of gods in the contexts of daily life, paradise, and damnation are found in most world faiths. In the Christian churches of Europe, thousands of paintings, sculptures, and stained-glass windows deliver powerful visual sermons to the once-illiterate populace. The salvation of heaven and terrors of hell are represented equally—enough to make any sinner shudder. Today, our literate and more secular Western society still hungers for another world and to ravenously indulge its fascination for the marvelous, impossible, or strange. Feeding this demand, movie studios now brim with as many monsters as the visual art of the Medieval and Renaissance Church.

Fantasy is most successful when founded on strong and familiar visual logic. When creating monsters, we select details of animals farthest from ourselves and that are widely thought disturbing—reptilian and insect features, serpentine tails, scales, wings, feathers, and deep fur—and we alter their scale. Humans are equally troubled by the imperceptibly small and the enormous. Monsters take advantage of both. We love our fear of the hybrid—ideally, a human–animal mix that implies this could happen to us. We then add substances we dislike: unidentified fluids, for example. We watch with captivated pleasure movies such as *The Fly*, *Star Wars*, *Lord of the Rings*, and the *Alien* trilogy, all of which originated as hundreds of drawings.

To learn to flex your imagination, look for images in the folds of clothing, in the cracks of walls, or in smoke. Be inspired by the irrational comedy of word association or puns. For example, I was on a train passing through Nuneaton, England. Reading the place name I momentarily glimpsed an alternative meaning, which is to have eaten a nun—it inspired the drawing on p.247. Throughout this book images are presented to excite and surprise and drawing classes created to increase your confidence. Perhaps the most important conclusion in this final chapter is to advise you to develop your skills in parallel with the joy of your unfolding imagination. Neither should be slave or master; a collaboration between the two will ensure that your drawings glow with originality.

Marks of Influence

MYRIAD CHAINS RUN THROUGH ART HISTORY, marking the influence of one artist upon another. This continuity enriches the making of art and our heritage. Francisco de Goya was a master of borrowing, quoting great paintings and popular culture to add cunning twists to his satires. In this ass, below, we see the international icon of stupidity. Opposite, Paul Thomas's studies of Picasso and Twombly can be traced directly. Compare his dark, rushing, barren land rising like

a wave to join Achilles' chase of Hector, to Picasso's similarly tight, noisy seascape on p.30. Violent white marks symbolizing Achilles' rage resonate with the energy of Twombly's script on p.220. Opposite below, a Shoshone seeking guidance and power meditates at the sacred site of a petroglyph. Visions experienced in front of the drawing sometimes instruct the making of a new one. This act defines the vision and continues the line of spirit guides.

FRANCISCO DE GOYA

Spanish court painter, printmaker, and draftsman, whose impassioned work begins with light tapestry cartoons, portraits, and church murals. Goya later recorded the horrors of Napoleonic occupation, and exposed the superstitions, vanity, and follies of court through copious graphic works including his best-known prints, *Los Caprichos*. Near the end of his life he made his "Black Paintings" on the walls of his home. They depict as if by lamplight the devil and witches, hags, deranged masses, his lover, a dog, Saturn devouring his son, and men clubbing each other to death.

Aquatint Goya has drawn a learned man as an ass, reading from a book of asses. The title "And So Was His Grandfather" adds that, should we not already know, such asinine behavior can be hereditary. The well-dressed mule is cumbersome, crammed tightly at his desk. He would be graceless if he stood. Other drawn versions of this image are more savage and frightening. In this softer aquatint he poses for his portrait.

Textured background The aquatint process has been used to great effect in making a gritty toned background. The high, plain wall suggests a blinkered view of nothing. Pictorially, it allows the mule to stand forward. Many students leave white backgrounds in their work, which can swamp the subject. Here, Goya's plainly textured gray background simply pushes back the space behind the illuminated subject.

Tambien ay Mascaras de Borricos
1799
8½ x 6 in (218 x 154 mm)
FRANCISCO DE GOYA

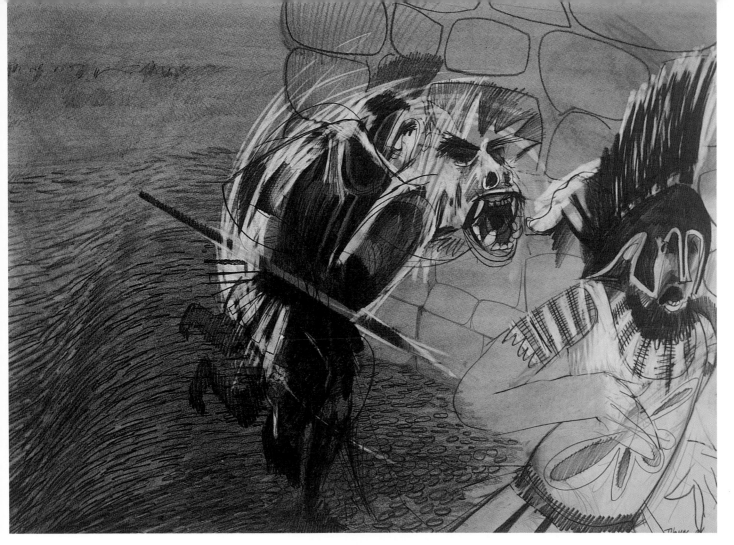

PAUL THOMAS

British contemporary artist whose epic graphic work questions and reflects upon issues of European identity, values, ideals, and personal and social struggles. Thomas conducts his explorations in the mine of Greek and Roman mythology.

Graphite marks Here Achilles chases Hector around the walls of Troy before killing him. A vivid spectrum of energized graphite marks and a masterly composition give this drawing vitality and speed. Simple wall stones cleverly state their cold solidity, while also fading from our attention as the scene roars by. White marks like flashes of light are cut though graphite with an eraser to reveal the paper beneath.

Achilles Chases Hector
1996
22 x 30 in (560 x 760 mm)
PAUL THOMAS

SHOSHONE PETROGLYPH

The Shoshone people of Wyoming name petroglyph sites *Poha Kahni*, meaning "place of power." Each sacred image drawn into rock belongs to one of three realms in the Shoshone world: the realm of the sky, of the earth, or of the water.

Chipped image This is a sacred creature of the sky chipped onto rock at Dinwoody Lake, Wind River Reservation, Wyoming. It was made with a sharp implement, perhaps a stone, by a supplicant in a trance of meditation. Parallel lines within the body of the figure are likely to denote power.

Petroglyph Figure in the Wind River Range
UNDATED
ARTIST UNKNOWN

Hauntings

THE EXPLORATION AND DEPICTION of the unknown is a classical and constant occupation for the artist. Children are also delighted to invent a monster or ghoul. Our subconscious can be drawn with pleasure and ease. Redon's eyeball balloon rises up, lifting its cranial passenger over a seascape of repose. They float toward us like a horrid visitation. We may feel safe so long as the eye looks heavenward. If it were to turn and stare this way, the shock would be extreme.

Grandville has drawn a scurrying zoo of half-known demons and animals that appear to have been stolen from the glass eye of the microscope. The monsters of Bosch grew from his observations of beggars going about their trade in 15th- and 16th-century Holland. Here we see how he evolved their injuries into new limbs and warped proportions, which sometimes—half-dressed and carrying a familiar trophy—stride, crawl, and scuttle over all known reality.

ODILON REDON
French painter, draftsman, graphic artist, and writer. In contrast to the light and visual accent of contemporary Impressionism, Redon explored the darker side of the human imagination through symbols and mysticism. He was influenced by his friends, the writers Joris-Karl Huysmans and Stephane Mallarme.

Erasure In this charcoal drawing, to the right of the balloon, we see parallel slanting pale marks that might have been made with fresh bread—a very effective eraser used before the wide availability of rubber or plastic. Compare worked textures throughout the whole of this image to those found throughout Anita Taylor's charcoal drawing on p.115.

Lifting out Fine strings of the hot-air balloon appear dark against the sky and light against the balloon. Redon lifted them out with some sort of eraser, as he did the grass, below left. Techniques demonstrated on pp.204–05 will enable you to produce a similar effect of white lines shining out of dark charcoal.

The Eye Like a Strange Balloon Mounts Toward Infinity
1882
16⅝ x 13⅛ in (422 x 332 mm)
ODILON REDON

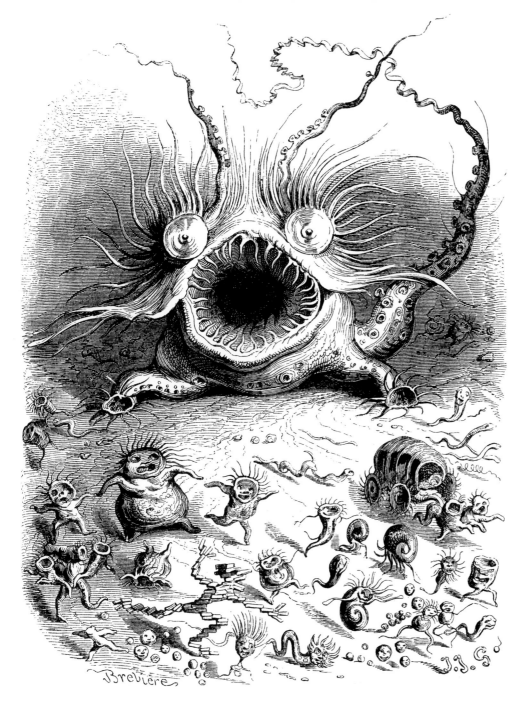

JEAN IGNACE ISIDORE GÉRARD ("GRANDVILLE")

French graphic artist and political satirist. This image is from one of Grandville's best-known publications, *Les Animaux* (1840), which is still available today. His other major works include *Metamorphoses du Jour* (1828), and he illustrated the *Fables of La Fontaine* and Daniel Defoe's *Robinson Crusoe*.

Engraving This is an engraving made so that Grandville's original drawing could be reproduced. The quality of the line is therefore uniform throughout. Light shines from the right. Smiling, grimacing, sucker-faced creatures dash and trundle toward it. They are drawn solidly to emphasize their earthbound weight. Comic little headbands of waving hair express more hysteria than fear.

A Volvox Epidemic Strikes the Near-Microscopic World of Scale Insects
c. 1840
6⅛ × 4½ in (155 × 115 mm)
GRANDVILLE

HIERONYMUS BOSCH

Dutch painter. Bosch's highly detailed iconographic religious panel paintings, teeming with the exhilaration of unrestrained fantasy, include *The Haywain*, *Garden of Earthly Delights*, *Last Judgment*, and *Ship of Fools*. Most of his work is in the Prado Museum, Madrid.

Quill and ink This typical Bosch monster is a quill drawing in bistre ink. The phrasing of light and contour here is masterly.

Two Monsters
UNDATED
4⅝ × 6½ in (117 × 163 mm)
HIERONYMUS BOSCH

Convolutions

THESE CONVOLUTED DRAWINGS were made almost 500 years apart. They share between them the pleasures of inventing a hybrid beast. A snake eating its own tail is a universal image of the eternal and continuous. However, sometimes artists purposefully tie a knot in the configuration to disturb, topple, and play with its perfection and meaning. Michelangelo's dragon, below, a stunning hybrid of a swan, lion, snake, and dog, wraps and coils its lithe body ready to strike or whimper at a touch. His entire drawing wrestles and weaves the viewer's eye into its retracting folds. Opposite, Grimes' delicately cavorting figures dive into and consume each other. Grimes found the genesis of her beast not among animals, as we might expect, but in the seductive landscape of Leonardo da Vinci's oil painting *Madonna of the Rocks*. In her studio, remembering the cavernous, pinnacled, and mist-swathed land, she formed a series of ghostly pale, gamboling copulations.

MICHELANGELO BUONARROTI
Florentine painter, sculptor, poet, architect, and engineer. Among Michelangelo's great works are the painted ceiling and altar wall of the Sistine Chapel, the dome of the Vatican, St. Peter's square, and marble sculptures including *Pietà*, *David*, and dying slaves.

Chalk and ink A quill dipped in brown ink was worked over black chalk on this reused sheet. Two previously drawn faces become humorous antagonists to the beast. Scaly, muscular tension is carved out of the paper using layered, hatched lines, phrased over the contours of form and bridging darker areas of shadow.

Dragon
1522
10 x 13⅜ in (254 x 338 mm)
MICHELANGELO BUONARROTI

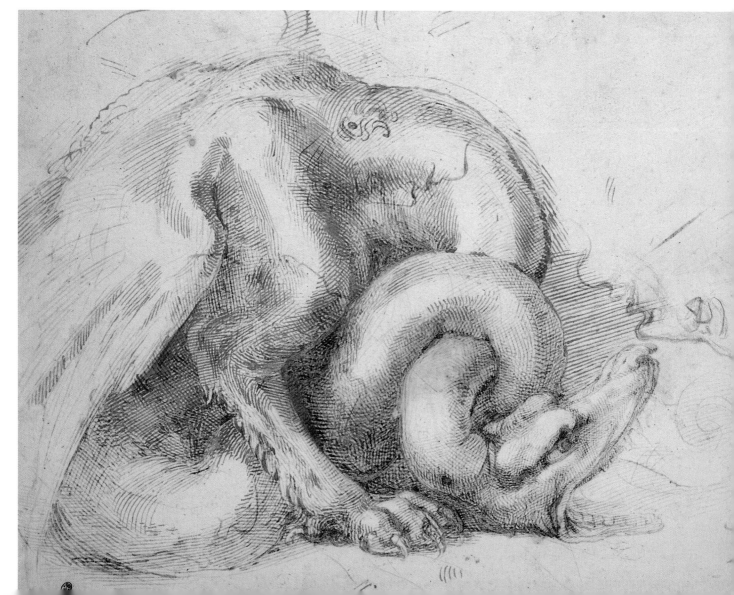

OONA GRIMES

British contemporary artist and professor of printmaking at the Ruskin School, Oxford, and the Camberwell and Slade Schools of Fine Art, London. Grimes exhibits internationally and features in the collections of the New York Public Library and the Victoria and Albert Museum, London.

Ink-wash and gouache This is a delicately brushed ink-wash and gouache drawing on hot-pressed (smooth) paper. The image was formed directly without first making a pencil outline. It is one of a series of fragile earth figures inspired by rocks, each one iridescent and crumbly like a weathered white oyster.

Shadows The dark shadow of the earth was made with a brushstroke of ink laid into wet paper. Other details evolved slowly using a drier brush. The large space around the figure has been cropped here. Grimes presses her finished drawings under heavy boards to flatten them.

How Clever of God #84
2002
22 x 30 in (560 x 760 mm)
OONA GRIMES

Brushes

THE BRUSH IS A VOLUPTUOUS and delicate drawing tool extending the arm, fingers, and wrist into a fluid and soft touch. The living marks of a wet, ink-laden tip allow an expression that is beyond the linear; the very opposite of pencil or silver point.

Brushes vary in size, shape, and texture. Some are bold, dense, and hold prodigious weights of ink or paint; others are as fine as a whisker with a gentle touch. The brushes shown here are a mixture of

weights, thicknesses, materials, all perfect for drawing and, between them, giving a variety of lines, washes, and effects.

How you care for your brushes will determine how long they last. Always clean them thoroughly, return them to their pointed shape, and never leave them standing on their tip in a jar of water. Soaps purchased from good art supply stores will gently cleanse particles of pigment that become trapped in the hairs or ferrule.

9 10 1

MATERIALS

This is a selection of riggers, liners, and writers, ideally suited to drawing. They hold plenty of ink and make continuous, flowing, and very fine lines. Shorter brushes designed for other purposes run out of ink more quickly.

1. SMALL JAPANESE BRUSH: Made with sable hair, this brush has a soft drawing tip and small ink-holding capacity.

2. SYNTHETIC-HAIR LINER: This brush gives a medium line and is firm with a spring to the touch. It has exceptional painting characteristics.

3. SABLE-HAIR RIGGER: Made with very long kolinsky sable hairs, it has good ink-holding capacity and is very flexible, with a fine point for delicate work

4. SABLE-HAIR LINER: Made with ordinary sable hair surrounding an extra-long, needle-sharp center of kolinsky red sable hair. This design supplies the fine tip with a long continuity of ink.

5. SYNTHETIC-HAIR RIGGER: Made with long synthetic hair for fine-point work. It has a good ink-holding capacity and is slightly more resilient than sable hair with more "snap."

6. POINTED TRADITIONAL WRITER: The ferrule is made from a small duck quill, which holds long sable hair. This brush holds large amounts of ink for long lines and points well for detailed work.

7. SQUIRREL-HAIR SWORD LINER: This brush has a maximum ink-holding capacity and an extremely fine and flexible point.

8. SYNTHETIC-HAIR SWORD LINER: A lining brush with high ink-holding capacity and a fine point. Slightly less flexible than the squirrel-hair sword liner.

9. POINTED SQUIRREL-HAIR MOP: With a synthetic quill ferrule and extra high ink-holding capacity. Suitable for wash techniques but also capable of very fine detail.

10. LARGER JAPANESE BRUSH: Made with natural hair held in a plastic ferrule on a bamboo handle. This brush has a broad wash capability and can achieve a very wide range of marks. It is still relatively small in the total range of Japanese brushes. Some used by master calligraphers are 2–3 in (5–8 cm) in diameter.

11. LARGER SYNTHETIC-HAIR LINER: Very responsive oriental-style liner. This brush holds ink very well, is firm to the touch, and has a fine tip for detailed work.

12. JAPANESE PAINTING BRUSH: Made with natural hair, it has good wash capabilities, making it ideally suited to Japanese painting and small-scale calligraphy.

13. SYNTHETIC-HAIR BRUSH: Bound in a synthetic ferrule with good ink-holding capacity and good spring and control. It is capable of very fine pointing.

1

2

3

4

5

6

7

8

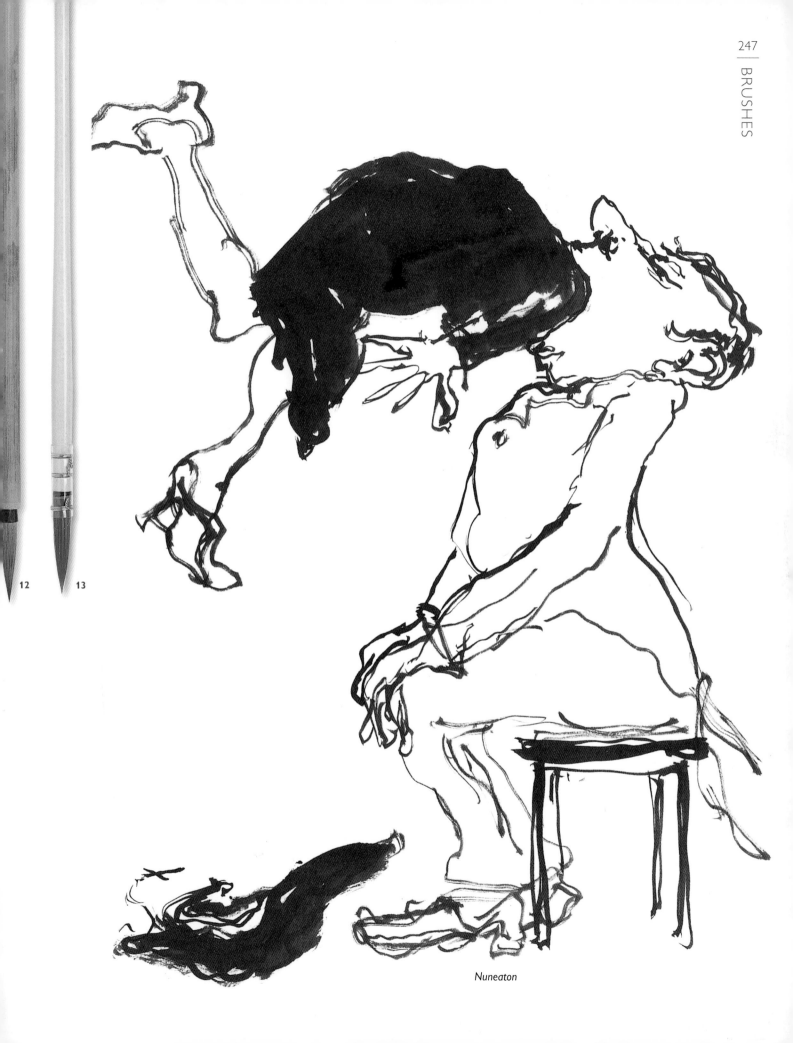

12 13

Nuneaton

Brush Marks

A SINGLE BRUSH will make an enormous range of marks depending upon the width, length, softness, and type of its hairs. It also depends on the angle at which it is held, the degree of pressure applied, the speed of the stroke, the texture and absorbency of the paper (which may be damp or dry), and above all whether the brush is saturated with pigment or relatively dry. A single brush has almost balletic potential to draw fine or undulating lines and curves, splashes, and spatters, and to make pools and stains on the page.

SETTING UP

Here I drew with a soft Japanese painting brush (see *pp.246–47*). I rubbed a block of Chinese ink (see *p.35*) into two tablespoons of water in a shallow, unglazed earthenware dish. I had left the end of the ink block in the water overnight to make it easier to dissolve.

Blowing spots

These three spidery creatures (*above right and below*) were made by dropping spots of ink from a brush onto the page and, with my face close, blowing hard on them several times to disperse the ink (close your eyes if you try this.)

Gritty texture

The details of the largest creatures below and opposite show the granular texture of Chinese block ink, and the way it distributes when the brush is dabbed on its side.

Wet and dry strokes

Among these drawings made with the same brush, we see fine lines and spots, bleeding from concentrated ink strokes into watery lines, and below left, the effects of the brush running out of ink.

Monsters

THESE LITTLE CREATURES of ink and invention were born out of animal and bird studies. I borrowed small and fragile specimens from the University Museum of Natural History, Oxford, and used their detail to draw new creatures that might at first seem familiar, until we look again.

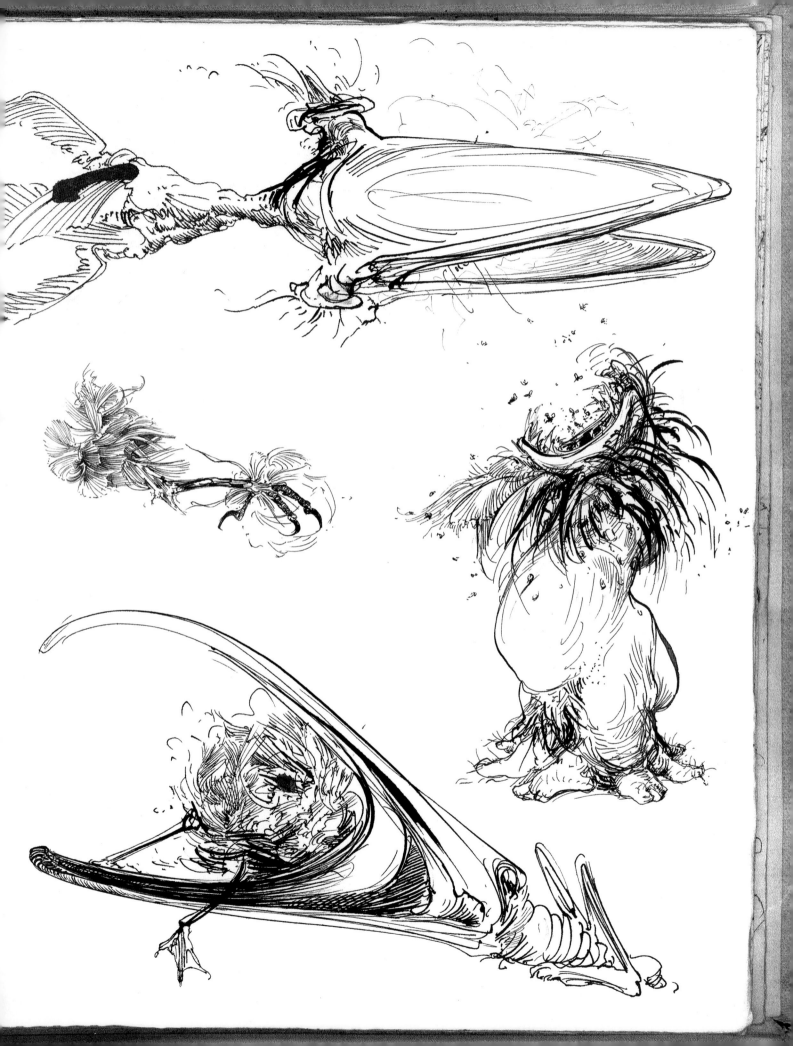

Goya's Monsters

WITH CUNNING BRILLIANCE, Goya often invented his monsters out of characters seen in other painters' works, showing us that gallery study is not just for the student and beginner. Among his "Black Paintings" in the Prado Museum, Madrid, are two long, thin works titled *The Witches' Sabbath* and *The Procession of St. Isidore*. They are a pair and hang opposite each other. Through studying and drawing these great paintings I have discovered that they are based on a pair of similarly long, thin works made by Bartolome Murillo in Seville about 120 years earlier. Here, two of my own drawings show you how Goya's devil (*below*) is based on the shape of Murillo's boy on a horse (*top right*). Goya's witches have been literally drawn and evolved out of the shapes of Murillo's prophet and pilgrims. With further research, I found relationships between all four paintings in terms of shapes, formal composition, and narrative twists.

To the right is my drawing of Murillo's painting "Moses Striking the Rock of Horeb". It hangs beside the altar in the hospital church of St. Caridad, Seville, opposite its mate, the "Miracle of the Loaves & Fish". The works were temporarily removed to Madrid in 1800 by Napolean. I think this is when Goya saw them.

Both of these preliminary drawings were made directly in front of the original paintings using a pen, brush, and india ink.
The more I repeatedly drew the two works, the more relationships I discovered between them. Concluding drawings (not shown) were carefully measured and diagrammatic.

My dark outline around Murillo's boy on a horse (above) shows
how I think their shape is the basis of Goya's devil (below).

The first witch in front of Goya's devil also seems similar to
the kneeling woman in front of Murillo's horse.

Consumed

THIS IS A SERIES OF CARTOONS I made some years ago, little comments on politeness and sexual politics, drawn rapidly and with great joy. Sometimes drawings come out of nowhere and surprise even the artist.

Glossary

Accidental drawing Random, chance mark-making.

Acid-free paper Paper with a neutral pH that will not darken or deteriorate excessively with age.

Aerial perspective The effect of the atmosphere over distance as it lightens tones and cools colors progressively toward the horizon.

Air brush A mechanical, pressurized tool used for spraying fine mists of smooth color. Pigment is delivered by a jet of air, not the bristles of a brush. Air brushes are used in the production of comics.

Anamorphic distortion Stretching an image across a picture surface so that it can only be understood, or will only appear normal, when viewed from a specified point, usually at an acute angle to the surface. Used as a correcting device or pictorial game. Also called accelerated perspective.

Binder A substance that holds particles of pigment together in a paint formulation, and attaches them to the support—for example, linseed oil or egg yolk.

Bleed The effect of two wet colors running into one another or one color applied to a wet surface and allowed to disperse.

Blending Merging two or more neighboring colors or tones together using a tortillon, for example.

Blotting The use of absorbent material to lift away excess liquid.

Bracelet shading Curved parallel lines that follow the contours of form. Also called ringlet shading.

Body color See *Gouache*.

Calligraphy Beautiful handwriting. From the Greek *kallos*, meaning "beauty". Words or symbols are written with a broad-nibbed pen or brush. In the West, pen calligraphy is used to create formal and decorative texts. In the Far East, calligraphy is a highly respected art form, practiced meditatively with a brush, and given the name *Sho*.

Camera lucida An optical device that projects an image of an object onto a plain surface so that it can be traced.

Camera obscura A darkened chamber into which an image of what is outside is received through a small opening or lens and focused in natural color on a facing surface, such as a screen, rather than recorded on a film or plate.

Caricature A representation in which the subject's distinctive features or peculiarities are deliberately exaggerated for comic or grotesque effect.

Cartoon 1. A full-size drawing made for the purpose of transferring a design to a painting, tapestry, or other (usually large) work—see *Pouncing*. 2. A humorous drawing or parody.

Chiaroscuro A 17th-century Italian term meaning "clear-obscure." It was first given to tonal paintings made in one color—see *Grisaille*. Later it came to mean highly contrasted light effects, in which parts of an image are depicted very brightly and dramatically against darkness. Rembrandt is a great master of chiaroscuro.

Collage Collected materials such as colored papers, photographs, newspaper cuttings, and ready-made objects arranged and stuck onto a flat surface. From the French verb *coller*, meaning "to stick."

Cold-pressed papers Paper manufactured with a "not" or "rough" surface. Rough paper is made between two blankets that are rolled through cold cylinders. The blankets give the paper its rough texture or "tooth." "Not" pressed paper is rolled a second time without blankets through cold cylinders to produce a smoother but still slightly textured surface. The name "not" simply refers to the fact that the cylinders are not hot in temperature. *See also Hot-pressed papers.*

Composition The arrangement of the parts of an image to make up the whole.

Conservation grade Describes a range of materials that do not decay and cannot be broken down by insects. Also called museum grade.

Contour line A line that follows the shape of a surface.

Contre jour A French term meaning "against day." Describes a painting in which the light source is behind the subject. For example, when a person is painted standing against a window, the light is behind him or her.

Crosshatching Parallel lines drawn across one another at right angles. A potentially harsh method of producing tones in a drawing.

Deckle edge The irregular edge of a sheet of mold-made paper, as opposed to the straight edge of a sheet of paper that has been machine-trimmed.

Diffuse To soften or make less brilliant.

Dry media Media that are not wet or oily—for example, charcoal, pastel, and graphite.

Drypoint A drawing is scratched directly onto a metal plate with a metal tool held like a pen. The plate is then rolled with ink and polished with a rag, so that ink remains only in the grooves of scratched lines. It is put on a printing press face up. Damp paper is laid on top, together with a thick felt blanket. The whole sandwich of layers is then rolled through the press to make a print. Drypoint is a very portable and immediate method of printmaking.

Engraving 1. A general term that describes the various processes of cutting a design into a plate or block of metal or wood. 2. The prints taken from these plates or blocks. Copperplate engravings were widely used to reproduce images before photography.

Erasure The act of removing an image from a surface.

Eye level The imaginary horizontal plane at the same height as the average person's eyes. Also called the horizon line.

Fauvism An early 20th-century painting movement characterized by the use of bold, often distorted forms and vivid colors. The movement was started by a group of French artists including Henri Matisse.

Ferrule The short metal tube that surrounds and grips the hairs of a paintbrush and fixes them to the brush handle. Sometimes ferrules are made of plastic or other materials.

Field In a two-dimensional image, such as a drawing or painting, the field is the apparent and believable space inside the picture. A "shallow depth of field" means the picture appears to have only a shallow space inside it.

Fixative Liquid acrylic resin and lacquer thinner usually applied as an aerosol spray mist to the surface of a dry-media drawing. Fixative lightly glues the drawing to the surface of the paper to prevent smudging. It can also seal a silver point drawing to prevent the oxidization (browning) of the

metal line. Hairspray is an effective and inexpensive alternative.

Focus 1. The degree to which detail is defined. 2. A point of interest in a drawing.

Foreshortening A method of depicting an object at an angle to the surface of the picture, so that (using vanishing point perspective) the object appears to change shape and become narrower or smaller as it recedes. This effect emulates what we see in real life.

Form The outer surface of a three-dimensional object.

Format The size, shape, and orientation of the image. A small image might be described as small format. Horizontal images are often said to be "landscape format" (abbreviated to "landscape"), while upright images are called "portrait format" (abbreviated to "portrait").

Frottage A French term meaning "rubbing." A piece of paper is placed on top of an object or rough surface, then rubbed over carefully but vigorously with a crayon. The paper then bears a crayon impression or copy of the surface that was underneath it. A number of Surrealists, including Max Ernst, used frottage in their work.

Fugitive A term given to a pigment that it is not stable, and that will "escape" or change over time.

Gamut A complete range or extent.

Glassine A type of thin, glossy, and translucent paper—a delicate material used in collage, or for wrapping and protecting a finished piece of work.

Golden Section A proportion in which a straight line or rectangle is divided into two unequal parts in such a way that the ratio of the smaller part to the greater part is the same as that of the greater part to the whole.

Gouache Opaque watercolor. Also called body color.

Grisaille A painting in gray or a grayish color. Often made by students as a tonal exercise, and by artists representing stone sculptures in a painting. Giotto's *Virtues* and *Vices* in the Arena Chapel, Padua, are painted in grisaille and appear to be made of stone. Rubens used grisaille to paint small images for engravers. Grisaille is occasionally seen in church stained-glass windows, and it has a history in enamel work.

Ground A wet solution usually of gouache or gesso (chalk and animal glue) brushed onto paper, board, or canvas and allowed to dry before an image is drawn or painted. The ground provides a particular color or texture beneath the image.

Gum arabic The natural secretion of the acacia tree, which is used as a binding agent in many liquid media. It improves the bonding properties of the ingredients in inks and watercolors, enabling them to stick to paper. It also helps to maintain a stable dispersion of pigment particles in water as the film of a wash dries. It is a strong adhesive, and is also used as a size.

Hatching (cross-) See *Crosshatching*.

Hot-pressed papers (HP) Paper made using hot cylinders, which give it a smooth surface (as opposed to cold-pressed paper, which has a rough surface).

Hue A term for a color, or a family of colors. Also used by artists' materials manufacturers to indicate the use of a substitute pigment—for example, cadmium yellow hue.

Impressing Stamping or printing.

Key A painting is said to be "high key" when the colors and tones are bright and "low key" when they are dark or somber. The term is also used to describe a surface to which paint will adhere readily.

Lifting out A method of creating highlights and mid-tones in a dry-media drawing (such as charcoal or graphite). Dark tones are laid down first, then an eraser or masking tape is used to lift away particles of the drawing media to reveal the lightness of the paper beneath.

Lightfast A term confirming that pigment in the product will not fade with exposure to light.

Linear perspective A form of perspective in which parallel lines are represented as converging, to give the illusion of depth and distance.

Lithography A method of printmaking in which a drawing or painting is made directly onto a smooth slab of particular limestone or a metal plate using an oil-based crayon or ink. After several intervening processes, the surface of the stone is made wet before being rolled with a thin film of oil-based printing ink. The ink attaches to the oil-based image and is repelled by the wet stone. Paper is then pressed against the stone to take a print.

Masking fluid Clear or opaque latex fluid developed for watercolor painting. It can be used with any wet media to isolate or protect parts of an image from further work. Artists can paint freely over dry masking fluid, with the area beneath remaining unaffected. It is then peeled away.

Masking tape Invaluable, multi-purpose, sticky paper tape, used for fixing paper to walls and boards, lifting out charcoal and other dry media, and masking off areas of a drawing that the artist wishes to keep untouched by media applied above or beside the tape.

Medium A generic term for art materials that produce marks on a surface, or can be otherwise used to create an image—for example, graphite, ink, pastel, or even a beam of light. Also refers to an additive used to control the application properties of a color.

Monochrome Usually refers to a black, white, and gray drawing, or a drawing made in any single color.

Monoprinting A direct method of printing in which wet medium (water-, oil-, or spirit-based) is applied to a surface that is then pressed onto paper and removed to leave a print. The surface can be reloaded or redrawn with more medium, but each print will be unique. Alternatively, oil-based printing ink is rolled evenly onto a smooth metal, glass, or plastic surface. Paper is laid on top and a rapid drawing is made on the back of it. The paper lifts away to reveal the image on its other side. This method incorporates the excitement of accidental and unpredicted marks.

Negative space The space between things. This may be disregarded in real life, but in picture-making it is as important as the objects/subjects themselves.

Objective drawing Refers to the concept of objectivity. Usually an academic drawing observed from life, aiming to represent facts rather than an interpretation of the subject.

Optical blending See *Pointillism*.

Papercut A type of collage in which flat sheets of paper are cut into an image.

Picture plane In the imaginary space of a picture, it is the plane occupied by the physical surface of the work.

Pigment Any substance used as a coloring agent—for example, the finely ground particles of plant, rock, mineral, or synthetic material that are suspended in a medium to constitute paint.

Plumb line A line from which a weight is suspended in order to determine verticality or depth.

Pointillism A technique of using points or dots of pure color in such a way that when the picture is viewed from a distance they react

together optically, creating more vibrant effects than if the same colors were physically mixed together with a brush.

Pouncing If a large drawing or design (called a cartoon) is to be transferred to a surface such as a wall or tapestry, a sheet of paper is placed beneath and pinpricks are made along every outline of the image. The drawing is removed, leaving only the pricked sheet of paper in place. Pounce (a fine powder of charcoal or similar material) dabbed through the pinpricks creates a "connect-the-dots" replica of the image on the plaster or cloth surface beneath.

Printmaking The act of making a picture, design, or mark using an inked or pigment-covered surface, such as an inscribed sheet of metal, or wood, or any physical object that can be stamped or pressed onto a surface to leave an impression. Artists' prints are normally made in multiple, which are then called editions.

Props An abbreviation of the word properties. A term borrowed from the theater, meaning objects used in setting up a life model or still life.

Recto The front or top side of a piece of paper, or the right-hand page in a book.

Scale Describes the size of one element in relation to another.

Sepia A brown pigment taken from the sun-dried ink sacs of cuttlefish and used to make ink or watercolor. The term is now often incorrectly used to refer to brown colors.

Serigraphy Silk-screen printing.

Sfumato An Italian term meaning "smoky." Applied to the blurring or softening of sharp outlines by the subtle and gradual blending of one tone into another.

Sgraffito A technique of scratching or cutting through a surface of paint, plaster, or ceramic glazing to reveal a different color beneath.

Shade A that is color mixed (or toned) with black.

Shading A lay term for adding tone to a drawing.

Shadow Darkness cast by the obscuring of light.

Silhouette A flat, cut-out profile usually made in black paper, and sometimes drawn from a shadow cast on a wall. Named for an unpopular 18th-century French politician, Etienne de Silhouette (1709–67), whose personal pastime was making cut-out portraits.

Single-point perspective The most basic form of linear perspective in which there is only one vanishing point, or point on which parallel lines converge to give the impression of receding space.

Size A weak glue used for filling the porous surface of wood or canvas in order to seal it.

Sketch A quick or rough drawing.

Spattering A mottled texture produced by drawing your fingers across the bristles of a stiff brush loaded with pigment, in order to flick the pigment onto the image surface.

Squaring up A method of enlarging and transferring an image from one surface to another, by imposing a grid that is then scaled up to a larger size.

Squeegee A rubber-trimmed scraper used in the screen-printing process for dragging ink across a surface.

Still life A picture composed of inanimate objects such as bowls, glasses, fruit, and flowers.

Stippling Applying color or tone in areas of fine dots or flecks, using a brush, pencil, or pen.

Strip Core of a pencil, commonly referred to as the lead.

Stylus A sharp, pointed instrument used for marking or engraving.

Subjective drawing A drawing that expresses the personal view and interpretation of the artist. An invented image.

Support The structure on which an image is made—for example, paper or canvas.

Technical drawing A universal language of lines and measurements that is used to make diagrammatic images. Technical drawing has been evolved by engineers and architects for the purpose of conveying accurate structural information.

Tint A color mixed with white.

Tonal scale A scale of gradations in tone running from black to white or vice versa.

Tone A degree of lightness or darkness.

Tortillon A short, tight, pointed roll of white paper that is used to blend dry media. Alternatively, a tightly folded piece of cotton batting can be used for the same effect.

Turpentine A colorless solvent distilled from the resinous sap of pine trees. The crude material is called oleoresin. "Spirits" or "oil" of turpentine refer to the volatile portion used by artists to thin or dilute oil-based paint.

Underdrawing A pale preliminary drawing made prior to adding layers of another medium such as oil paint or watercolor.

Value The extent to which a color reflects or transmits light. This is the equivalent of tone in a black and white image.

Vanishing point In linear perspective, a point at which receding parallel lines meet.

Verso The back or underside of a piece of paper, or the left-hand page in a book.

Viewpoint The position from which something is observed or considered.

Volume The amount of space occupied by an object or an area of space in itself.

Wash A technique using ink, watercolor, or gouache, usually diluted with water and applied with a brush. Although drawings can be made with wash alone, it is often used in conjunction with line drawings in pen and ink—for example, to model areas of light and shade.

Watercolor A painting compound of water-soluble pigment. The translucent nature of watercolor allows the white surface of the paper to shine through, giving it a brilliance.

Wet media Any liquid media—for example, ink, acrylic, or watercolor paint.

Zen A school of Mahayana Buddhism that asserts that enlightenment can come through meditation and intuition rather than faith.

Zen brushwork This is an oriental meditative art form originating in China and practised for many centuries in Japan. Zen brushwork encompasses calligraphy and painting. Zen paintings usually depict scenes of nature and plants such as bamboo, orchids, plum blossom, and chrysanthemum—which in Chinese tradition are called "The Four Gentlemen." Materials for Zen brushwork include round brushes of varied size, carbon ink, an ink stone usually cut from slate, fine paper, and paperweights.

Index

Page numbers in *italics* refer
to captions and illustrations

Acknowledgments

Author's Acknowledgments:

The author wishes to thank the following people for their enormous help, support, and encouragement in making this book:

Mamoru Abe, Rocio Arnaez, Carole Ash, Diana Bell, Roddy Bell, Clare Bryan, Len, Flossie, Finn, Jack and Brian Catling, Andy Crawford, Antonia Cunliffe Davis, Christopher Davis, Sammy De Grave, Jackie Douglas, Sarah Duncan, Mandy Earey, Sir Brinsley Ford, Natalie Godwin, Oona Grimes, Tony Grisoni, Dawn Henderson, Phyll Kiggell, Bernd Künzig, Sophie Laurimore, Simon Lewis, Peter Luff, Heather McCarry, George McGavin, Julie Oughton, Ruth Parkinson, Angela Palmer, Anna Plucinska, Paula Regan, John Roberts, Jon Roome, Gina Rowland, Jean Pierre Roy, Rosemary Scoular, Helen Shuttleworth, Roy and Dianne Simblet, Kevin and Rebecca Slingsby, Patty Stansfield, Anita Taylor, Paul Thomas, Agnieszka Mlicka, Kirsten Norrie, John Walter, Angela Wilkes, Kathryn Wilkinson, Sarah Woodfine, and Tamsin Woodward Smith.

Also, The Ruskin School of Drawing and Fine Art, Wolfson College, and Departments of Entomology and Zoology at the University of Oxford.

Publisher's Acknowledgments

Dorling Kindersley would like to thank Caroline Hunt for editorial contribution, Pamela Ellis for compiling the index, Carlo Ortu for picture research support, Andy Crawford for photography and L. Cornelison & Son, London, for supplying the drawing books, papers, and brushes on pp.20-21 and 246-47.